Google SketchUp Workshop

Modeling, Visualizing, and Illustrating

Edited by
Laurent Brixius

Routledge
Taylor & Francis Group
New York London

First published 2011 by Focal Press

711 Third Avenue, New York, NY 10017, USA
2 Part Square, Milton Park, Abingdon, Oxon OX14 4RN

Routledge is an imprint of the Taylor & Francis Group, an informa business

First issued in hardback 2017

Authorized translation from the French language edition, entitled *Créer avec SketchUp – 16 Projets, de l'Architecture au Théâtre*, collective work directed by Laurent Brixius, published by Pearson Education France, Copyright © 2009 Pearson Education France.

English language edition published by Taylor & Francis. Copyright © 2011.

Library of Congress Cataloging-in-Publication Data
Applicationsubmitted

British Library Cataloguing-in-Publication Data
A catalogue record for this book is available from the British Library.

ISBN 13: 978-0-240-81627-2 (pbk)
ISBN 13: 978-1-138-45622-8 (hbk)

Typeset by: diacriTech, Chennai, India

Contents

Contents

iv

Contents

Contents

Overview

Working on Complex Models in SketchUp

SketchUp is both simple and intuitive; there is no doubt about that. It usually takes a couple of hours to get grips on it and to create your first 3D models. But when you are using it for a professional project – with all the attendant time and quality constraints – you have to get a few things straight first to avoid the traps that users inevitably fall into, whether they are beginners or experienced operators.

When you are working on a complex project, made up of a large number of elements, SketchUp can slow down, often considerably. The working methods and the tips and tricks presented in this book can considerably improve SketchUp's performance, enabling you to work much more quickly. The good news is that many of the methods used to efficiently organize a model actually make SketchUp a lot quicker.

So, here are a series of good habits that you should pick up when you are working with your models, in order to optimize SketchUp's performance.

Configure SketchUp

In an architectural project, solid foundations are indispensable for supporting the rest of the construction. Here is how to go about creating solid foundations in SketchUp.

Configure Your Template File

At the start of the project, configuring your model is a fundamental step that you should not neglect. But who gets any pleasure from continually reinventing the wheel? Instead of configuring your model for every new file, create your own template file in which you have configured all the options that do not change between projects.

To save your template file, from the Menu Bar, choose File > Save As Template…. Type any relevant information into the fields (file name, description) and click Save. If you have a version of SketchUp earlier than 7.1, choose File > Save As…; in the dialog box that appears, save the template file in the path C:\Program Files\Google\Google SketchUp\Resources\en-US\Templates in case of Windows and in the path ~/Library/Application Support/SketchUp/Templates (where "~" is the name of your home directory) in case of Mac.

If you are using the Save As… method, type the name of your template file in the File Name field, click on Type, select SketchUp Model, and then click on Save. Using both these methods, your template file will appear in the list of templates that are available when you click on File > Preferences… > Template. You can then create different template files and select them according to the type of project that you are working on.

Before you save, here are several options that you will need to set.

Choose Your Units

Do you want to work in a fluid and an efficient manner with the others taking part in your project? And, additionally, do you want to take advantage of the vast library of SketchUp components available through the Google 3D Warehouse without having to rescale them? In that case, start by setting the units of measurement of your model. To do this, click on the Window menu and choose Model Info. In the dialog box that appears, select Units from the left-hand column and choose the units that you will be working with in your model. You also have the option at this point of specifying the precision of the units of length and angle.

> **Info**
>
> SketchUp does not handle multiple decimal places very well. If you are working on an object at very small scale, you should choose a more appropriate smaller unit that will allow you to work with whole numbers.

Creating the Layers That You Will Use the Most

If, in your work, you regularly use the same layers, creating them in the template file means that you will not have to re-create them all over again for each new project. To add new layers, go to the Window menu and call up the Layers palette. Click on the Plus icon to add a new layer, making sure you put a meaningful name in the name field.

OVERVIEW FIG 1.1 Adding a layer.

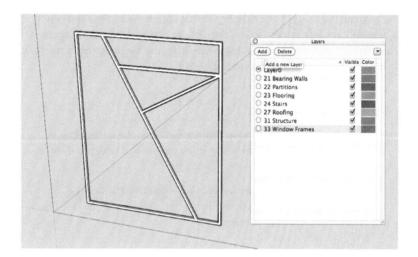

Tip

Many practices have standard naming conventions for layers used in models across all the programs that are used in the office (31 Windows, 47 Door Furniture, etc.). Manually entering the name of a layer each time that you need it is tiresome and a potential source of errors. Furthermore, you do not want to overload your Layers palette by systematically adding all the types of layers used by your office in your template file. To automate the creation of layers, guaranteeing the correct name, follow these instructions:

- Create a library of external components, called, for example, "Layers," that will contain one file for each layer name used by your practice.
- In a model, erase all the unused layers (except Layer0).
- Create a layer using your layer-naming system.
- Draw an object – a rectangle, for example – and make it a component, giving it the same name as the layer that you have just created.
- Save this model into the Layers Components library that you previously created.
- Repeat the operation for any other layers.

Once you have carried out this procedure (admittedly long, but you only have to do it once), you simply have to insert the component

corresponding to the desired layer in order to automatically create that layer. The layer will then have exactly the same name as the component. Then, simply delete the component.

Purge Any Unneeded Elements from Your File

For example, you should erase the figure that appears each time you create a new file from your template file. Alternatively, you could erase the figure in the original template file as well. Make sure that your file does not contain any components or layers that you will not need.

Tip

To automatically delete unneeded elements, click on the Details icon in the Layers, Components, Materials, or Styles palette and select the "Purge" command.

The PurgeAll.rb plug-in, created by TIG, allows you to automate the purging of your model while allowing the possibility of selecting the types of elements that you want to purge.

Set Up Keyboard Shortcuts for Your Most-Used Tools

Whatever the software, keyboard shortcuts save you a lot of time and increase your productivity. SketchUp is no exception to this rule.

To see the default keyboard shortcuts, go to Window > Preferences > Shortcuts (Windows) or SketchUp > Preferences… > Shortcuts (Mac). Or, you can use the old Quick Reference Card (no longer available under the Help menu, but you can download at http://googl/FR0a).

Tip

It is up to you to change the default shortcuts, but first make sure that you are the only person working on this installation of SketchUp: Your colleagues will not be pleased if all their keyboard shortcuts have been changed.

Organize the User Interface

Organize your installation of SketchUp to give priority to your Workspace. Try and avoid the clutter of toolbars and palettes that can get in the way of your model. Give priority to palettes anchored at the side of your Workspace, laid out according to the proportions of your screen.

For the palettes, you can save a lot of time and space by displaying only the title bar on each palette. You simply need to click on the title bar to expand or collapse the palette. You can also think about "gluing" title bars together (they are "sticky" and will snap to one another); in this way, you can move all the palettes around, simply by grabbing the title bar of one of them. Practical and quick.

Other Things to Configure

- Scenes
- Rendering style
- Face and edge style
- Font and size used for text labels
- etc.

This wraps it up for the configuration of your template file. Other parameters can be changed on a case-by-case basis, such as the following:

Model Location and Setting the North Point

For the ultimate in realism, make sure that you set the geographical location of your site by clicking on Window > Model info > Location and entering the geographical coordinates of the site.

You can also configure the direction of the north point for your project. You can either type in an exact angle or indicate the orientation manually by clicking the Select button. Click on a point in your model, for example, at the center of the north indicator of an imported plan, and then click on a second point to indicate the north direction. By selecting Show in Model checkbox, you can visualize the north angle directly in your Workspace.

Once these two parameters are set, shadows in your model will be correct.

OVERVIEW FIG 1.2 Stacking the palettes.

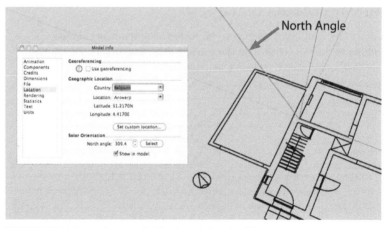

OVERVIEW FIG 1.3 Setting the geographical location and orientation of the project.

Creating with SketchUp

A lot of the problems that SketchUp users encounter are caused by inappropriate working methods. Here are some rules for best practice:

Save Your File

The first thing that you should do, before you even draw a single line, is to save your new file with a meaningful name. This means that your automatically saved backup files will be in the same folder as your .skp file. Your file must be saved at least once for this to work.

Model at or near the Center of the X, Y, and Z Coordinates

SketchUp has difficulty in displaying a model that is far removed from the origin of the X, Y, and Z axes. In this situation, you can get rendering errors while using the Orbit tool O (or click on the middle mouse button).

As far as possible, model at or near the origin of the axes.

Tip

If your model looks truncated (parts of it disappear intermittently) from certain viewing angles and it is a long way from the origin of the axes, start by deleting elements that are a long way off from your model. If the problem persists, select the model and move it closer to the origin of the axes .

Always Model on Layer0

Difficulties with using layers correctly often lie at the heart of many problems that SketchUp users face. Users often find that objects remain visible even though the layer is switched off or, conversely, objects disappear even though the layer that they are on is switched on. It can get really confusing!

Info

You need to know that SketchUp does not use layers in the same way the other CAD programs do. In SketchUp, the layers do not isolate objects; they simply control their visibility. It is essential that all edges and faces be created on Layer0. Only groups and components should be assigned to other layers.

Model by Following the Red, Green, and Blue Axes

Generally, if you model off the X, Y, or Z axes or you do not use inferences, you can never be sure of the (often surprising) results that you will obtain. By default, SketchUp starts out drawing on the ground plane (level 0), but things can get out of hand when you venture into the third dimension. This is why it is always better to follow the Red, Green, and Blue axes because these will help you place your design in 3D space. Of course, you will often want to work off axis, so this is what you do…

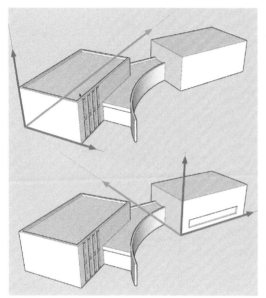

OVERVIEW FIG 1.4 Changing the axes.

Change the Axis Orientation When Drawing Off-Axis Objects

If you have to model a project where an important part does not line up with the main X, Y, and Z axes, you can always realign the orientation of the axes using the Axes tool. Click on a point to set the origin, then on a second to define the X axis and a third to define the Y axis.

To go back to the default setup, click on the axes' origin with the right mouse button (Ctrl-click on a Mac) and choose Reset.

Tip

If an object is located exactly on this intersection, click as close to the point as possible in an area of your model that does not contain any objects. If there are objects all around the axes' origin, the easiest solution is to simply hide them and repeat the operation.

Tip

A particular orientation of the axes can be saved by creating a scene and making sure that the Axes Location check box is ticked. You can also save a scene before you change the axis orientation, which will enable you to return to the default setup with a single click.

Use Construction Lines

Construction lines are the best ways for modeling precisely in SketchUp. There are several methods available for creating construction lines:

- Use the Tape Measure tool. Click on two points of one edge to define the direction of the construction line.

- Use the Protractor tool. Click on a point to set the origin or rotation and then on the second point to define the axis of origin. You can then click on the new point or enter a value for the angle of rotation for the construction line.

Using Inferences

You must be a past master at using inferences, by now. No? Inferences correspond to the well-known snapping functions in other CAD software, like AutoCAD or Vectorworks. In SketchUp, these drawing aids are always switched on.

When you are drawing or modifying an object, inferences provide you with a visual aid in the form of the color of the "snap dot" displayed with the particular inference. These come in two types:

Point Inferences

Endpoint: Green dot
Midpoint: Light blue dot
Intersection: Black dot
On an edge: Red dot
At the center of a circle or a circle segment: Green dot (SketchUp 6) or dark blue dot (SketchUp 7)
On a face: Dark blue dot

OVERVIEW FIG 1.5 Creating construction lines to assist in making your model.

Linear Inferences

On an orthogonal axis: A dotted help line, the same color as the axis, will appear when you are drawing or moving an object along this axis.
In relation to a point: A dotted line will appear between the cursor and the point in question.
Perpendicular: You can tell SketchUp which line you want to draw perpendicular to by moving your cursor over the edge (without clicking). A magenta line indicates that the line that you are following is perpendicular to this edge.
Parallel: You can use the same method described earlier to draw lines that are parallel to one another. Simply hover your cursor over the line parallel to the direction that you want to follow.
Tangent: This inference is extremely useful for drawing segments of circles that are tangent to other arcs or lines. Start by clicking on a point on the line or the arc in question and then click to select the end point of the arc. As you are moving the cursor to set the radius of curvature of the arc, the arc will turn cyan (light blue) when it is tangent to any lines impinging upon it.

OVERVIEW FIG 1.6 Point and linear inferences.

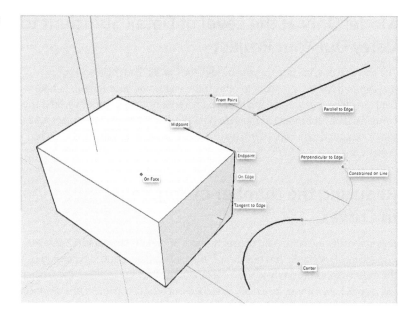

Tip

In order to make sure that you are drawing or moving an object along a specific axis, you can lock the inference along that axis. As soon as you see the dotted help line appear with the color of the axis that you want, hit the Shift key and keep it held down until you click the second point. When the inference along an axis is locked, the help line appears thicker. You can also lock axes by using the cursor keys on your keyboard: Hitting the "up arrow" or "down arrow" keys will lock movement or drawing in the Blue axis; hitting the "right arrow" key will lock the Red axis; and hitting the "left arrow" key will lock the Green axis.

Tip

SketchUp can sometimes be a little picky when activating an inference; at other times, there can be so many inferences to choose from that the program can not decide which one to choose. If this happens, you can help out by repeatedly mousing over the point or edge that you want to indicate to SketchUp that you want to activate the inference about that point or edge.

Tip

You can also easily combine inferences. You can, for example, draw one line parallel to another (by mousing over the line beforehand), lock the axis (by holding down the Shift key), and click on a point (using the End Point inference) to set the length of your line.

Model Only at the Level of Detail Sufficient to Carry Out Your Project

The more faces and edges in your model, the harder SketchUp and your graphic card will have to work to refresh the images on your screen. To take the load off your processor and to keep the rendering flow smoothly, limit the complexity of your model as much as possible. For example, if an object is in the background, you could use a texture to simulate faces modeled in three dimensions.

Reducing the Number of Segments in Curves

Arcs and circles are composed of a set number of straight segments (12 and 24, respectively, by default). This number of segments can be reduced according to the object size, its proximity to the camera, and the final use to which the project will be put. For example, for a really stretched-out arc or an element at a distance, you can reduce the number of segments to six or eight. This reduction in number of segments can have repercussions later in the number of faces produced when a surface is extruded with the Push–Pull tool or with the Follow Me tool.

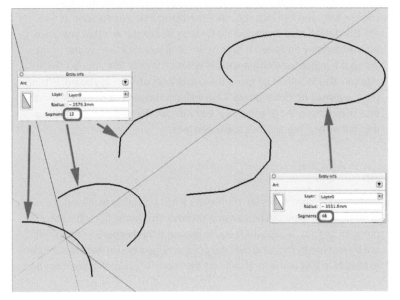

OVERVIEW FIG 1.7 Reducing the number of segments in a curve.

Info

If you are making a model that will ultimately be used to produce photoreal renders, you may have to actually increase the number of segments in order to get smoother curves and surfaces.

Do Not Get Ahead of Yourself by Modeling Too Many Details, Too Soon

It can sometimes be tempting to add details in the very first conceptual stages on a project. However, the more detailed the model is, the more time the subsequent modifications will take. It is better to go forward step by step, limiting the complexity of the model to only that necessary for the current task in hand. Check every stage in your modeling before proceeding further and adding details.

Tip

Even if you do take these precautions, you sometimes still have to take a step backwards, returning to an earlier version of your model. Get into the habit of systematically saving each modeling stage with a unique file name. In this way, you can get back to an earlier stage should the need arise.

Use Low-Resolution Images

Using images in your model can considerably slow down SketchUp's real-time rendering. This is particularly noticeable with large-scale (high-resolution) images that have been imported or applied as textures. If possible, use reduced-size images. You can easily reduce the resolution of an image with software like Photoshop or the various image conversion software like XnView, IrfanView, or Picasa™, for example.

Finding Your Way Around in SketchUp

Navigating your way around in a complex 3D project can sometimes be difficult. The Red, Green, and Blue axes are a useful visual aid, but they will always arrive at a moment where you get hopelessly lost.

Position and Set Up the Camera

One of the first things you need to do to make working inside a 3D model easier is to position the camera using (logically) the Position Camera tool. You can then set the eye height from its default 5'6" (about the average eye height in adults) by typing in a new value in the Value Control Box on the far right of the status bar at the bottom of the Workspace window.

Once the camera is placed in a good spot, you can change the angle of view by clicking on the Look Around tool. At this stage, you can still change the eye height.

You can then use the Walk Through tool to move around your model in three dimensions, using either your mouse or the cursor keys on your keyboard.

The Position Camera tool is a great help, but there are also other tools that can help you avoid selecting hidden edges or faces (and I am sure you can guess

what the consequences of that are) or that can help you to orient yourself when the camera height is too low.

Changing the Face Styles

The Wireframe face style allows you to see whether you have accidentally selected any hidden edges or faces. If you have done this, then simply moving the visible selection can have catastrophic results at other places in the model.

> **Tip**
>
> As long as you have not closed the file, you can always get out of the above situation by using the Undo command Ctrl+Z, assuming that you have noticed it in time.

Change to Wireframe mode to see if you have accidentally selected hidden faces or edges.

OVERVIEW FIG 1.8 Selection with shaded face style.

OVERVIEW FIG 1.9 In wireframe mode, you can see that you have accidentally selected hidden faces.

A more practical solution is to change to X-Ray mode. This allows you to check for any unintended selections, but because it renders the faces as translucent, it makes it easier for you to orient yourself within your model. It also preserves depth perception, something that practically disappears when in Wireframe mode, especially if you have perspective switched off.

OVERVIEW FIG 1.10 X-Ray mode.

Tip

You should always aim to lock groups and components that you know will not be erased or moved, for example, plans imported from other CAD programs. Select the items that you want to lock, right-click (Ctrl-click on a Mac), and choose Lock from the contextual menu.

Displaying Your Model Using Sections

For developing or presenting the interior of a SketchUp model, the Section Plane tool is particularly useful. You can, for example, create a horizontal section plane for each story and front-to-back and side-to-side section planes that you can then switch on and move around according to your wishes. Do you need to work on the ceiling of a room? Activate a horizontal section plane and select the Reverse option. You can now change your camera positionto get the best possible view onto your ceiling.

Tip

If you have the Section Planes option ticked in your Scenes palette, you can combine section planes with scenes, enabling you to turn a section plane on or off with a single click, simply by choosing the appropriate scene .

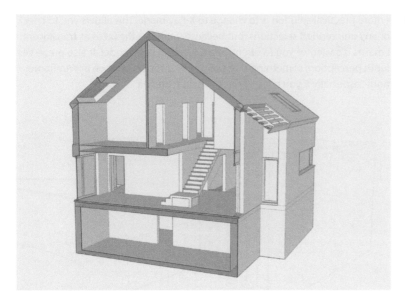

OVERVIEW FIG 1.11 Using sections.

Zoom Extents for an Overview of Your Project

Are you lost? Can't you orient yourself inside your 3D model? If this happens, it is time to turn to SketchUp's life preserver: The Zoom Extents tool. Zoom Extents will zoom the current view so that your entire model fits within the work space.

Organize Your Project

Managing Imported Objects

Let's not kid ourselves; files that you import from other CAD programs will more than likely cause problems once they are in SketchUp, for example, overlapping lines, unwanted bits and pieces that bog down your model that is composed of too few segments, objects not recognized by SketchUp, etc. There are many good reasons for trying to avoid modeling with imported objects.

The first thing that you should do is to select any imported elements, group them, and then lock the group (its bounding box will turn red). Then create a new layer to which you will assign this group. Done! This group cannot interfere with the rest of your model now.

Then you can use this group and its End Point inferences to trace the objects that you want to model. It does take a little time, but you will avoid a lot of frustrations down the line.

OVERVIEW FIG 1.12 Lock groups created from imported objects.

Edges and Faces in SketchUp

In SketchUp, edges are distinct from the faces they define. When the end points of three or more coplanar edges touch, a face is created. If you now select the face and erase it, the edges will remain exactly where they were. Conversely, if you erase one of the bounding edges, the face is automatically erased. As soon as you move an edge or a face, any entities touching it will also be displaced by the same amount. This is a consequence of SketchUp's "sticky geometry."

This "stickiness" can come in useful for certain types of modeling operation, but often you will be able to "unstick" various elements so that you can move them without affecting the rest of the model. Here is how you do that.

Using Groups and Components

Knowing how to use components properly is the cornerstone of efficient SketchUp use. Furthermore, I would suggest that you adopt Tim Danaher's motto: "group early, group often." You should group elements when you want to disassociate them from the rest of the model without affecting it or when you want to select multiple elements with a single click. Apart from their use for "unsticking" geometry, groups are also indispensable if you want to use the Layers palette – or better still, the Outliner – efficiently.

When to Group and When to Make a Component?

If you are going to use a collection of elements only once, make a group. In all other cases, make a component.

Tip

SketchUp has one feature that on its own means that you should be creating components rather than groups: In the Menu Bar, go to View > Component Edit > Hide Rest of Model. When you choose this option, the rest of the model is automatically hidden when you enter a component to edit it. If you choose the other option, Hide Similar Components, all the instances of the edited component will be hidden.

This option is saved at the same time as your file. You could, therefore, add this option to your template file so that you can benefit from it automatically.

Making a Group

To create a group, select all the elements that you want to collect together or isolate, right-click (Ctrl-click on a Mac), and choose Make Group from the contextual menu. Your new group will be displayed with a blue bounding box.

Tip

By default, all new groups are given the name… Group. This means it can be difficult to keep a track of what is in your model, so get into the good habit of giving your groups meaningful names, in the Entity Info pallette or in the Outliner. Using the Outliner, you can select your name groups extremely rapidly.

Making a Component

To make a component, select all the elements you want to collect together or isolate, right-click (Ctrl-click on a Mac), and choose Make Component from the contextual menu. In the Make Component dialog box, you will be presented with many options. In order to make group work easier, you can add a description of the component here.

In the Alignment field, you can choose a particular type from the drop-down menu:

- **None.** If you choose this option, your component will not stick to any particular surface: You can move it freely with no constraints.
- **Any.** Your component will stick to any face in your model. This is the most practical alignment mode. The only constraint is that the component must be inserted either on a face or on the ground plane.

OVERVIEW FIG 1.13 Making a component.

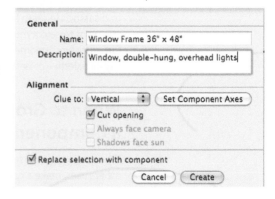

- **Horizontal**. Your component will only stick to horizontal faces. This can be useful, for example, to ensure that a table component is actually sitting directly upon a floor element.
- **Vertical**. Your component will only stick to vertical faces. This option is particularly useful for window and door components.
- **Sloped**. The component will only stick to inclined surfaces, such as roofs. This option can be particularly useful for inserting Velux window components, for example.

If you need, you can also define your own alignment plane by clicking on the Set Component Axes button and then clicking on three points within your component.

Tip

To get rid of this alignment once the component is inserted, select the component, right-click (Ctrl-click on a Mac), and choose Unglue.

There are a few other options that allow you to control the behavior of your component:

- **Cut opening:** The component will cut a hole in the face where it is inserted. This face must correspond to the component's alignment plane.
- **Always face camera:** This is a really useful option that allows you to use images or 2D shapes in your model. Rather than using a 3D tree model composed of thousands of polygons, you can insert a simple face with a tree image placed on it as a texture. Ticking this checkbox means that as your camera moves through the scene, the 2D component will rotate so that it is always facing the camera.
- **Shadows face sun:** If you have ticked the preceding option, then this option is also checked by default. It assures that the shadows stay coherent, even if the sun is shining on them edge-on, something that should, theoretically, result in no shadow.

Attention

When you create a component, make sure the most important option is checked: Replace Selection with Component. It is an oddity of SketchUp that this checkbox is sometimes ticked, sometimes not.

Editing a Group or Component

If your group or component is visible, simply double-click on it. This will open it for editing. If it is not visible, look for it in the Outliner palette, right-click (Ctrl-click on a Mac), and choose Edit Group/Component. You will then see a bounding box composed of dotted lines, which indicates

that you are now editing inside the group or component. To end the editing session, double-click outside the bounding box. You can also right-click (Ctrl-click on a Mac) within the bounding box and choose Close Component/Group.

OVERVIEW FIG 1.14 Editing a component.

Nested Groups and Components

To make managing the objects in your project easier, consider nesting your groups and components. This is the route taken to create the 2.5D trees in the case study by David Harned (see Chapter 16, Road Rage Book) and in the multifaceted collaborative project by Takeshi Hashimoto (see Chapter 2, Te Wero Bridge Competition in Auckland, New Zealand). Adopting this approach, you can create hierarchical components made up of a large number of objects that will nevertheless be extremely simple to manipulate and modify.

OVERVIEW FIG 1.15 Branching structure of nested components.

Managing the Display of Groups and Components

Imagine that you are working on an architecture project: Your model is made up from the different floors of the building, furniture, vegetation and plant, and technical equipment. In addition, you have put together various options for the building that you want to show to the client. Clicking around on all the components and groups to show or hide them one by one would really be an onerous task. Luckily, SketchUp makes the job easy by giving you the following tools.

OVERVIEW FIG 1.16 The Outliner palette.

The Outliner Palette

The Outliner displays the names of all the groups and components in your model. Using this palette you can select them, rename them, move them from layer to layer, turn their visibility on and off, etc., simply by selecting their names in the list and right-clicking on them (Ctrl-clicking on a Mac) and selecting Hide/Unhide. You do not even need to know exactly where they are in your model. What a time saver!

Let us have a look at the options for the Outliner palette in more detail:

- **Make Unique:** This option allows you to dissociate a single copy of the component from all the other instances. When you now edit this component, the other components from which it was derived will not be modified.

Tip

A nice touch is when you select many copies of a component: Clicking on Make Unique now will make all the selected components copies of a new component; modifying any one of them will affect all the other components that were originally made unique.

- **Save As**: This option lets you save the component in a library outside the current file.
- **Reload**: This option lets you replace a component with any other to be found in the library. The following are several applications for this feature of SketchUp:
 - Quickly replace one object with another: Pieces of furniture, window frames, etc.

xxxiii

- Replace low poly, stand-in components by their more detailed counterparts when you want to render out an image or animation. This allows you to carry out the bulk of your work quickly and easily, by using objects that will not stress your graphics card, but still, in a few clicks, give you the opportunity to produce detailed images.
- Replace a project element with one of its variants, to gauge its impact on the rest of the model. In my opinion, this is the best method for managing project options in SketchUp.
- Major collaborative work can be made easier by subdividing a complex model into several simple components that are saved in the same directory. You can open each external component like a normal model that can then be modified and detailed by a team member. Each time that an external component is updated, it can be loaded into the master file. This method of collaborative project management is detailed in the case study of Takeshi Hashimoto (see Chapter 2).
- **Zoom Extents**: When you choose this option, SketchUp zooms in on the group or component so that it fills the entire Workspace. This would be ideal when you want to rapidly modify component .

Tip

In order to make the most of the Outliner palette, get into the habit of systematically naming your components and your groups logically and of using names that will be comprehensible to other users. In this fashion, you can rapidly select an element in a list and you will instantly know what group or component it belongs to.

The Outliner palette is not the only way to manage the display of groups and components. Here are some other options open to you:

The Layers Palette

Managing the display of groups and components is the chief task of the Layers palette.

Creating a New Layer

With the Layers palette open (from the Menu Bar, choose Window > Layers), click on thePlus icon to add a new layer. You can now click on the name of the new layer to edit it.

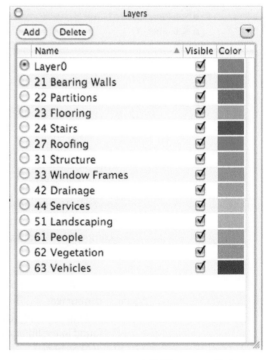

OVERVIEW FIG 1.17 The Layers palette.

Tip

By default, the visibility of any new layer created is toggled on. It is better to create all your layers before you create the scenes that will control how the layers are displayed. If you do it the other way around, you will need to update all your scenes in order to manage the visibility of your layers.

To change the layer that a group or component is on, use the Entity Info palette. You can bring up this palette by right-clicking (Ctrl-clicking on a Mac) on the group or component in the Workspace or in the Outliner.

You can also choose Window from the Menu Bar and then click on Entity Info. Click on the layers drop-down menu, and you can then assign the object to any of the layers in your model.

Tip

Do not forget: As long as Layer0 contains only edges and faces, everything will be OK! Only groups and components should be placed on other layers.

Tip

On a Mac, you can create a new layer simply by typing its name into the Layer field in the Entity Info palette.

Managing Model Variants

By assigning the different groups and components that represent a particular model variant to a particular layer, you can switch the different variants in or out using the Layers palette. However, using external components and the Outliner palette is actually a lot more practical and better suited to this task .

Managing Group or Component Visibility

By placing groups and components on distinct layers, you can easily manage their visibility by toggling their layer's visibility on and off. If you often need to turn multiple layers on or off, then it is much more efficient to use scenes (see next page). For any given scene, you can determine exactly which layers are visible or hidden, something which is much more practical than manually switching layers on or off.

OVERVIEW FIG 1.18 Show/hide layers.

Creating Scenes

While, naturally, scenes are used for setting up different points of view in your model, they are also equally adept at managing the visibility of a group of layers. Rather than switching multiple layers on or off one by one in the Layers palette, you can perform the same task with a single click. How, exactly? If you have the Visible Layers option checked in the Properties to Update section of the Scenes palette, the visibility of the layers in your model becomes a property of that particular scene: SketchUp will remember which layers it has to show or hide for a particular scene.

The other options available for scenes are the display of hidden geometry and active section planes, the active style used, shadow setup, and the location of the axes. Here are some examples:

- You can record shadow studies at different times of the day (and make an animation of them).
- Reord different camera views to produce plans and perspectives for presentations.

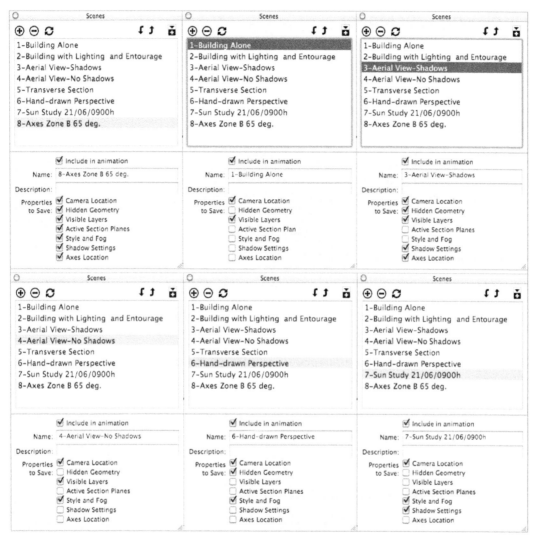

OVERVIEW FIG 1.19 The Scenes palette.

- Associate a different style with each view: For example, plans and sections should have a technical drawing style, whereas perspectives could have more of a hand-drawn feel to them.

Tip

In order to save only the camera position within a scene, untick all the options that you do not need in the Properties to Save section of the Scenes palette. You can quickly forget the fact that you have deactivated a layer, modified the shadows, or changed the style between two scenes. The result when you are rendering an animation can be… well… rather picturesque.

Displaying Your Model

In order to work efficiently, you need to limit the number of objects that are simultaneously displayed in your Workspace because SketchUp has problems when it needs to display large numbers of faces (i.e., when they reach around a million). Thanks to layers, scenes, and the Outliner, you can quickly and easily manage the display of the elements within your model.

Hide all the objects that you do not need for the task in hand. In architectural projects, for example, you could display all the walls that you want to modify but hide the furniture, vehicles, and people. One particular resource hog is 3D vegetation: A single detailed tree can easily contain as many faces as the entire rest of your project.

Only Display Shadows When You Need Them

You will have probably noticed that SketchUp still does not take advantage of multicore processors, nor does it use some of the more specialized functions of top-of-the-range graphics cards (we were on version 7.1 at the time of writing). While we wait for these features to be implemented, you will need to keep the load on the processor down in order to keep the navigation fluid and to conserve some processing power for certain cycle-hungry commands.

After you have turned off the visibility of unneeded elements, one of the best means of speeding up the display is to turn off shadows. Only turn them on when absolutely necessary, for example, when you are rendering out stills or an animation.

Apply the Right Materials to the Right Faces

On the screen, could you easily differentiate between a light beige coating, light beige paintwork, and SketchUp's default material? Not easy, is it? You usually find yourself with two or three different SketchUp materials assigned to faces that should all have the same material. In order to avoid this situation, your materials should show a high level of contrast. By using this method, you can easily identify and correct any mistakes.

It is true that these contrasting colors are rarely realistic or even pleasing to the eye. Once you have used the Paint Bucket tool to add these colors to the appropriate faces, you will almost certainly want to change them to something a little closer to reality. The most simple method is to modify each contrasting material to make it look more like the actual material. However, it is often difficult to obtain exactly the right material appearance for each project.

OVERVIEW FIG 1.20 **OVERVIEW FIG 1.20** By using contrasting textures, you can rapidly identify faces carrying different materials.

Tip

Luckily, there is a plug-in that lets you replace one material with another, fr_Global_Material_Change.rb, created by TIG. Once you have placed it in SketchUp's plug-ins directory, you can access it the next time that you start SketchUp. From the Menu Bar, go to Plugins > Global Material Changer. From the list that appears, select the material that you want to replace and the material you want to replace it with. The change will take place on every face in your model that carries the first material, even if they are nested inside groups and components. This is also another reason why you should give your materials names that are descriptive and easily understood.

When you apply a material to a face, any faces subsequently created with the Push–Pull tool or the Follow Me tool will have that same material applied to them.

Tip

Imagine that you are modeling a volume that represents a house. In the first stage, you draw some simple rectangles to indicate window and door openings and you apply a transparent material to them. Now, when you use the Push–Pull tool on the faces to model the window opening, the reveals will also have the same transparent material applied to them. It is a bit of a chore to go back and apply the correct material to the reveals.

It is far more practical to apply the material *after* using the Push–Pull tool.

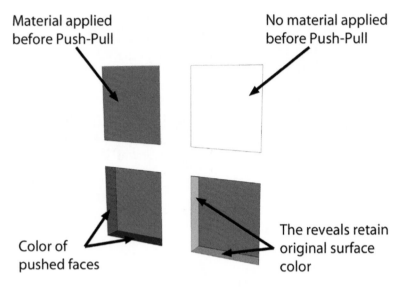

Material applied before Push-Pull

No material applied before Push-Pull

OVERVIEW FIG 1.21 Results of the Push–Pull tool after the application of the material.

Color of pushed faces

The reveals retain original surface color

Choose a Simple Rendering Style for Efficient Navigation

If your model is composed of a large number of faces, you should avoid as much as possible the use of "sketchy" styles with hand-drawn edges. This rendering style is much more calculation-intensive for SketchUp and can lead to jerky orbiting, panning, etc.

Give Meaningful Names to Files, Layers, Components, and Scenes

Whatever names you choose to give your files, layers, components, scenes, or even styles, make sure that you employ a logical and consistent naming scheme. The scheme could be informed by the standards of your particular industry or your firm, your project's stage of completion, or its location. The main thing is to be able to recognize quickly and without ambiguity what a particular layer, file, scene, etc., contains. Ideally, a person not familiar with your project should be able to easily understand what each name represents.

Example: A unique suffix representing category–name–number.

The following is a nonexhaustive list of elements that could appear in a logical classification:

- Name of project
- Participant: Architect, designer, technician, etc.
- Project area: Conception, structures, special finishes, etc.
- Type of work: Masonry, public works, electricity, etc.
- Location: Lot W, building X, room Y, cupboard Z, etc.
- Development phase: Sketch, preproject, project, construction, etc.
- Alphanumeric code: 01, B52, etc.

Tip

In the Windows version of SketchUp, the width of the Scenes palette is fixed, and so you should limit your scene names to 40 characters so that you can view the whole of the name at a single glance.

Communicate

Publish a Guide That Explains Your Working Methods and the Naming Conventions Used

Ideally, every person taking part in your project should be able to join it at any point, without having to pull his/her hair out trying to understand the working methods and the naming conventions used by his/her predecessors. Notice I said "ideally." In practice, too few enterprises have implemented an efficient and logical working process. Is yours one of them?

Certainly, the preparation of such a document takes time, and changing the working habits of dyed-in-the-wool (and often blasé) users is never easy. "We've always done it this way… why should we change?"

Use the Same Point of Reference for All Project Files

Try to keep the same origin point for the axes in all project files, whatever be their origin. In this way, it is much easier to import and export plans and 3D models between the other CAD applications used in the project.

Tip

If this is impossible, use a reference point (a simple line will suffice) that will allow you to precisely move the different imported objects into their correct position in your SketchUp model.

OVERVIEW FIG 1.22 Reference guides for moving imported elements.

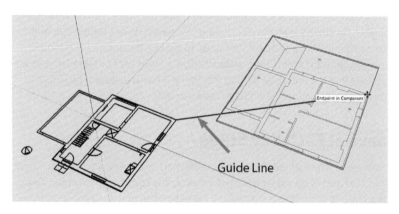

Guide Line

Check Every Stage of the Project Before Adding Any Details

You know that the simpler your model is, the easier it is to modify. Before adding any details, check the model, as far as possible, with the clients and the other project participants.

Share Your Component Libraries

Do you collaborate regularly with the same partners on certain projects? Then you should use the same components and working methods to save time for all concerned. Why not publish the rules for creating and using components in the good practice guide mentioned previously?

Save

Human error, a software or workstation crash… the risks that your computer data faces are real, and SketchUp is not exception to the rule. It is therefore essential to save your SketchUp files regularly and in an organized manner.

Understand SketchUp's Automatic Backups

By default, SketchUp automatically saves your files at regular intervals and creates a backup file of the previous version with the extension .skb.

Tip

Has your model become a chaotic mass of polygons, thanks to an ill-advised modeling operation? Is the Undo command not helping? You could recover a part of your work, thanks to the backup file. Simply change the .skb file extension to .skp to make it readable by SketchUp.

With complex projects, the time taken to create the model can become relatively long. Unless SketchUp is crashing frequently, do not set the automatic backup interval to less than 15 minutes. To change the automatic backup interval, from the Menu Bar, choose Window > Preferences > General, where you will find the option for setting this. You will have to decide the length of this interval for yourself (frequent crashes or not).

Save at Each Key Stage

Save every time that you finish an essential part of the project. Try, also, to get into the habit of saving your file before using any command that could cause SketchUp to crash (this is particularly the case when you are using plug-ins).

Save Under a New Name

Save each key stage with a different file name. This will allow you to easily retrace your steps. Who knows if their client will ask them to start over from an earlier concept stage?

Save Your Files in Various Locations

SketchUp is not the only thing that can crash: The same is also true for your hard disk, and so you should get into the habit of saving the new files to an external storage medium (tape, external hard drive, CD, or DVD) at least once a day. If your file sizes are not too big, you could also save to your personal web space or to an online backup provider.

Tip

To assist you in this task, there are various pieces of software that allow you to manage incremental backups. These programs look for all the new or modified files and then transfer only those to the backup device, for example, SyncBack SE or Cobian Backup. Mac users using OS X 10.5 or later can, of course, take advantage of the built-in Time Machine backup system.

When SketchUp Misbehaves...

You know how it is – suddenly, you cannot get anything done: SketchUp is misbehaving! That operation that you wanted to perform – the one that seemed so simple – is proving to be impossible. Your model looks as though it has been knocked over by a bulldozer. Your model disappears and reappears according to your camera angle… just what on earth is going on?

SketchUp has a well-deserved reputation for being simple and intuitive, but nevertheless you still need to know some tips and tricks to avoid these snarl-ups or, worse, the loss of several hours of work. Here are several situations that you may have the misfortune to encounter:

But… It's Sticking!

When you first start modeling with SketchUp, you will quickly encounter the following situation: You simply cannot move a selection of lines and faces perpendicular to another collection of lines and faces with which it shares a common face or edge. Yet you have carefully selected the elements that you want to move and you are using the Move/Copy tool, but without success.

Your selection appears to be "glued" to the common face it shares with the other collection. What can be going on here?

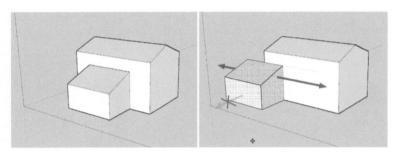

OVERVIEW FIG 2.1 The selection cannot be moved off the plane of the shared face.

In SketchUp, when two collections of lines and faces share a common face or edge, that face/edge is unique: it cannot be in two places at the same time.

The solution for "unsticking" these two collections of lines and faces is to select the collection of lines and faces that you want to move and then group them or turn them into a component. By doing this, you isolate the faces and edges within the group or the component from the rest of the model: a second face or edge is created automatically. If you choose to make a component, do not forget to make sure that the Replace Selection with Component check box is ticked.

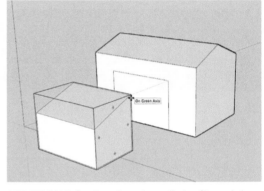

OVERVIEW FIG 2.2 Grouping to disassociate a collection of lines and edges.

If your two collections of faces and edges share a common bottom face, do not forget to draw in a line to split this common face into two separate faces.

You Cannot Create a Face

There are three classic situations that can stop SketchUp from closing a face:

1. **Fewer than three edges are meeting at a point**
 Zoom in on the corner points and make sure that there are no gaps. This is very often the problem with plans imported from other CAD programs. To solve the problem, you can always redraw each edge one by one using the Point inference.

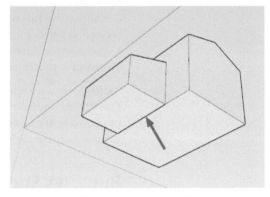

OVERVIEW FIG 2.3 If necessary, split this common face into two separate faces using the Line tool.

2. **The edges are not lying in the same plane (are not coplanar)**
 You can use the Constrained On Line from Point inference to move each end point in alignment with a single reference point. (You may need to

redraw one of the edges of your outline once all the points are coplanar, in order for the face to properly close.)

3. **One or more of the edges are actually inside another group or component**
 If this is the case, simply draw the missing edges.

Attention

Until version 7, SketchUp did not automatically split edges that crossed over each other, even if they were lying in the same plane. To correct this problem, you need to redraw the edges up to their intersection. In version 7, SketchUp automatically subdivides any edges that cross, creating the corresponding faces. Neat! Unfortunately, however, this does not work for imported plans.

An Outline You Have Drawn Will Not Cut a Face

Usually, you can draw a rectangle on a face and watch as its edges go thin, indicating that you now have two new faces. You can then use the Push–Pull tool to extrude either of the new faces. But sometimes, things do not go as planned. Here are some possible causes:

1. **The face that you are drawing is actually inside another group or component**
 In this case, the only solution is to enter the group or components to edit it, making sure that you are drawing on a "raw" face. Be careful that your group or component does not contain any other nested groups or components.

OVERVIEW FIG 2.4 Drawing on a group or component will not cut the face.

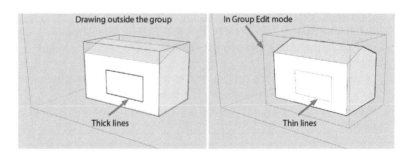

2. **What seems to be a planar face is, in fact, a series of smoothed facets**
 To find out whether this is the case, from the Menu Bar, choose View > Hidden Geometry. If it really is a smoothed surface, the solution to being able to cut it is to create a volume with the same dimensions as your cutout. Then group the volume and move it into position on the surface. Right-click (Ctrl-click on a Mac) and choose Intersect with Model from the contextual menu. Erase or hide your volume, and your curved face will be cut.

OVERVIEW FIG 2.5 Cutting a smoothed surface with the Intersection tool.

3. **You are not actually drawing in the plane of the face**
 Make sure that your drawing tool is displaying a dark blue dot and that you are getting the On Face tool tip. If you need to, you can temporarily align SketchUp's axes with this face to make the task easier: Right-click (Ctrl-click on a Mac) and choose Align Axes from the contextual menu.

Optimize Imported Faces and Edges

Drawing directly on the edges and faces of an imported CAD file is definitely not recommended: The problems you encounter are manifold and often have no easy solution.

A good procedure is to group all the imported edges and faces and then trace over them using the drawing tools and the inferencing engine. If you absolutely have to work directly on imported CAD files, then Todd Burch has developed several plug-ins (most of which have to be paid for) to automate certain tedious tasks.

- **IntersectOverlaps** helps to split any edges that cross over each other.
- **CloseOpens** looks for any lines that should be touching at their end points and closes them.
- **DeleteShortLines** erases any little lines that go past end points. This is particularly useful for making sure that the Point inference does not get confused.
- **ExtendClosedLines** finds any lines that have not met their end points and elongates them to the nearest point of intersection.
- **MakeFaces** analyzes your model and automatically creates any missing faces.

Autofold to the Rescue

Have you ever come across an edge that obstinately refuses to move on the Z axis? It will move no problem on the X–Y plane, but it is impossible to move it vertically. What is going on here? It is clear that a certain amount of subdivision of faces is going to be necessary to get this operation to work, but SketchUp will not do this automatically. This is where Autofold comes in: You simply need to hold down the Alt key (Cmd/Apple key on a Mac) before moving the recalcitrant edge.

OVERVIEW FIG 2.6 Autofold used with the Push–Pull tool.

Display Problems or Truncated Models

This display error, where a part of your model disappears, is one of the most common questions asked on SketchUp forums.

OVERVIEW FIG 2.7 A part of your model disappears for no apparent reason.

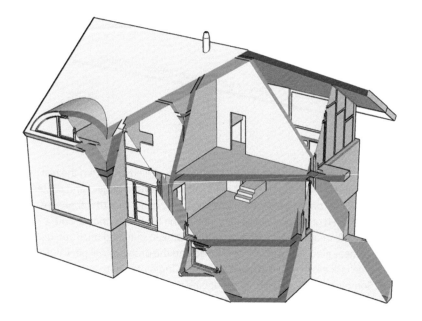

When you use the Orbit tool to tumble your model, you can sometimes find your model truncated, as if it is being cut by a section plane. This problem can have several causes, and there are several solutions that I will detail below.

The Causes of the Truncated Display Problem

The problem has been christened with the seemingly innocuous name of "Camera Clipping Plane." However, its causes can be many and varied…

Below, you will find different situations that can cause the problem and the solutions to them. I have decided to start with the most common cause, but

read through the whole list and choose the solution that best suits your case. It is worth determining the cause precisely because some solutions require modifications to the model.

Your Model Is Situated Far Away from the Origin of the X, Y, and Z Axes

This problem is often found when you are working with plans imported from AutoCAD or another piece of CAD software. When you are working in CAD and using surveyor's plans, your project can sometimes be situated very far away from the point of origin of the X, Y, and Z axes. Once imported into SketchUp, it is common to get display problems when there are elements present that are a great distance apart from each other. This is often the case with surveyor's marks or with segments that have been placed to be used as reference points.

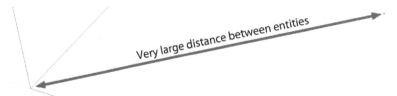

OVERVIEW FIG 2.8 The model is situated far away from the origin point of the axes.

The first solution has you erasing all the "forgotten" elements from the rest of your model. If that still does not work, move the entire project and center it over the axes origin. Before moving everything, make sure that there are not any hidden groups or components (from the Menu Bar, choose Edit > Unhide > All) or any layers whose visibility has been switched off. If you do not do this, these elements will not get moved and the problem will persist. To make the task easier, you can use the MoveToOrigin plug-in to automate this task. Sometimes, this approach will not cure the problem: Sometimes, certain elements that are difficult to detect – or are even invisible – are present at the outskirts of your Workspace and will continue to cause these display problems.

To identify and eliminate these elements, follow these instructions:

1. Click on the Zoom Extents icon Crtl+Shift+E (Cmd/Apple+Shift+E on a Mac) to make sure that your entire model fits within the Workspace.

Wide Field of View

SketchUp's default camera field of view is 35 degrees. Sometimes, you can type in too high a value by mistake, getting a wide-angle lens (or a fisheye for photographers).

Perspective Is Off

The truncated model problem can appear when the model is being displayed in parallel projection. Click on Zoom Extents to correct the problem.

The Scale of the Project Is Too Large or Too Small

SketchUp has problems working with very small unit sizes. In this case, it is often the whole of the project that will disappear rather than simply displaying the truncation. The solution is simple: Change the scale.

To quickly change the scale of the entire project, draw a help line 1 unit long (inch, foot, yard, or whatever) and measure it using the Tape Measure tool. The length of this line will appear below right in the Value Control Box (VCB). Type in the new length (for example, 100 if you want to scale it up by 100 times) and click on Yes when SketchUp asks you if you want to resize your model.

Attention

Any components in your model that have been loaded from an external library *will not be scaled using this method*. You either need to explode them first or scale them up afterwards – but that can be a chore.

Incompatibility with Your Graphics Card

Certain graphics cards do not manage the type of OpenGL acceleration used by SketchUp very well. To find out if this is the cause of your problems, in the Menu Bar, go to Window > Preferences > OpenGL and then untick the Use Hardware Acceleration checkbox. SketchUp and your processor will then take over the duties of calculating the images to be displayed on your screen. For users who work daily with SketchUp, this solution brings with it a display slowdown and a subsequent loss of productivity. Your only option in this case is to consider the purchase of a graphics card that handles OpenGL correctly.

Before you change your card, make sure that your drivers are up to date by downloading them from the manufacturer's Web site. You never know…

For more information concerning the choice of the graphics card that works well with SketchUp, you can visit Google's webpage on the subject: http://sketchup.google.com/support/bin/answer.py?hl=en&answer=36252 .

What? Still Not Working?

If your file resists every attempt at solving this display problem, the only solution that I have found is to do a Copy–Paste into a fresh SketchUp file. The problem with this approach is that you lose all your scenes, but at least the problem is solved, and you can work efficiently with your project again.

> **Tip**
>
> To get your scenes back, you can use the PageExIm.rb, which allows you to export your scenes in .sup format and to reimport them into another SketchUp file.

Faceted Surfaces When You Want Smooth

Faces formed from circles or arcs produce smooth surfaces when they are extruded with the Push–Pull or Follow Me tool. This is not always the case, however, with arcs, circles, or polylines exported from a CAD program. By default, arcs are made up of 12 segments, whereas circles have 24. Before creating a volume starting with an arc or a circle, you can modify the number of sides in the Entity Info palette. Once the face is extruded, it is impossible to change this value.

If you get a faceted surface, you can still select the edges that you want to smooth, right-click (Ctrl-click on a Mac), and choose Soften/Smooth Edges. Still not working? Simply increase the Angle value in the Soften/Smooth Edges palette that appears after you carry out the previous command.

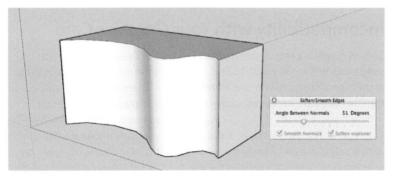

OVERVIEW FIG 2.9 Softening edges to produce smooth surfaces.

Your Model Is Completely Deformed

Who has not experienced this? You carry out a move or a rotation operation, you change the camera angle, and… oh no! Your model resembles Quasimodo on one of his bad days. But the usual cause of this problem

is often that you have moved faces or edges that were hidden when you made your original selection. To avoid this catastrophe, try using the X-Ray face style after you have made your selection. You can then make sure that you have selected only the elements that you want to move. Any faces or edges that have been inadvertently selected can be removed from the selection by using the Arrow tool in combination with the Shift key.

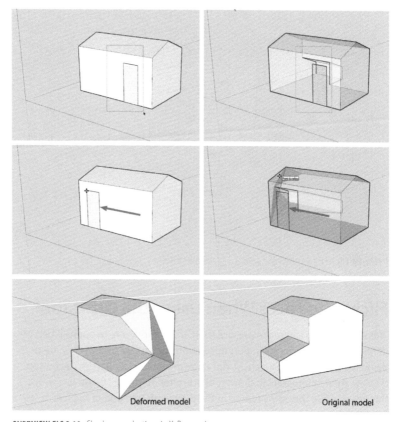

Deformed model

Original model

OVERVIEW FIG 2.10 Check your selections in X-Ray mode.

If you only notice the damage much later, you can always use the Undo command Ctrl+Z (Cmd/Apple on a Mac) to go back to the stage where it all went wrong.

If you have already saved your file and quit SketchUp, there is still a glimmer of hope for you: By default, SketchUp backs up your model in files with the .skb extension. You can try renaming this extension to .skp to see if the backup file corresponds to a stage before the mistake was made. These backup files are found in the same folder as the .skp files.

Attention

Correcting a deformed model often takes more time than simply erasing the mess and modeling from new.

OVERVIEW FIG 2.11 Flickering effect when two faces are coplanar.

Flickering Faces When Using the Orbit Tool

This effect, which can ruin a presentation or an animation, happens when two different-colored faces are superimposed on each other so that they are occupying the same space. SketchUp, not knowing which faced a display on top, displays them alternately to draw your attention to the problem. To correct this effect, erase the part situated at the intersection of one of the two faces.

This effect can also occur when you draw a face on top of another face that is part of a group or component. In this case, one solution is to move the face by a tiny amount so that the faces are no longer coplanar. The other, better solution is to give a slight thickness to the face using the Push–Pull tool.

SketchUp Prints Badly

Even though your image may look superb on the screen, your printed drawings may leave something to be desired. In this scenario, check your printing setup and, more particularly, the Print Quality settings situated at the bottom right of the Print dialog box. If the printing quality selected is Draft or Standard, change it to High Quality at a minimum.

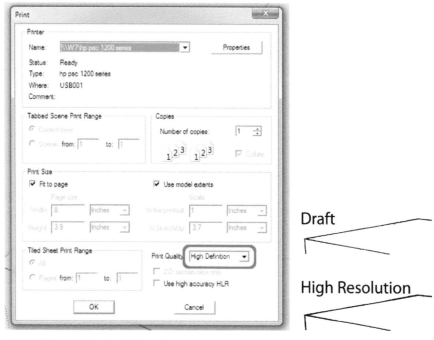

OVERVIEW FIG 2.12 Setting the printing quality.

Line Thickness and Image Resolution

Even if your chosen display style looks perfect on the screen, it may not look so good when you are printing or rendering images at high resolution. Basically, the thicknesses of the edges are dependent upon the resolution of the image. What looks like a lively, hand-drawn line at low resolution will lose its thickness (and, therefore, its hand-drawn appearance) as the image resolution increases.

Get into the habit of testing the results of increasing the resolution before rendering out a long series of images or an animation. If you cannot find a style that suits your illustration, you still have a solution of creating one yourself using the Style Builder that comes with Google SketchUp Pro 7. However, the line thickness that you can use is limited to 16 pixels.

Resources

Scripts
Plugins IntersectOverlaps, CloseOpens, DeleteShortLines, ExtendCloseLines, MakeFaces, MoveToOrigin, by Todd Burch. Available at www.smustard.com .
Plugin fr_pageExlm.rb, by Rick Wilson. Available at http://www.crai.archi. fr/RubyLibraryDepot/Ruby/FR_cam_page.htm .

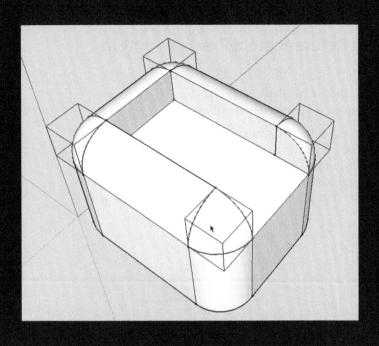

More Tips and Tricks

Smoothing Arcs, Circles, and Curved Polylines Imported into SketchUp

Any arcs, circles, and polylines imported into SketchUp are assigned SketchUp's own default number of segments, namely 12 for arcs and 24 for circles. These numbers may be OK for a schematic model, but you will need smoother curves for more detailed modeling. This is not a problem for arcs and circles: You can still modify their number of segments by selecting them and entering the desired number of segments in the Entity Info palette. It is too late for polylines, though: SketchUp sees these as a sequence of straight segments .

The only solution is to decompose your polylines in the program that gen-erated them *before* you export to SketchUp. Do this on a copy of the file, though: You may still want to edit your polylines in the original file later.

It is rarely a good idea to start modeling directly on the elements of an imported file in SketchUp: Modeling errors crop up frequently (lines whose end points do not touch, unwanted elements that clutter up your model, etc.).

Copy–Paste Referencing a Precise Point in Your Model

Are you trying to perform a Copy–Paste in SketchUp, but you just cannot place the copy in relation to a precise reference point?

Most often (but not always), SketchUp uses the bottom left point of the selection as a reference point. So, what do you do? You simply have to draw a line from your object, whose one end touches the reference point. Select this line as well when you select your object for copying (or you could draw it inside the group or component). Once you are in the file where you want to paste your

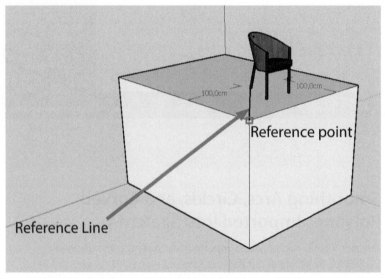

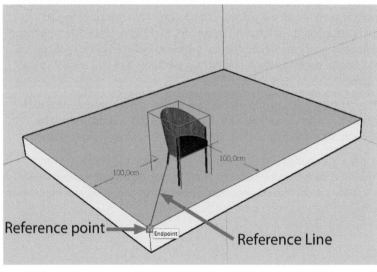

OVERVIEW FIG 3.1 Using reference lines to move imported elements to their position in the model.

selection, either hit Ctrl+V (Cmd/Apple+V) or, from the Menu Bar, select Edit > Paste. The objects that you have just pasted will remain selected. Now, you just need to move the end of your reference line onto the reference point in the file, and the job is done. Do not forget to delete this line if you do not need it anymore.

Aligning Objects to Nonorthogonal Planes

If you have ever tried to place a component on a nonorthogonal plane, then you have probably been dreaming that someone would invent a plug-in like fr_align_tool.rb. Your component will be placed in just six clicks, without you having to jump through any hoops. You have just got to try it!

How to Use It?

1. Start by selecting the elements that you want to align – it is easier if you group them or turn them into a component.
2. Right-click (Ctrl-click on a Mac) and choose Align from the contextual menu.
3. Click on a point that will define the movement origin of your selection. Click on a point on the X axis and then click on a point on the Y axis. This defines the plane of origin of what you want to align.
4. Choose three points that will define the surface that you want to align to. And that's it.

You may have to move your selection to get it precisely where you want on the surface, but the hard work is done.

OVERVIEW FIG 3.2 Alignment on an inclined plane.

What Do I Do if My Component Does Not Have Any Visible Angles or if It Is Not Orthogonal?

It may be that your component is made completely out of curved elements and has no well-defined axis to select. In this case, the simplest solution is to draw a rectangular element that encompasses the base of your component and temporarily group it.

Tip

Another method is to group all the elements that you want to align into a single component. When you create the component, choose the option Any in the Alignment drop-down menu. You could also choose the option to Set Component Axes if the standard alignments do not suit you. Now, erase the component from your scene, and reinsert it from the Components Browser. Thanks to the Any option, your component will align itself to any faces that your cursor moves over.

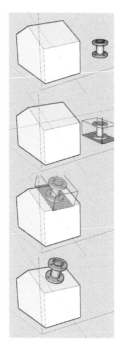

OVERVIEW FIG 3.3 Defining a rectangular reference base.

Rounding Edges

In real life, very few buildings or objects have true sharp corners. Beveling or softening the edges of a 3D model will, therefore, add realism to a scene. Additionally, these rounded edges produce a specular effect which heightens the realism of your renders. Unfortunately, SketchUp does not have a tool for beveling one or more edges, although...

As is often the case, it is possible to use a simple SketchUp tool to carry out a complex operation. To get a beveled or chamfered edge (the equivalent of the Adjust command in AutoCAD) in SketchUp, start by drawing a line or an arc on the surface that you want to chamfer or bevel. Now, use the Push–Pull tool to remove a part of the solid and obtain a rounded or chamfered edge.

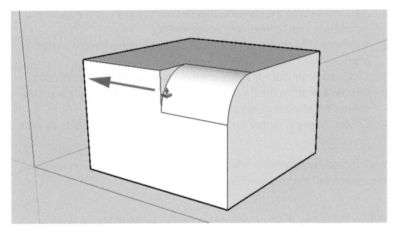

OVERVIEW FIG 3.4 Beveling with Push–Pull.

If you need to chamfer or bevel several contiguous edges (if you are modeling a piece of furniture, for example), then use the Follow Me tool.

> **Tip**
>
> If you need to round or chamfer corners frequently, you should consider creating reusable bevels or chamfers that you can save to the component library. Once they are inserted into your model, you can scale them to adapt them to your needs.

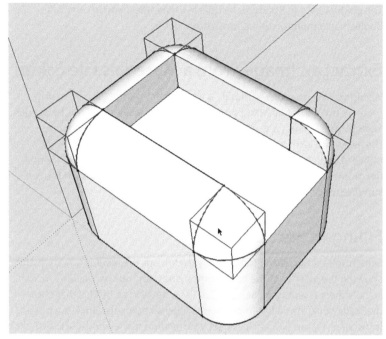

OVERVIEW FIG 3.6 Reuse beveled edges as components.

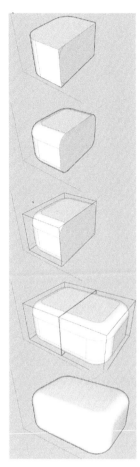

OVERVIEW FIG 3.5 Bevel multiple angles using the Follow Me tool.

Cutting One Volume with Another – Boolean Operations in SketchUp?

You know that SketchUp is a surface modeler, and that is one of the things that prevents it from being able to carry out true Boolean operations – subtraction, union, or intersection of solids. But there is no need to panic as an alternative solution exists: You just need to use the Intersection operation. Select the volumes that you want to union, subtract, etc.; right-click (Ctrl-click on a Mac); and choose Intersection from the contextual menu. A further two options are available in a fly-out menu: Intersect with Model or Intersect Selected. This operation calculates the edges that constitute the intersection between the different selected faces and cuts them at this junction. All you then need to do is to erase the unwanted faces.

In order to keep the number of edges and faces in your model down, you should use Intersect Selected in preference to Intersect with Model. The former has the advantage of being faster because SketchUp (and your CPU) has to deal with considerably fewer elements.

The paid-for plug-in BoolTools by Dale Martens allows you to carry out Boolean operations on groups and components.

Extract an Image From a Materials File (.skm)

Would you like to reuse or modify a texture that is used for a SketchUp material but do not have the original bitmap? It really could not be simpler. SketchUp's .skm files are, in fact, nothing more than ZIP files. Change the extension .skm to .zip and you can now open the archive directly, either in your Windows File Manager or in the Mac Finder, or even with a decompression utility if you have to. The images can be found in the /ref. subdirectory.

Filling-In Section Cuts

SketchUp's section plane tool is really useful, but the resulting section cuts, showing the interior of the cut volumes, does not look particularly nice. Luckily there is a plug-in, Section-Cut Face, developed by TIG, that automatically generates filled-in outlines for the section cuts. Once the plug-in is installed, restart SketchUp, select your section plane, right-click (Ctrl-click on a Mac), and select Create Section Faces in the contextual menu.

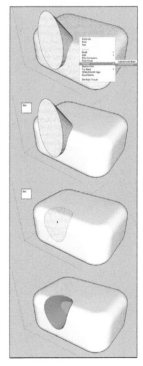

OVERVIEW FIG 3.7 Simulate a Boolean operation with the Intersection tool.

Resources

Scripts
Plugin fr_align_tool.rb, by Didier Bur. Available at http://www.crai .archi.fr/RubyLibraryDepot/Ruby/FR_edi_page.htm .
Plugin booltools.rb, by Dale Martens. Available at www.smustard.com.
Plugin fr_SectionCutFace.rb, by TIG. Available at http://www.crai.archi .fr/RubyLibraryDepot/Ruby/FR_arc_page.htm .

Pushing the Envelope – Advanced SketchUp Use

Modeling a Complex Curved Roof

In CAD, modeling a pitched, hipped roof on a building with U-shaped wings of varying widths is, to say the least, not the easiest of tasks. But when the roof pitches are curved, the task, frankly, becomes a pain. Luckily, with the help of SketchUp, you will be able to carry out this task in a couple of minutes, thanks to the Follow Me and Intersect Selected tools.

Stage 1: Modeling the Building Base and a Roof Pitch Profile

Place the roof pitch profile at one corner of the building.

Tip

In order to make the selection off the roof pitches easier, make sure that their profiles do not touch the main building volume, in case you need to modify its position later.

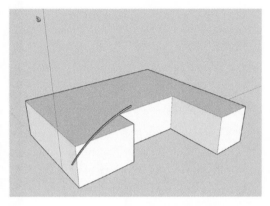

OVERVIEW FIG 4.1 Main building volume and roof profile in place.

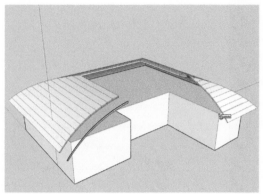

OVERVIEW FIG 4.2 Stages in the creation of the basic roof, using the Follow Me tool, tracing the outline of the building plan.

Stage 2: Extruding the Roof Profile

With the Follow Me tool, extrude the profile using the outline of the building as your guide. Click on the profile, then, holding your left mouse button down, move your cursor toward the first edge of the outline, then follow the entire outline using the cursor until the entire extrusion is complete.

It looks a bit chaotic, but the hardest part is over.

Stage 3: Intersecting the Curved Roof Pitches

Now, you need to cut all the faces that are intersecting so that you can trim away the superfluous parts. The simplest way to do this is to select all the roof pitches, then right-click (Ctrl-click on a Mac) and choose Intersect > Intersect Selected from the contextual menu.

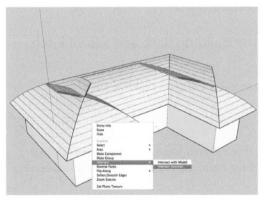

OVERVIEW FIG 4.3 Intersecting the roof curve with itself prior to cleanup.

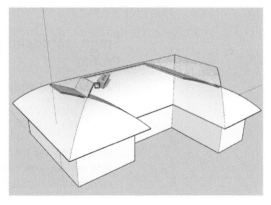

OVERVIEW FIG 4.4 Deleting the superfluous faces and edges.

Stage 4: Cleaning Up the Unwanted Faces and Edges

This is the stage that can cost you quite a bit of time. Select all the faces that are definitely beyond the roof's ridgeline and delete them by hitting the Delete key.

Attention

Make sure that you only select the elements you want to delete. For example, you can use the X-Ray display mode to make sure that you have not inadvertently selected any elements that you want to keep.

You can also use the Eraser tool to clean up the little "orphan" edges that remain. To keep the edge count of your model down, you can erase any edges between coplanar faces. If you need to, you can also erase any edges on the interior faces of the roof.

Tip

On a curved surface like this, you can display hidden geometry (from the Menu Bar, choose View > Hidden Geometry) to easily see any hidden lines dividing coplanar faces.

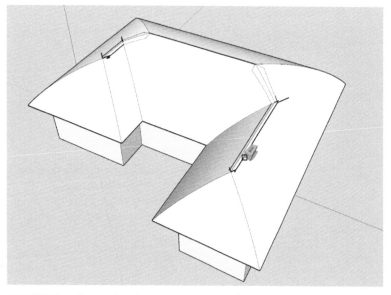

OVERVIEW FIG 4.5 Removing lines joining coplanar faces with the Erase tool.

Tip

Getting rid of all the little stray bits of edges that get left behind when you remove faces ("dust" as it is often known) can be a real chore. However, there is a plug-in to automate the task: cleanup_model.rb will automatically do the tidying up for you.

Creating a Gable End From the Roof Hip

If your building needs a gable end on one of the wings, you have two options open to you:

- Model your roof in parts, stopping every time that you encounter a gable end.
- Model the whole thing as a hipped roof and then edit it to create the gables.

Using the second method is usually the quickest.

1. Select the hip end (including the eaves) and move it so that the ridgeline projects beyond where you want your gable to be.
2. Move your selection so that the ends of the ridgeline are beyond where you want your gable to be.
3. Model a box that completely encompasses the hip end of the roof and place it so that one of its faces corresponds to the position of your gable (see Overview Figure 4.6).
4. Select the roof and the box, right-click (Ctrl-click on a Mac), and choose Select Intersected from the contextual menu. This will cut your roof where it intersects with the face of the box.

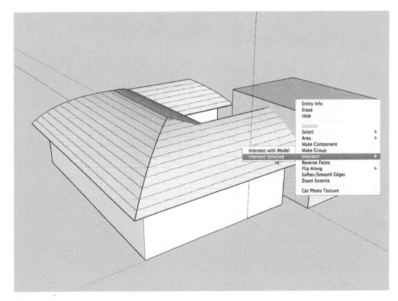

OVERVIEW FIG 4.6 Placing a rectangular volume for intersection.

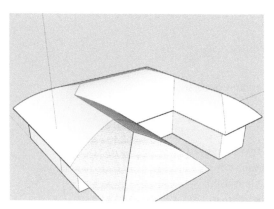

OVERVIEW FIG 4.7 The roof volume cut using Intersect Selection.

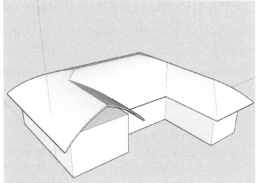

OVERVIEW FIG 4.8 The gable end after removing the superfluous faces.

5. Erase the box and all the geometry that is beyond your gable line.
6. Draw a single line on the open end of your cut section. This will fill the open end.

And there you go. You can use this method with any sort of roof or building profile, even if it is curved.

Modeling Using Photos

Let us be clear on one thing: Modeling using photos in SketchUp is not the catch-all answer for every project or use. In order to create a model from one or more photos, you have to bear in mind several limitations:

- Some element in the photo must be at 90 degrees (i.e., perpendicular) to the horizontal elements, in order for SketchUp to be able to determine the perspective.
- You should aim for a three-quarter view of the whole object to be modeled, i.e., from about a 45-degree angle.
- You should not crop your photos because SketchUp needs the center of projection of the photograph to calculate the perspective.
- The resolution of the photograph should be sufficient to distinguish the details to be modeled.
- It is better to avoid photographs that have been taken with a wide-angle lens. These images contain distortions that make it impossible for SketchUp to calculate the perspective. You should also avoid telephoto lenses, since these images have only a shallow perspective.
- You should also avoid, where possible, objects in the foreground (vehicles, vegetation, furniture, people, etc.). These types of photo cannot be used for the application of textures, and the foreground objects can get in the way of modeling.
- The model to be created from the photo should have flat surfaces, more or less perpendicular to each other. PhotoMatch is not of much use if you want to model curved buildings.

Using the Match New Photo Tool

Even if the limitations of the PhotoMatch tool are numerous, its uses are equally so:

- Model an existing object (or one that has existed): furniture, decorative elements, design or historical objects.
- Model the surroundings of the project to evaluate its impact on the environment and vice-versa.
- Pull dimensions from a photograph when the area to be surveyed is inaccessible. The precision of any measurements will strongly depend upon the resolution of the photograph, the lens used, how carefully the axes are placed, and the unit scale set up in SketchUp.

Tip

Take note of the viewing angle and the focal length used while taking the photograph: This can help you greatly when integrating your model with photographs that have been edited in other programs.

PhotoMatch in Action

Stage 1: Taking and Retouching Your Photos

When taking a photo, you should always aim for a viewing angle of around 45 degrees. However, when there are a lot of trees around, this is not always possible. To reduce distortions as much as possible and to allow you to get the whole of your building in your viewfinder, choose a focal length of between 35 and 50 mm. Make sure that your camera is completely horizontal while you are taking the photos; a tripod with a spirit level is indispensable here. To get as much detail in your photo as possible, take it at the highest resolution that your device will allow.

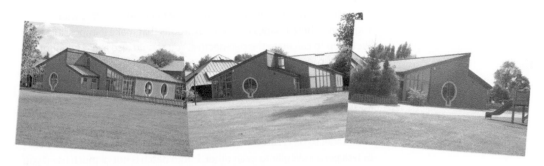

OVERVIEW FIG 4.9 Collection of photos showing building viewed from different angles.

Info

The photos that you use are stored within the .skp file, and so using numerous images at very high resolution can significantly increase your file size and slow SketchUp down.

Tip

If you want to project the photo textures—apply the photo as textures on the surfaces of your 3D model—try and time your shooting session to avoid shadows. If the front of your building is generally obscured by vehicles or other objects, try to shoot on the weekend or holidays.

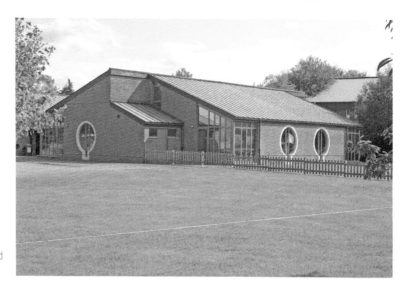

OVERVIEW FIG 4.10 Photo retouched to emphasize the horizontals.

When the photographs are available, you can rework them in an image editor like Photoshop. The idea is to limit as much as possible any tonal differences between the photographs you are going to use. This will avoid texture mismatches when you use the Project Textures command.

Tip

If you are not going to use your photographs to project textures, you can make your work in SketchUp easier by accentuating the horizontal elements of the building in your image editor, by using the Line tool in a contrasting color.

On the other hand, if you do want to use the photo to project textures, try and retouch them to get rid of any elements in the foreground and to correct any other problems (cables and wires, signboards, graffiti and dirt, etc.).

OVERVIEW FIG 4.11 The photo retouched to get rid of any elements that are in the way of the building.

Stage 2: Placing the Axes

From the Menu Bar, go to the Camera menu and choose Match New Photo. Choose your photo in the dialog box that appears and click on Open. SketchUp now displays the PhotoMatch workspace as well as your photo. SketchUp automatically creates a new scene with the name "name-of-your-photo (2D)." The Match Photo palette will appear at the top of your workspace.

OVERVIEW FIG 4.12 The PhotoMatch workspace.

First, move the point of origin (yellow square) so that it lines up with a prominent corner of the building that is visible on several photos. Now, take the handles on the red and green axes and line them up with horizontal elements in the building (in Overview Figure 4.14, they are lined up with the brick courses). To get more precision, you can always zoom in on your photograph in SketchUp.

lxx

OVERVIEW FIG 4.13 Placing the point of origin.

OVERVIEW FIG 4.14 Moving the axis handles onto the horizontals in the photograph.

Attention

The red axes absolutely must be perpendicular to the green axes. However, axes of the same color do not necessarily have to be in the same plane as each other in the photo; they do have to be parallel, though.

Tip

Avoid using the ground plane as a reference; generally, it is never horizontal.

Once the origin and the four axes (2 red, 2 green) have been placed, they are now, theoretically, correctly oriented according to your photograph. You can now scale your model by clicking on one of the axes and holding down the left mouse button. Two arrows appear on the selected axis, and by moving the mouse, you can change the scale to make it correspond to the photo. Once that has been achieved, click on the Done button, and you can start to model.

Tip

It is difficult to get the right scale unless you have already set up a reference point. But there is no need to panic: You can set the scale of your model once you have created an element whose dimensions you know. This could, for example, be a door or window opening that you measure on-site. Then, use the Tape Measure tool, as previously explained, to scale the whole model.

Tip

After clicking the Done button, you will leave PhotoMatch mode. If you need to make any modifications, right-click (Ctrl-click on a Mac) on your PhotoMatch Scene tab and choose Edit Matched Photo.

Stage 3: Modeling

Finally, you can model your building or object using all of SketchUp's classic drawing tools. It is essential to begin your modeling at the axes origin. In Overview Figure 4.15, modeling was begun by drawing a rectangle on one of the facades and extruding it along the length of the building.

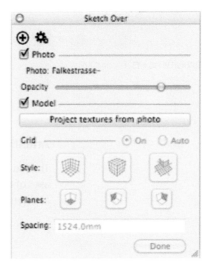

OVERVIEW FIG 4.15 Modeling in Sketch Over mode.

Tip

If you use the Orbit tool to change your point of view onto the model, the display of the photograph will disappear. To get it back, simply click on the PhotoMatch Scene tab.

Stage 4: Project Your Textures

Once the face is created, you can texture it using the photo. Select one or more faces and click on the Project textures from photo button.

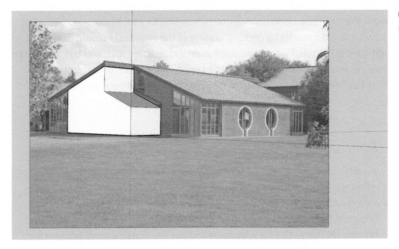

OVERVIEW FIG 4.16 Projecting the textures onto the modeled faces.

Stage 5: Using Other Photographs

If you have any other photos of the building or object being modeled, you can add them simply by following the same steps in stages 1–4. This way, you can model your object or building in its entirety.

OVERVIEW FIG 4.17 Use another photo to carry on modeling the other sides of the building.

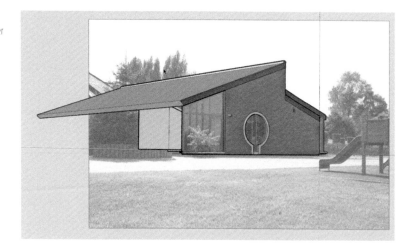

OVERVIEW FIG 4.18 The final building model, the result of using several different photos.

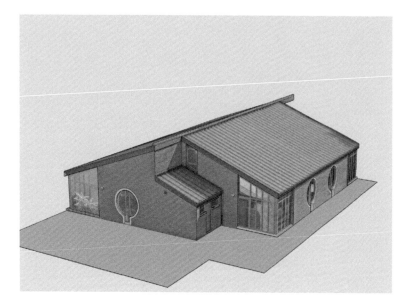

PART 1

Architecture

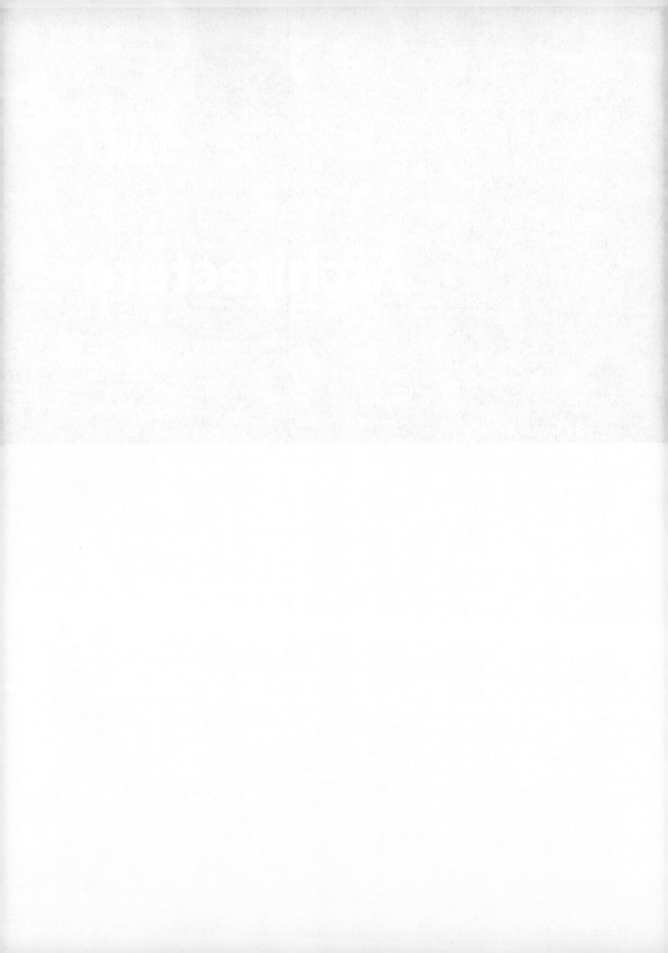

Creating Virtual Concept Models in SketchUp

Jean Thiriet

Jean Thiriet is an architect, qualified in 2008 by the école nationale supérieure d'architecture de Nancy (also called EAN). A passionate user of 3D, he has been working for a practice that creates real-time virtual models since finishing his studies. His other interest is teaching, and in 2009, he created the website wip-archi.com, which is dedicated to conveying the concepts of modeling and rendering, so indispensable in today's profession, to both students and professionals alike.

www.wip-archi.com

Project: Virtual models in SketchUp.

Tools: SketchUp 6, Artlantis, Vray, Photoshop, and Internet.

Jean Thiriet: "The last few years have seen an unprecedented boom in the use of 3D tools. More and more professionals are beginning to notice the undeniable advantages of these virtual approaches, and the growing presence of SketchUp in architecture practices is the best proof of this. In spite of its novel approach, SketchUp often still finds its place in the production pipeline at the same stage as traditional model makers: at the end of the design process. However, given the potential that it possesses, it would be

interesting to try to push for new working methodologies based on a simple concept: the virtual model."

"This model grew and was added to as the project evolved, and it was possible to use it throughout the process to create more traditional graphics (rendered images, for example), whose common origin guaranteed an overall visual coherence."

Project Context

Although many people consider it to be a "basic" program, SketchUp can be integrated into a rich and complex creative process, while at the same time remaining quick and easy to use.

Technical Aspects

Since this project was based on existing building, the design process started with a site survey and desk study, followed by importation of all the data into AutoCAD. This laid the groundwork for future design work.

We soon realized that we would need a virtual model. Using this model, we were able to easily visualize the impact of the many design choices throughout the conceptual stage, something that is indispensable when working with renovations. The 3D construction of the surrounding site backed up this approach and made it easy to take decisions that affected the overall, wider urban vision.

The model for the conceptual phase was often constructed using a fairly empirical method, the volumes being drawn in space with neither a priori research nor the use of clearly defined structural elements (walls, windows, slabs, etc.).

As the project progressed, these purely geometric objects – which were, at this stage, fairly malleable – were transformed into groups and components that were then organized into a hierarchy of layers, the implementation of which makes sense of the whole project, making it more usable and concrete.

This free-form approach explains the success of SketchUp in the conceptual research phases, since it offers a flexibility that other architectural software that is based on parametric objects simply cannot match.

Tip

SketchUp cannot deal with groups of layers: This can make it difficult to keep a clear overview of the project, especially when the number of layers begins to grow large. Creating numbered categories allows you to get around the problem and gives you a reasonable and efficient organization (for example, 01 for the gross structure, with layers 01_Columns, 01_Slabs, 01_Walls, etc.).

Once the project design had stabilized, the next step was the presentation stage. First of all, the model showed a relative uniformity of scale and definition of space (here, at about 1:200), and details were then added to certain specific areas. This method reduced the construction time for the whole project and left more flexibility for further adjustments.

In order to create high-quality images, it is often necessary to go beyond SketchUp's rendering capabilities, notably in terms of complex reflection effects, material rendering, or lighting calculations. There are many programs capable of utilizing the data from the 3D model, and for this project, we used two programs in particular: Artlantis Studio and Vray for SketchUp.

Artlantis is a stand-alone application that takes in the data exported from another 3D modeling program. This program offers a real-time preview of applied material effects, coupled with a very approachable interface; it makes it very easy to adjust the overall look of a scene (lights, textures, etc.).

Vray is a rendering engine, developed originally for 3D studio Max, then ported to several other programs, with SketchUp being one among them. Unlike Artlantis, it is integrated directly within Google's program, where it posts its own toolbar. The renderer offers many advanced control possibilities, something that can put off new users at first. Luckily, sets of parameters can be saved as preset files that can be easily reused, and only a few clicks are necessary to generate a basic render.

Tip

Many websites offer these parameter files for use directly within Vray, and so it is not necessary to know all the ins and outs of the program to make use of it. The parameter files utilized here are from the website www.wip-archi.com .

The use of different pieces of software allows you to really appreciate the flexibility of SketchUp and underlines the necessity of a reasoned approach at every step of the way.

New Approaches

Treating the modeling phase as something intimately tied up with project development, and seeing the images produced as a spur to further development, rather than as an end in themselves, is quite far removed from the classic approach. However, it is bound up with the very nature of SketchUp.

Having a discussion about the model, asking yourselves the questions raised by it, and then creating renders to answer those questions are much more interesting than arbitrarily choosing some points of view in your model, simply rendering them out in 3D, and showing them to the client.

Finally, this "decompartmentalized" use of software in a dynamic, collaborative pipeline (SketchUp, Vray, Artlantis, Photoshop, Internet, etc.) and the exchange of data in various formats represent an original and efficient approach.

To illustrate this, we are going to look at three distinct cases: three images generated from the project. They were not intended to convey the same information and would, therefore, be produced using different methods. Nevertheless, they were all created from the same 3D model that formed the basis of the project.

FIG 1.1 Model of project.

An Aerial View

Presenting the building in its entirety, showing its relationship with the urban fabric, entailed the creation of an overall view that summed up the intentions and the impact of the project.

Stage 1: Define a Composition

Objectives: Make choices that optimize how the image will be read.
Data: 3D model.
Tools :SketchUp and Vray.

Here, we tried to get over a notion of the hierarchy of the elements shown, in order to stress the major points of the project in relation to its environment.

To do this, the urban context was modeled entirely of schematic blocks rendered in "clay render" mode. The easiest way of achieving this is to choose an appropriate preset within Vray: In Vray's options, click on File > Load, choose a preset (the file extension is .visopt) and start the render.

Thanks to this approach, it was easy to see the scale and relation of the principal elements, without overburdening the image with graphic information.

The building, framed at the center of the scene, was going to be rendered in color, primarily to stress the importance of the landscaping aspects of the project. The numerous clusters of trees were largely responsible for the character of the spaces, and a graphic representation of this was needed.

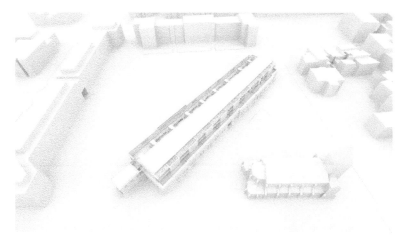

FIG 1.2 "Clay render" model.

Stage 2: Updating the Model

Objectives: Adding elements to communicate the intentions of the project.
Data: SketchUp components.
Tools: SketchUp and Component Spray plug-in.

At this scale and viewing angle, it was apparent that placing photorealistic 2D trees would not make reading the project any easier and would entail long hours of manipulation in Photoshop.

We, therefore, went for schematic 3D trees that had sufficient explicit volume to render the image readable. However, in light of the number of elements that we needed to place, this was going to be a complex operation: SketchUp does not have any tools that could help in this regard.

Luckily, a Ruby script programmer has come up with a solution to get around this constraint. Ruby plug-ins, often free and developed independently by a dynamic community of enthusiasts, provide quick-and-easy solutions in cases too numerous to mention and fill many of the holes in the original program. We used the Component Spray plug-in, which allows you to easily duplicate components across a surface using a simple click (or across a chosen geometric shape: square, circle, etc.). The script also includes a function that randomly changes component scale and rotation, which gives a very natural-looking appearance to the results of multiple copy operations. The same method was used to place the people in the scene.

FIG 1.3 Updated model, rendered with Vray.

Stage 3: Refining the Render Further

Objectives: Compositing the different elements to obtain the final image.
Data: Renders from SketchUp and Vray.
Tools: SketchUp, Vray, and Photoshop CS.

Once we have the two images (both the "clay render" and color images produced with Vray), it was simply a matter of compositing them in Photoshop and applying a mask to allow the one layer to show through the other where necessary.

In order to increase the readability of the whole image, and in particular the white of the massing model, we composited the edges from the SketchUp render on to the render created in Vray. If your software allows you to create a renderer with exactly the same camera position and angle as in your SketchUp scene, it is easy to composite the two. To do this, you simply need

to take a screenshot in SketchUp's Hidden Line mode (with the background set to white) and place it in a new layer in Photoshop, overlaying the previous render. You then simply need to change the layer's Blending Mode (usually to Multiply). This will knock out the white of the black-and-white layer, revealing the full-color image underneath, but will keep the black edges intact.

Using this method, you can create some fairly original-looking renders, half-way between photorealism and a hand-drawn effect.

Finally, since the green spaces are particularly important as regards the use of the space as a whole, they were brought more to the fore by giving them a specific texture using Photoshop's Clone Stamp tool.

Tip

A realistic-looking grassy surface can be easily obtained by using any sort of grass image, painted at low opacity on any areas rendered with a lawn texture. The variations in shades of green create a realistic appearance, eliminating the tiling effects often observed in these types of textures.

FIG 1.4 Final image.

Principal Section

Since the project was based on an existing building and the brief called for a multifunction use, the final scheme consisted of many complex, interlocking spaces and varying usage zones. It was, therefore, necessary to communicate these clearly in order to convey the overall idea of the project. With this in mind, a section seemed ideal in this regard.

Stage 1: Choose an Approach and Understand the Constraints

Objectives: Decide on the type of render and the method that will allow you to achieve it.
Data: 3D model.
Tools :SketchUp.

From the start, we chose a "clay render" style, in order to place the accent on the building volumes themselves and not on the extraneous details that might hinder the reading of the whole scheme. The section view for this stage is further accentuated by rendering it in perspective, something that is richer and more dynamic than a simple 2D cut.

FIG 1.5 Simple white render of the section cut.

SketchUp makes it easy to dynamically place section cuts, thanks to its dynamic Section Plane tool. However, these cuts are "virtual," and the model always remains intact.

Unfortunately, rendering engines work on the entire geometry of the model so that the section cuts would not appear in any renders produced by third-party programs. This means we needed to turn to other methods to achieve the desired result.

If you are using Artlantis, it is possible to get the same effect by using its own Section Cut tool. Unfortunately, to get a monochrome model, it would be necessary to replace all the materials one by one with a uniform white texture, something that entails a considerable time investment. For these reasons, we chose at this stage to work with Vray, to obtain a very high-quality "clay render," but this approach would require some modification to the model.

Stage 2: Adapting the Model

Objectives: Creating a model with a section cut that can be rendered by third-party programs.
Data: 3D model.
Tools: SketchUp, Zorro 2, and Section-Cut Face plug-ins.

Now, the rendering engine had been chosen; next, we needed to solve the problem of how to create a model with a section cut. We could modify all the groups in the model one by one, cutting them where we want our section plane to be, using the Intersect Selected tool, but that would be an extremely long and tedious operation.

Luckily, in this situation – as in so many others – we can get around the initial limits of the program, thanks to the ingenuity of Ruby script programmers. To resolve the current problem, we just need to use the Zorro 2 script, which automatically erases all the geometry on one side of a SketchUp section plane, allowing the model to then be exported to a rendering program with a section cut visible.

FIG 1.6 The render.

Tip

Since the operation carried out by the Zorro 2 script is destructive (it erases geometry) and is sometimes subject to errors, it should always be run on a copy of your model.

SketchUp, being a surface modeler, produces open section cuts when used with the Zorro 2 plug-in. This would be a good point to run the Section-Cut Face plug-in, which, as its name suggests, caps the open ends of the section cut with a face, giving a solid edge to the section – a much more aesthetically pleasing result.

Stage 3: Fine-Tuning the Render

Objectives: Bringing together several elements to obtain the final image.
Data: Rendered images from Vray and SketchUp.
Tools :SketchUp and Photoshop.

Once the image is generated, there are only a few adjustments that need to be carried out in Photoshop to obtain a convincing result.

Often, you only need to adjust an image's levels (from the Menu Bar, choose Image > Adjustment > Levels) to tweak the contrast, to bring out details, and to make the image more clearly readable. The Levels palette shows a histogram and three sliding cursors: Black, Gray, and White. By sliding these cursors, you can adjust the luminosity values for different parts of the grayscale spectrum far more accurately than you could with the Luminosity tool.

Tip

To obtain a quality "clay render," it is often a good idea to create two different renders with two types of illumination: One uses the sun and creates high-quality projected shadows and the other uses only ceiling lights to produce a more uniform level of detail. Compositing the two in Photoshop produces a result that is precise and has great contrast.

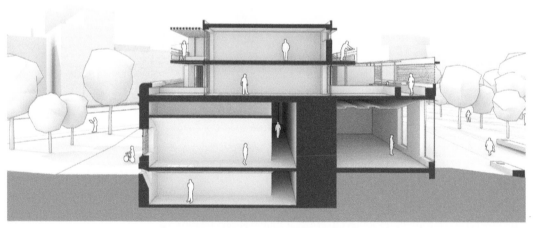

FIG 1.7 Final image.

An Interior Perspective

Once the functioning and the logic of the building had been clearly explained, it was necessary to present the interior ambience of the project in more detail. To this end, we chose to create the perspective of the exhibition space, a pivotal point between the extension and the existing structure.

Stage 1: Dressing the Envelope

Objectives: Increase the level of detail in the model in the area under consideration.
Data: 3D model and images (textures).
Tools: SketchUp and Internet browser.

First of all, we carried out a texture search for the stone wall, the wooden floor, and the concrete for the walls. A few clicks on sites containing free texture libraries (such as CGtextures.com) will turn up a vast array of suitable textures.

Once the image was downloaded, it needed to be integrated into the model's geometry. To do this, we first of all needed to apply a material to an object (using the Paint Bucket tool), and then, using the Materials Editor (the Colors palette on the Mac), we needed to assign the texture to our material. To do this on the Windows version, go to the Edit tab, click the Use Texture Image check-box, and navigate to your texture in the dialog box that appears. To do this on the Mac, go to the Colors palette, choose Materials in Model (the little brick icon), right- or Ctrl-click on your material's swatch, and choose Edit... from the contextual menu. Now, from the Edit pane, you can change your material's bitmap texture, overall dimensions, and hue to obtain a more precise effect.

FIG 1.8 Textured model.

Stage 2: Dressing the Space

Objectives: Fitting out the model to convey the nature of the space.
Data: 3D model, images, and SketchUp components.
Tools: SketchUp and Internet browser.

Once the boundaries of the space have been defined, it needs to be fitted out. Since the building was a former military barracks in a garrison town, we immediately thought of using Vauban as a theme.

Using the name as a keyword for an Internet image search, we easily turned up many of Vauban's original plans, which we simply had to drag and drop into SketchUp to create exhibition displays.

At the same time, research on Wikipedia returned a bibliography whose first paragraph, copied into SketchUp's 3D Text tool, became an integral element of one of the wall displays. Also, by using the 3D Text tool to change the font and the size of the text, we were able to create a convincing title for the exhibition.

Finally, still adhering to the same theme, Google's 3D Warehouse offers no end of models of Star (Escarpment) Fortresses (a specialty of Vauban): You just need to reduce them down to the appropriate scale to compete the exhibition.

FIG 1.9 Improved model.

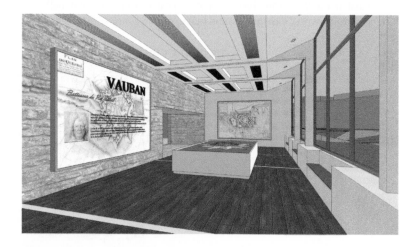

Stage 3: Creating an Image

Objectives: Rendering a photorealistic image of the space (lighting, materials).
Data: 3D model.
Tools :Artlantis.

After fitting out the exhibition space, we then moved on to the rendering proper. In view of the number of different materials to adjust and the number of light sources that needed to be placed, we decided on Artlantis, since, in such a situation, Artlantis is far more flexible and easy to use than Vray.

Rendering the model began by opening the SketchUp file directly in Artlantis; there is no need to export from SketchUp in an intermediate format beforehand. Artlantis automatically converts SketchUp's scenes into cameras, and you just need to click on one of these to select the desired view and obtain a previsualization render of the space.

Tip

Take care to note the visibility of your layers in SketchUp when you save the .skp file before loading it into Artlantis: Any hidden elements will not show up in Artlantis.

After placing a bump map on the wall texture, adjusting the reflection of the flooring, and defining the intensity of the neon luminaires in the ceiling, we only needed to hit the render button to produce an image at the chosen resolution.

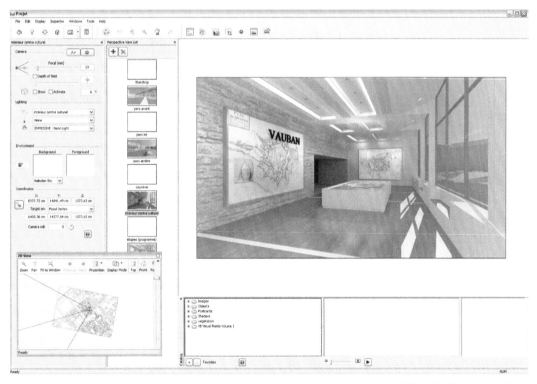

FIG 1.10 Model rendered in Artlantis.

Stage 4: Finishing Touches

Objectives: Work on the render to produce the final image.
Data: Images from Artlantis and SketchUp.
Tools :SketchUp and Photoshop.

To be efficient at this stage, you need to appreciate the contribution that each program makes to the final render and to use that program only within its field of application.

After several minutes of setting up and a very short render time, the "raw" render produced by Artlantis was somewhat lifeless, but contained enough definition in the material and lighting effects to enable us to produce our final image.

It would have been possible to rework the lighting intensity or the color of the Sun directly within Artlantis and then to render again to produce an image more in line with what we wanted. However, this process can take time, since you are not always certain of the results that you will obtain from any given render. Luckily, we were able to use Photoshop to achieve the desired results within a relatively short space of time, all the while conserving flexibility, mainly by using the Levels, Curves, and Color Balance commands.

Similarly, the silhouettes of people that give life and a sense of scale to the scene can also be added in Photoshop, using classic 2D cutouts. However, it is sometimes difficult to judge the scale of each individual silhouette within a perspective, and so, in order to save time, these cutouts can be placed in the SketchUp file itself, simply by dragging and dropping them from the Component library, but placing them on their own layer. This allows the figures to be exported independently and later composited in Photoshop. This was the route that we chose, since we wanted an "abstract" silhouette effect, without shadows or reflections.

Tip

You need to analyze all the constituent elements of the model in the same way as the 2D silhouettes. For instance, you can place vegetation into the model as 3D objects. With trees and shrubs especially, this will allow you to obtain very precise shadows. Unfortunately, the geometric complexity entailed by such models brings with it a considerable hike in render time and file size in SketchUp. Therefore, it is often preferable to quickly composite masked photos of trees directly within your image-editing software.

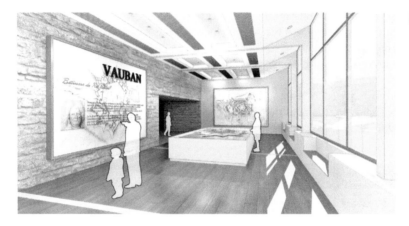

FIG 1.11 Final image.

Conclusion

In this project, it can clearly be seen that constructing a model in SketchUp serves both the conception and presentation phases of a project equally well, providing both flexibility and efficiency.

The flexibility and versatility of the platform allow for the exploration of multiple aspects of the project and give you the ability to precisely convey complex architectural intentions to the client.

FIG 1.12 Some examples of rendering compositions.

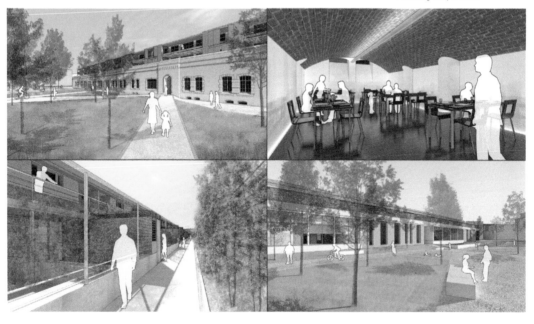

Finally, using a model means that you can view your project from any angle, but at the same time, it teaches you the importance of correctly framing and composing a render. The growing presence of 3D tools in today's projects often leads to a proliferation of ill-thought-out images, and the readability of the entire project suffers as a result of this. This is why final compositing work in an image editor is always necessary, meaning that a few well-chosen and well-presented images should be sufficient to efficiently convey the essence of a building.

Resources

Software

SketchUp 6.4.

Atlantis Studio 2.0.

May for SketchUp.

Photoshop CS3.

SketchUp Plug-ins

Component Spray by D. Bur.

Zorro 2 by D. Martens.

Section-Cut Face by TIG.

These can be found on the Ruby forum at www.sketchucation.com and in the database of the CRAI laboratory at http://www.crai.archi.fr/RubyLibraryDepot/ .

Vray preset files, Artlantis workflow

www.wip-archi.com .

Miscellaneous

http://SketchUp.google.com/3dwarehouse/ .

www.cgtextures.com.

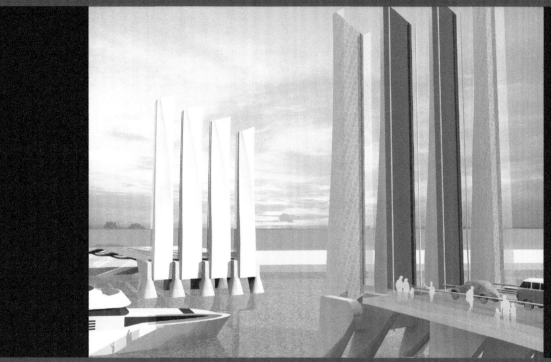

Te Wero Bridge Competition in Auckland, New Zealand

Takeshi Hashimoto

After studying under Peter Eisenman, Elizabeth Diller, Ricardo Scofidio, and John Hejduk, Takeshi Hashimoto graduated from The Cooper Union School of Architecture (New York USA) with a B. Arch. in 1992. He then moved back to Tokyo and established Hashimoto Architecture Studio in 1996.

Project: Te Wero Bridge in Auckland, New Zealand.
Tools: SketchUp6 Pro, Podium, Photoshop CS3.

The project started as a two-stage international competition organized by the city of Auckland, New Zealand. The Te Wero Bridge is a swing bridge that connects the central business district and the Wynyard quarter (also known as "the tank farm," it is a 35-hectare reclaimed landmark area surrounded by water), integrating the old and new cities while providing boat access in and out of the Viaduct Harbour marina.

The new bridge needed to span a maximum of 100 m, carrying two lanes each for vehicles and pedestrians and light rail or similar passenger transport systems for use in the future. From its closed position, the bridge had to fully open in 30 seconds, making a minimum 35 m clearance to let boats pass.

After being selected as one of four finalists in the first-stage competition, I teamed up with TILT group (an amalgam of various international firms, led by Pete Bossley Architects of New Zealand) to complete the second-stage competition .The thirty-five-million dollar budget seemed a bit short for a bridge of this scale and function, and as a consequence, our team had to give up some of the fancier options such as carbon-fiber composite as a main material for the bridge (there was an Italian yacht designer in the team, who specialized in carbon-fiber).

Project Context

As this was a competition project, all the usual constraints of competitions (time, budget, free labor…) weighed on us just as heavily as they would do on others. However, since we were preparing the first stage of the competition alone, the limitation of time was probably the biggest constraint of all.

As a consequence, before starting the design of the bridges and making renderings of them, we had to make many choices based on questions of time efficienc y.

Although it was a competition for the design of a swing bridge, the only deliverables that the brief called for were a few still images (renderings), 2D drawings, and texts on one A1 sheet. Submission of animations was not required in the first stage of the competition. Of course, if you have a structure that moves, ideally you want to show it in motion, which we did with modo animations and movable models in the second stage of the competition, when we had more time and budget, but there was not enough time to do animations in the first stage. We had to live with static designing, and so we started thinking of ways to simulate the movement with still images in a sequence.

Technical Aspects

Within the time limit set for the competition, our office was to do all the designing, modeling, and rendering in-house. Knowing that the combination of SketchUp and Podium would do these things rather efficiently – we were familiar with both programs prior to entering the competition – it was natural for us to select them as our main design tools for this competition.

After we decided to have eight bridges instead of one as our scheme, we started setting up the drawing structure in SketchUp. Since our scheme had many variations of one element, a 'finger' of the bridge, we thought SketchUp's component instances feature would work perfectly at the design study level, especially for quick design evaluation.

This meant:

1. **Simultaneous modeling by a team:**
 SketchUp does not have an advanced Xref (external references) function. However, it is possible to divide the main project model into

a series of submodels and work on them simultaneously as a team. Of course, we were going to use component instances, but with a bit of know-how, they can become a very sophisticated tool for group designing.

2. **Easy design evaluation of bridge forms:**
The position and sizes of the eight bridges were pretty much fixed at the early stage of design. We needed to know how their formal variations affect the views from various viewpoints, at different stages of their open/close cycle. The second part of the following steps deals mostly with setting up the file structure for quick design evaluations.

3. **Quick rendering of still images:**
We picked Podium as our renderer because it has a very fast rendering engine, and it requires no importing/exporting of files as long as it is used with SketchUp. Converting files from one piece of software to another is usually a very time-consuming, painstaking process, even when it claims smooth file conversion. So being able to create renderings within SketchUp was a big plus for us.

Other software used to complement SketchUp and Podium were Vectorworks (2D drawings, annotations, and page layout) and Photoshop (fine-tuning of renderings from Podium and adding Depth of Field [DOF] effect with layers). I also used Moment of Inspiration to create a couple of form studies with complex curves, an area where SketchUp is particularly weak.

New Approaches

The key functions of SketchUp in this particular design process are the following:

1. **Component instances:**
We used component instances to speed up the design evaluation process. The decrease in file size brought about by instancing was not the only reason to use components: they were also used to speed up the overall workflow. Prior to modeling several schemes for the bridge, we spent some time setting up the file structure with component instances so that we could minimize modeling time but still being able to review various aspects of each scheme. Of course, as I stated earlier, being able to work on a model as a team is always a bonus.

2. **Animation export:**
We did not make any animations at this stage, but the function is very useful for batch-exporting scenes to high-resolution image files.

3. **Fog:**
I learned this unique way of creating depthmaps by using SketchUp's fog function from my friend Lewis Wadsworth. Depthmaps are used to give a DOF effect of camera lenses to exported images from SketchUp. They add

a touch of the real world to the otherwise typically super-crisp, digitally generated images.

What I like about the SketchUp's tools is that they are so "simple" and "essential." I like the fact that simple tools will not interrupt your thinking, rather their simplicity makes designing in 3D (as opposed to modeling mindlessly) that much easier. Well-considered, essential tools will let you create new tools by combining them so that most of your modeling needs will be covered with a minimum number of tools.

Step 1: Picking Up the Right Competition

Goal: Finding the right competition to enter.
Inputs: Web newspapers, Google News search, competition-listing websites.
Tool :Internet.

Competitions are everywhere nowadays. I just looked through a few competition-listing websites on the Internet and found more than sixty ongoing international competitions. But good competitions are rare.

What makes a competition "good"? To me, as a practicing architect, the feasibility of the project counts for a lot. A good jury is a must, and an interesting program will motivate everybody.

You can be pretty sure about the jury and programs, but you cannot really be sure about the project's feasibility; there are just too many unknown factors involved.

Well, we can never be sure, but at least we can do a bit of research at least. For a public project like a landmark bridge, it is not difficult to find related articles on the area (in this case, New Zealand) in newspapers. I collected them via the Internet and concluded that the project was a worthwhile one. You should also check the status of your design copyright in case you win the competition, and you should also cover yourself if they cancel the construction altogether after the competition.

After much research and investigation, I decided to enter the Te Wero Landmark Bridge Competition.

Step 2: Working as a Team

Goal: Simultaneous editing of a single SketchUp model by a team.
Tool :SketchUp.

Most of the following techniques I explain here were developed in the course of taking part in this bridge competition. In the first stage, we worked on the site model and the project part (the moving bridge)

separately in our office, but things got really complex when we were doing the second stage; there were contributing offices in Europe, New Zealand, Australia, and Japan. Most offices in the team, to varying degrees, had some experience in designing with SketchUp prior to the competition. Therefore, there was no argument about which 3D software we were going to use for the actual designing. It was simply a natural choice, but we had to come up with some rules for working simultaneously as a team of designers since, SketchUp lacks a good Xref function.

Looking back, what was most unlikely about us as a design team was the fact that we did not have any premeditated, strict framework of how the models should be created. We tried to create the environment where we could focus only on what we modeled, not on how we modeled them. As a result, everybody worked in a way that suited them, yet nobody had any problems with taking over somebody else's models.

We completely divided the main project model into component files.

Then, most importantly, all components were saved as individual component files *from inside the main model*. After that, there is only one rule for everybody: work on any component files you like, but always rename them after editing is done.

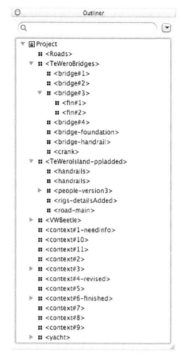

FIG 2.1 Outliner with component tree.

Tip

When one of us made some modifications to a component or a submodel, they saved that component file with a new name before sending it to others. Naming convention was <name of the part>-<explanation>.skp. That way, other people would know in which part of the model modifications had been made and in what way.

With these simple rules about components, you did not have to understand everything that was happening in other parts of the model you had just received. The time of modification of the components was registered with the files themselves; you can clearly see that in the Finder (on the Mac) or File Explorer (on Windows), and that was all the information we needed to know most of the time besides what was there already in their names.

File exchange between the designers in the team was rather intensive throughout various design stages. Sometimes, revised designs were sent out for review several times a day. Of course, this kind of loosely structured system cannot work properly with a large number of people, but for a competition team the size of ours (fewer than ten people), it did the job well.

Step 3: Dividing the Main Project Model into Submodels

Goal: From the main model, create submodels as separate component files with their exact locations registered in the main model.
Input: SketchUp model of the project (including the site).
Tools: SketchUp's component instances and Outliner.

Even though we tried to keep the project model down to its essentials, it got quite complex in the end with its surroundings and was heavily laden with various components by the time the rendering started.

So, we divided the project file into two separate file types, the main-model file and sub-model files, and generated the latter from the former as component files with their exact locations registered in the main model.

I set up the models as follows:

1. In the main project model, select entities (edges, faces, groups, components, etc.) to be handled as a separate file.
2. To create a component, context-click on the selection, choose Make Component, and the Create Component dialog box appears. Set all parameters to your preferences, but make sure Replace Selection with Component is always checked.
3. After the component is created, context-click the component name in the Outliner > Save As and name the file as <name of the part>-<explanation>.skp. Specify the file location and click Save.
4. Component files can also be saved as separate files via the Component Browser or Edit > Component > Save As menu, but almost always the Outliner is the most convenient and straightforward method.

FIG 2.2 Saving a component as a separate file with context-click.

You now should have submodel files in the folder you specified in the earlier steps. Repeat the steps until the main model is totally divided into comprehensive submodels (components) and no free entities or groups are left in the main model.

Step 4: Editing Component Definitions in Submodels

Goals: Edit entities in submodels and modify component definitions.
Inputs: Component files (submodels) created in the previous step.
Tool :SketchUp's component instances .

Now you have several submodel files that are generated from the main-model file. Whether it is a piece of furniture, a floor of a building, a whole building, or a city block, try to break the main model completely into comprehensive design units .

Info

When you open one of the submodel files they do not appear to be components; there is no bounding box around the entities. This is because you are already inside the component when they are opened; in other words, changing anything in the submodels means that you are modifying the component definitions.

The submodels created are just like any other components, and there is no special knowledge required to edit these. You can push–pull faces, add details, or apply textures to objects.

Attention

The only restriction of submodel editing is that in submodels, you should not change the general positional relation of objects to their SketchUp axis.

In the same way, you should not redefine SketchUp's axes and change their original position in submodels. SketchUp's axes in submodels corresponds to the component's axes of that component. Its position in the main model is registered by the position of the component's axes to the original position of main-model SketchUp axes; therefore, changing their positions will force them to be positioned wrongly when reloaded (the next step). On the other hand, changing the axes of the main model does not affect the positions of components within the file.

FIG 2.3 A component axis in the main file and a component axis in the subfile.

Tip

If you need to move SketchUp's axes in one of the submodels temporarily for modeling reasons, make sure you reset it before saving the file.

The only exception to this rule may be when you are evaluating positional variations of your project, and this is much more easily done if components are modified as a whole, rather than modifying component definitions from inside of them.

I will explain the other modification method (nested components) later.

Attention

You also have to be careful not to edit submodel components inside the main model. Any changes you make to these components in the main model will be canceled upon reloading those components. One way to avoid this mistake is by locking these components in the main model: the other way is by working only on submodels (therefore, nobody is editing the main model). If, by mistake, you modify some components and do not want to discard the changes you made, just save that component as a file with a new name before updating.

Step 5: Reloading Submodels into the Main Model

Goal: Put submodels back into their precise locations in the main model.
Inputs: Components (submodels) edited in the previous step.
Tools: SketchUp, Component Instances, and Outliner.

When components are inserted from the Component Browser or imported via File > Import, you have to manually place them where you want them to be in the drawing area. This can easily lead to mistakes and can result in a mess if 20–30 components are constantly being replaced with updated versions.

Reloading is different. Unlike inserted components, reloaded components have their precise position in the main model already registered as their component axis. Unlike inserted components, reloaded components know their precise locations in the new environment because they are registered with the component's axes. You do not have to place them in the model by reloading them; they automatically go where they should be.

Tips

Another advantage of reloading over insertion is that reloading does not accumulate components in files like Insertion does, and as a result, the file size of the main model depends on the amount of components there are at the moment, rather than the accumulation of all inserted components.

Reload submodel files into the main-model file using the following steps, after some editing. Make sure you save submodel files before reloading them into the main model.

1. In the main model, select a component to be reloaded in the main model window, the Outliner or the Component Browser; unlock it before selecting it if locked.

2. Context-click > Reload.
3. Open. A File dialog box opens. Select the component file you just finished editing. If you want to switch the component to another one, select that file.
4. The component will be reloaded at the right location.

FIG 2.4 Select a component to be reloaded.

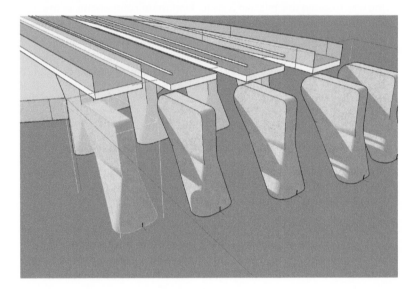

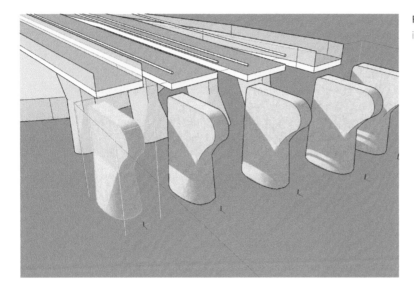

FIG 2.5 A component and its instances reloaded.

I would recommend using the Outliner for the above steps, since you will always be aware of the overall file hierarchy of the model, and it even shows the status of hidden or locked components.

Step 6: Editing Submodels as a Whole 1/Proportional Modifications

Goals: Manipulate proportional modifications of component instances.
Inputs: One of submodels created in the previous steps.
Tools: SketchUp, component instances, and the Scale tool.

Our scheme for the competition consisted of eight separate bridges, rather than just the one.

These bridges were formally similar, but slightly different in their lengths. Instead of modeling all eight of them one by one, we used scaled component instances to carry out quick design evaluations.

Tips

The rule of thumb is that modifications done to a component instance as a whole affect only the properties of that particular component instance, whereas modifications done to individual entities within a component (i.e., component definitions) affect all other component instances.

So, if I scale four component instances as a whole to varying degrees, modifications to the component definition of one of them will be proportionally reflected in other component instances.

This means that you can have many variations of the same component (of various sizes and positions), and changes in one of them will affect all other component instances proportionally. Let me explain in models.

1. Create an object and make it a component
2. Create several component instances by duplicating the component
3. Modify them with Scale tool
4. Change the component definition of the original component (i.e., one without modifications)
5. All component instances will be modified proportionally

FIG 2.6 A component is duplicated four times.

FIG 2.7 Component instances being modified to various degrees.

FIG 2.8 When one of the component instances is reloaded, all instances change proportionally.

Note that, although all these components in Figures 2.6–2.8 have different lengths and different widths, they are instances of the same component, and updating all of them requires only one of them to be reloaded.

Step 7: Editing Submodels as a Whole 2 (Nesting Technique)/Positional Modifications

Goal: Manipulate positional changes of component instances within another component.
Inputs: A set of component instances created in the previous step.
Tools: SketchUp, the Outliner, nested component instances, the Move and Rotate tools.

Sometimes, we need to evaluate positional changes of a scheme in addition to its formal variations. I briefly touched upon the topic in one of the previous steps as positional changes can also be handled by changing component definitions.

However, if we need to evaluate both options in various combinations, positional options should be handled at different component levels so that we can manipulate forms and positions separately.

Tips

I cannot recommend the use of the Outliner enough, especially when one has to deal with a complex model with multiple nesting of components. The Outliner reduces the need for zooming in and out to search for components or groups to almost none because all components are always visible (even hidden components are visible) in the tree structure of the Outliner, no matter which part of your model is showing on the screen.

So, we will create a nested component from a group of component instances generated in the previous step.

The nested component levels allow us to manipulate positional changes by moving each component instance as a whole, and we can modify the forms of each component instance by its component definition at another level.

1. Make a component from a set of component instances created in the previous step.
2. Context-click > Save As…, and save it with a new file name.
3. Open the saved file, make the positional changes needed, and save it with a new name.
4. Repeat point 3 and create positional options. In this case, I created different moments of the bridges during their sequential open/close cycle.
5. Go back to the main file, context-click the set of bridges > Reload, and switch it with a set in a new position.

FIG 2.9 The saved component file with positional modifications.

FIG 2.10 Select the nesting component in the main file and reload it.

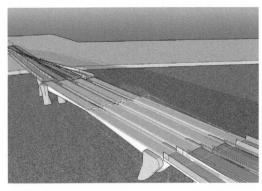

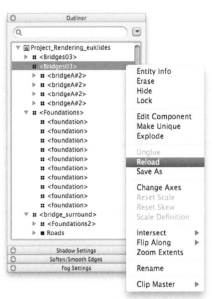

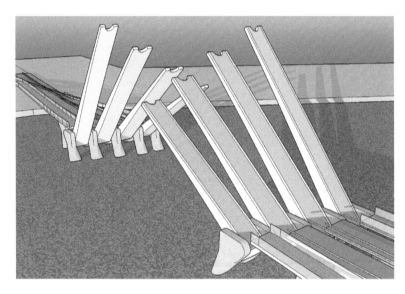

FIG 2.11 The nested component
instances change their positions.

Step 8: Evaluating Design Options in Scenes

Goal: Evaluating several design options quickly by reloading different ver-
sions of components.
Inputs: Components (submodels) edited in the previous steps.
Tools: SketchUp, component instances, the Scene Manager, and
animationexport.

We usually assign several design options to different layers and set up scenes
so that option A is visible only in scene A and option B is visible only in scene
B. We switch back and forth between two scenes to evaluate both options.

However, scenes are also used for other purposes, such as animations, image
export, etc. Using the already overloaded function for just one more purpose
will only leave us confused and the Scene Manager crowded and too complex.

If submodels are used in place of scenes as a means to switch design options
as explained in the last step, scenes and layers need to be set up only once for
whatever purpose. Submodel B reloaded in place of submodel A will take over
all properties (visibility in scenes, layer-related settings, size modifications,
positions of component axes, etc.) of submodel A.

1. Select one bridge from the set in the Outliner, context-click > Reload, and
 update to another formal option.
2. Context click the set of bridges > Reload and switch it with a set in a new
 position.
3. Repeat the above two points and try out as many combinations of forms
 and positions as you need.

FIG 2.12 Select one bridge from the set in the Outliner, context-click > Reload.

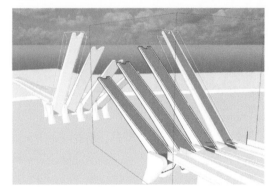

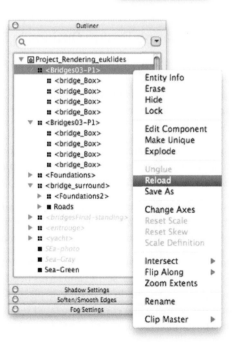

FIG 2.13 A design option appears.

Run through all the scenes (an animation with some delay, but without transitions, might suit this process the best), reload components, and go over all the scenes again.

I think that a series of high-resolution still images usually works best when comparing several design options. In the next step, I will explain the trick of automating batch-image export from SketchUp.

FIG 2.14 After a positional option is reloaded, yet another design option is reloaded.

Step 9: Evaluating Design Options in Still Images/Batch Image Export

Goal: Using the animation export function, automatically export all scenes as image files.
Inputs: The main project model and submodels as design options.
Tools: SketchUp, the Scene Manager, and animation export.

SketchUp does not have batch 2D export, but we can export images one by one via File > Export > 2D graphic. The following procedure automates this process by utilizing SketchUp's native animation export function.

1. Set up your scenes with all properties set to your preferences. Check Include in Animation, of course.
2. View > Animation > Setting, Uncheck Enable Scene Transitions. Scene Delay has no effect on this operation.
3. Go to File > Export > Animation and choose a file destination and an image format from the options of .jpg, .png, or tiff.
4. Click Options. Image size and Frame rate can be set to whatever you what. Uncheck Loop to Starting Page and Play When Finished.
 If you want high-quality images, check Anti-Alias, but this can make the process too time-consuming. Click OK.
5. In the destination folder you specified earlier, you should find rendered image files of all your scenes.

Step 10: Applying DOF Directly to SketchUp Output

Goals: Generate a depthmap from SketchUp using its Fog function, then apply the map to images to give them DOF.
Inputs: A SketchUp model and depthmap.
Tools: SketchUp, Fog, and Adobe Photoshop CS3.

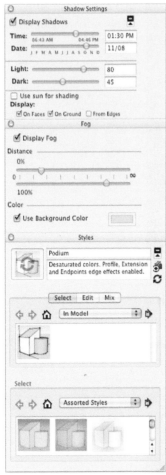

FIG 2.15 Depthmap settings in SketchUp.

About the same time I was taking part in the Te Wero bridge competition, a friend of mine, Lewis Wadsworth, was playing around with SketchUp's Fog function and managed to find a way to output depthmaps straight from SketchUp.

A depthmap is an image that uses grayscale values to show which areas in our model are closer to us (white) and which are more distant (black). It can be used to give focal blurring to super-crisp, computer-generated images. The resulting images have a DOF closer to what we actually see in reality.

How to create depthmaps in SketchUp:

1. Create a new scene with only two properties checked: Style and Fog, and Shadow Setting. With this scene, you can turn any other scenes into depthmaps instantly. View any scene first and then click this scene tab.
2. Open the Styles Browser to Fog and Shadow Settings. Set parameters as shown in the following:
 The important parameters are
 Shadow Settings: Dark must be all the way – or nearly all the way – to the right. Check Use Sun for Shading.
 Fog: Check Display Fog. The right setting for Distance varies from image to image, so play around with sliders. Do not use a Background Color; specify black for it.
 Styles Browser: Turn all edges off. Both Front and Back Colors are white in Face Settings; select Display Shaded Using All Same in Styles. In Background Settings, Turn Sky off, and the Ground too if you have no physical ground plane. Set Ground color to white if it is on.
3. Export a depthmap along with a colored image of the same camera setting.

FIG 2.16 The depthmap generated.

How to use depthmaps in image editors:

I am using Photoshop CS3 in this minitutorial, but the same process can be done in many other image editors with a layer function. In the following tutorial, all operations are done in the Layers palette unless otherwise indicated.

1. Open the SketchUp images in Photoshop.
2. In the colored image, double-click the background layer to turn it in to a normal layer.
3. Add a new layer, fill it with white using Edit > Fill, and move it to the bottom of the layer stack.
4. Add a layer mask to the colored image layer: Layer > Layer Mask > Reveal All. Alt + click the layer mask and paste the depthmap into the layer mask created.
5. Select the colored image, then choose Filter > Blur > Lens Blur.
6. In the Lens Blur panel, choose Layer Mask as the source of your depthmap. Play around with the Blur Focal Distance slider to set the depth at which the pixels are in focus.
7. Adding some noise will give the image more air and a realistic feeling. Click OK.
8. Right-click the layer mask and disable it.

If you create a separate line-drawing layer on top of the colored image layer, you have much more control over the look of the image. If you do this turn off all edges from the colored image and switch the line-drawing layer to Multiply and add a layer mask and depthmap as you did for the colored image layer.

The first image is a straight output from SketchUp, and the second is a Photoshopped image with DOF.

When Lewis wrote a depthmap tutorial on one of the SketchUp forums, it was an instant success and the word spread quite fast. Now, you can easily find many depthmap-related tutorials and videos on Internet.

Conclusion

In the last 15 years, I have used many CAD packages, both in the offices I worked for and in my own office, to make construction documents, to create a base for physical models, or to make an impressive presentation. However, SketchUp must be the first (and still the only) CAD program I have used for designing, and I believe many other architects use it in the same way.

It doesn't have B-splines or Bezier-type curves (although some of these are now available through Ruby scripts), and it can be a pain to work on a big project with these shortcomings. However, in spite

FIG 2.17 Photoshop's Layers palette.

FIG 2.18 Photoshop's Lens Blur palette.

FIG 2.19 Straight output from
SketchUp.

FIG 2.20 SketchUp output with
depthmap applied.

of this, I have kept using it throughout various design stages of many projects
and have so far found no substitute for it.

What is most interesting about SketchUp for me is that there are always work-
arounds for its shortcomings. I assumed, in this chapter, that the key must be
its simplicity and its pared-down nature. Because of these two characteristics
of SketchUp, I have never really encountered in the course of my work that
I haven't been able to get around.

The competition for the Te Wero landmark bridge was the largest project I
had taken on with SketchUp; hence, I did not know how well it was going to

FIG 2.21 Final image.

perform. Although we were not sure about it at the beginning, it did not take long for us to find out how to use components as Xref files. That is the beauty of this piece of software.

SketchUp does not draw beautiful curves, nor does it automatically generate extremely complex forms like many CAD packages easily do these days. But it made us work directly on our 3D models and, as a result, kept our communication flowing .Needless to say, that's the most important thing.

Resources

Software
Adobe Photoshop CS3

Sketchup Plug-ins
Podium by TBD

Restorative Urban Design for Lescar Lane Park, Sheffield, United Kingdom

Robet Playford M.A.

Robert Playford graduated in 2006 from Sheffield University, United Kingdom, with a BA (Hons) in landscape architecture with planning. He spent 2 years working in Glasgow (United Kingdom) for Mike Hyatt Landscape Architects. Robert completed his Masters in landscape architecture in 2009 and is currently looking forward to getting back to work. He has found SketchUp a powerful tool in the design process, allowing him to clearly present potential proposals that often incorporate visualization videos. SketchUp is invaluable throughout all design stages especially when one has to come up with quick and easily understandable ideas and concepts.

> **Project**: Lescar Lane Park, Sheffield—restorative urban design.
> **Software**: SketchUp Pro 6, Photoshop CS3, Piranesi 5.0, AutoCAD, and Sony Vegas.

Context

The regeneration of a site near the Hunters Bar area of Sheffield is proposed. The site currently comprises unkempt car parking and poor streetscape; but it has the potential to be transformed into a superb haven of greenery inside the city. The nearby pool hall, public houses and shops will make this a vibrant and well-used space. This design aims to add interest, color, and life to the area and to provide a space that rejuvenates the spirits of a visitor trying to escape the daily struggle of city life . The design aspires to make this area an oasis of tranquility in the center of the city.

FIG. 3.1 Aerial photograph of the site.

Aims and Technique

The project required the development of an innovative design proposal for regenerating an urban open space within the district of Hunters Bar in Sheffield. Emphasis was to be placed on a design approach that interprets elements of human experience in a spatial form; thus, a design language responsive to the aspects of human psychological functioning related particularly to orientation, place attachment, and neighborhood awareness was proposed.

Even a small space, if it has extent, can constitute a whole different world. A restorative environment permits the eye to focus on things that are inviting and fascinating without requiring any special effort. In such a setting, the mind wanders easily, absorbed by what the eye takes in and also by one's thoughts. Such mental wanderings are more likely when the setting gives the impression of having extent. Although the sense of extent is important,

the physical area need not be vast. In fact, vastness if lacking in structure and interest can interfere with restorative benefits. The Lescar Lane Park design aims to maximize the restorative benefits of the selected area using cost-effective and practical means.

Initially, I came up with a variety of rough sketches of ideas for the site using paper and pen. I find this is still the best initial design method; once I had the basic design structure down on paper, I was able to start the SketchUp model even though many design issues were still unresolved.

By creating a SketchUp model, many design problems or issues are answered in the "step-by-step" build of the model.

FIG. 3.2 Artistic impression of final design.

Why SketchUp?

The straightforward style of SketchUp is probably one of the most attractive features of this model. In just a few short hours, you can be up and running the program. In addition, in a few months, you can learn nearly all there is to know about the tool and become extremely productive. The benefits of SketchUp are as follows:

- SketchUp is very useful for quickly testing object orientation, formation, and size with the added bonus of seeing how the shadows are cast.
- Before I started using SketchUp, I would use AutoCAD when I had finalized my design and wanted to transfer it into a digital format.

In landscape architecture, this would normally take the form of a 2D plan drawing. The SketchUp is much quicker to use, and the resulting model is much clearer and realistic.

- A SketchUp model can be sent to anyone having no prior knowledge of SketchUp, and the design can be easily explored, making it much more illustrative than a picture or a drawing.
- In landscape architecture, it is important to be able to portray the design as it would look from the eye level of the user. SketchUp allows this type of view in an instant, whereas in many other programs this easy feature would be more time consuming.

Techniques Used

I found the following techniques useful in developing my model:

- The habit of using the Outliner tool is one of the most important habits to acquire. It is a very useful tool for organizing your model. Whenever you group a selection of objects, they will appear in the Outliner window. Rename this group according to preference. Later, when the model is more complex, this tool is very handy in hiding and locking certain features and in concentrating on areas that overlap. Although layers can be used in the same way, it is less user-friendly and can quickly overcomplicate a model.
- Importing files from CAD is a frequently required, and when implemented correctly, this can save valuable time and effort and ensure the starting SketchUp model is of the correct scale and fits into the specified design space. In this example, it allowed me to correctly map my design directly onto a digital map of the Lescar Lane area. (See stage 1 for a more in-depth explanation.)
- Plug-ins are invaluable and help save much time and effort. These take the form of Ruby scripts, many of which can be downloaded for free; when these files are added to the SketchUp folder, they appear in the plug-ins drop-down menu. A good Web site to find these is http://www.smustard.com. The Web site is very helpful and gives step-by-step instructions on how to use plug-ins.

The following scripts were used in my design: Weld, Nightsky, Offset, and Tools on Surface.

- The use of components within this design was very helpful. The houses that surround the park all generally look the same. Instead of creating many different houses, I simply created one house and turned it into a component; the rest was just a case of copying and pasting. Any further changes to any house will affect all connected components.
- Although this may sound obvious, it is important to make sure to regularly save your model, but with a different name/number. I usually

FIG. 3.3 Image created using the Nightsky plug-in, rendered with Piranesi.

end up with a folder of up to 40 different files at various stages of the model progression. Sometimes, SketchUp may crash, or you may delete certain objects by mistake and not notice until you have made subsequent saves. If this happens, you can easily retrace your steps to find the object in a previously saved version, copy this object, open the most up-to-date file, and use the Paste-in-Place option. The deleted object is back and in the exact location as before. No added annoyance of having to re-create the lost item.

Tip

Once a model has begun to take shape and is growing in complexity, a good tip is to toggle visibility by using the Scene Manager. Select different styles, choose which parts of the model should be hidden, and create a new scene. For instance, you may add a scene where all trees are hidden so that you can concentrate on the built design and the program speed is not affected. Likewise, you may add a scene with shadows and edge style profiles turned off to ensure SketchUp runs as smoothly as possible.

See the Scene Manager for different options for work settings that help to maximize your productivity.

Useful Model Building Help

As mentioned earlier, the Outliner tool is an extremely powerful but not easily understood organizational tool,

You can perform the following using the Outliner tool:

1. Find any name group or component within your model.
2. Change visibility of groups or components.

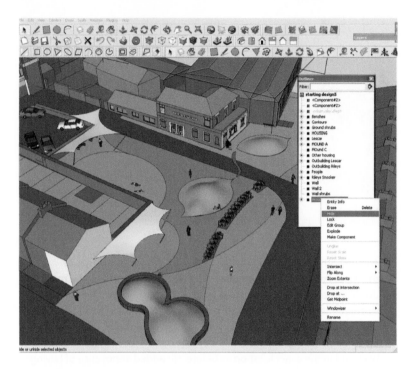

FIG. 3.4 Outliner tool in use.

3. Determine the hierarchy of any group or component.
4. Change the hierarchy of any group or component.
5. Control the visibility of your model without layers, using instance names carefully.

Helpful Tips

- Use the Outliner dialog box to make sure your groups and components have meaningful names.
- Use components for elements of your model that will be repeated.
- Use groups for elements of your model that are unique.
- Use the Outliner dialog box to control the visibility of large numbers of similar components, like furniture, trees, or people.

Stage 1: Initial Ideas and Concepts

Goal: To establish the main ideas and concepts.
Input: Brainstorming, primary sketch ideas, and site visit.
Tools :Pen and paper.

For the majority of this stage, I used brainstorming, mind-mapping, and rough sketches, and let all ideas form organically. I found that an important part of this stage was visiting the site and spending time there, getting a feel for what can be done and how different ideas may work. I looked at how people currently use the site and the nearby

shops, bars, and houses and how a decent design would improve the whole area.

Landscape architects create places for people to live, work, and play and places for plants and animals to thrive. With this in mind, it is important to put the user first and provide the best possible design to maximize the well-being of visitors coming to the park.

Stage 2: Desktop Study

Goal: To organize ideas and form design principals.
Input: Desktop study including web- and book-based research.
Tools: Pen, paper, and research material.

Following on from Stage 1, I took the initial ideas and concepts and molded them into a clearer plan with more detailed sketches, still working with pen and paper but focusing more on the practical workings of the site. These include subjects such as accessibility, circulation, facilities, and features in and around the potential design.

Stage 2 helped me form the main foundation of the design to translate clear drawings and plans from paper into digital 3D format with the help of SketchUp.

Stage 3: Pre-SketchUp Model Preparation

Goal: To prepare information for model building.
Input: Digital map information.
Tools: Microsoft Live Earth and Digimap.

This stage involved sourcing of available map and photographical data to make my model as realistic as possible and to make sure it is at the correct scale. During the time I designed Lescar Park, I had access to Digimap, which is a database of all UK maps at all scales in the digital format. This

FIG. 3.5 AutoCAD map data loaded into SketchUp.

information can be acquired from a number of Web sites but normally for a small fee. I was able to download a file in AutoCAD format.

I also referred to Microsoft Live Earth, which is similar to Google Earth but has some very detailed bird's-eye views of many city centers. This was a useful reference point throughout all stages that helped ensure buildings and facades are as lifelike as possible.

Stage 4: Importing CAD Files

Goal: To successfully load accurate map data into SketchUp.
Input: AutoCAD file.
Tools :AutoCAD and SketchUp.

SketchUp will import .dwg and .dxf file formats. Importing of files for the model was performed as follows:

- In AutoCAD, I turned off unnecessary layers such as dimensions and spot heights. Then I simplified the drawing to basic line information. I saved the simplified drawing as a new CAD file with just one layer.
- Once the imported file was in SketchUp, I clicked on the drop-down menu File, selected Import, and then selected file type under AutoCAD files (*.dwg,*.dxf). I selected my file and clicked on Options to make sure the scale unit of the CAD file matched the unit of the SketchUp model.
- First, I checked the size of the imported plan with the Tape measure tool to check if the scale is correct. As an example, consider door frame/car-parking space. You can use the Tape measure tool to resize the model

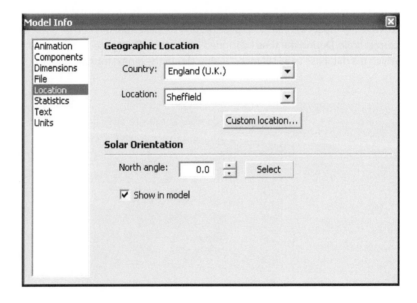

if it is incorrect. With the Tape measure tool, click the two ends of a line whose length you know. Put the real-life values in VCB and ENTER options. Answer "yes" when you are asked "Do you want to resize the model."

- Next, I selected the whole base map, turned it into a group, and renamed it suitably for later reference. Often CAD-imported files may have gaps between lines that make it difficult to form shapes. So I locked the base map and traced over this map, which helped to easily create shapes on a different, unlocked layer.
- I lined up the resulting group with the axis to ensure north direction is correct. Then I used the Rotate Q icon tool. This ensures the shadows appear correct. In model options (drop-down menu Window>Model Info), you can chose the geographical location of the site to ensure shadow accuracy. You can specify the north orientation either by typing the value or by choosing Select option to place it manually in your model. You can display the north orientation by clicking on the checkbox titled Show in the model.
- Sometimes, the CAD import will bring in extra layers. I normally go to layers and select all layers apart from Layer0, delete them, and choose the button Move contents to default layer. Thus, all the imported geometry is moved to the default layer. Next, I create a new layer named BASEPLAN and then move the base map group via the entity information to this layer. This is useful as a reference and, as mentioned earlier in this section, to trace over.

Review

- import CAD file, and check options.
- Checksize of import.
- Group the plan.
- Line up the plan with axis – north point with rotate tool.
- Delete extra layers, and place group on new layer.
- bck group, and use for reference.

Stage 5: Building Initial Model

Goal: To lay down the basic foundations for model construction.
Input: Blocking in building footings.
Tools :Line tool.

I began the building of this model by first removing unnecessary lines from the imported CAD file, basically cleaning my canvas and making it ready to use. Then I blocked in the shapes of all building footings. By locking the base map layer, I was able to trace on top of this map.

FIG. 3.6 Building footings blocked in.

Stage 6: Building Details

Goal: To build up the surrounding landscape around the proposed design site.
Input: Basic building construction using groups and components.
Tools: SketchUp's primary tools, that is, Line, Shapes, and Push/Pull.

With all the building footprints in place, I am ready to build the walls and roofs. In some cases, this means a simple use of the Push/Pull tool; but with more complex buildings, construction may take longer and require more facade detail.

All the surrounding housing in this design is very similar; so to save time, I used SketchUp's component feature. I created a detailed house with doors, windows, roof, etc. I then selected all the lines and sides of the building, and then right-clicked and chose Make Component from the context menu. I then copied and pasted this new component and added the required houses. Components are very useful because if you change something on one of the houses, the change will take place on all of them. For instance, while creating my house component I forgot to add a chimney; by simply double-clicking on one component and adding a chimney, this additional feature was added to all houses. If you want to make changes to only one component, right-click and choose Make Unique from the context menu. By using this option, changes to a component will apply only to the unique entity.

Tip

Components save time and effort. Minimize your work time by turning similar objects into components. When a change is made to one object, the change will be made to all components. This is useful when working with a constantly changing design.

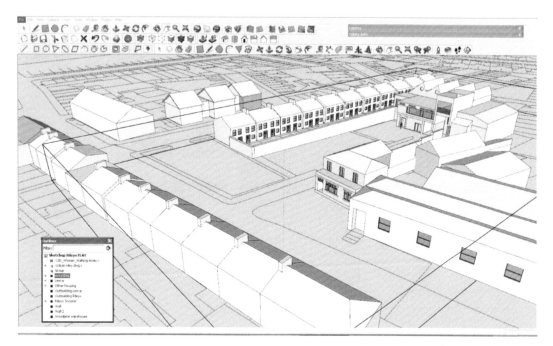

FIG. 3.7 Buildings in place, and house components in group (see bottom left).

Stage 7: Building Grouping

Goal: To organize the model efficiently using grouping and to add extra buildingdetail.

Input: Grouping and additional model detailing.

Tools: Plug-ins such as Windowizer and Roof.

Throughout my project design, I chose to design the existing surroundings first and then move on to putting my ideas from paper into SketchUp. With more buildings and details added to the model, it can become trickier getting round your model. It is very useful to be able to hide certain areas of your model to simplify your view and make model building easier. As touched on earlier in the section "Useful model building help," the Outliner tool is great for organizing your model. It is possible to group like objects and rename them with entity information or directly in the Outliner window. All buildings were put into different groups and could be hidden by the click of a mouse, which is very useful when objects overlap or your model view is obscured.

During the design phase, I used two useful plug-ins: The first is called Windowizer, which helps to create impressive windows on any surfaces with a variety of options for layout configuration. The second one, Roof, helps to create roofs of all shapes and sizes.

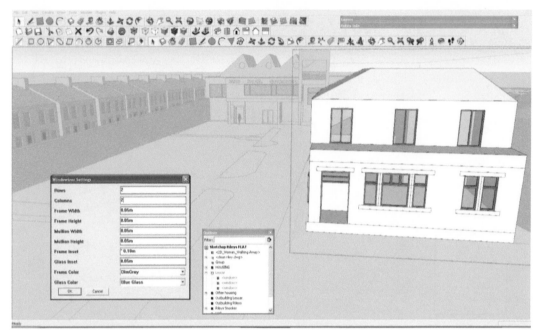

FIG. 3.8 Right-click on a surface and follow the Windowizer plug-in options.

FIG. 3.9 Gradient angle for design site.

Stage 8: Implementing Gradient

Goal: To implement the correct gradient angle for the site.
Input: Spot heights from digital map data.
Tools :Rotate tool.

With the majority of buildings in place, I turned my attention to the gentle slope on the site. In hindsight, I should perhaps have dealt with this earlier, but thanks to the gentle gradient on site it did not pose a serious problem. By taking spot

heights from the digital map data, I worked out the angle of the slope and turned the whole model floor about the *Y* axis using the rotate tool. Some buildings had to be slightly rearranged, but this took only a small amount of time.

Stage 9: Mapping Boundary Design Lines

Goal: To map out design lines and edges.
Input: Drawings in primary design lines used to build on later.
Tools: The plug-in Tools on Surface and SketchUp's basic drawing tools.

The Tools on Surface plug-in is invaluable for drawing on angled or curved surfaces. This plug-in features an additional toolbar that is automatically added to the original SketchUp toolbars. I used this toolbar to map out all edges, paths, lines, and surfaces. I was now ready for more landscaping detail.

Tip

Save, save, and save again. After many painful lessons of losing large amounts of the model through not saving changes, I now save at regular points and always change the name of the file. This is very useful for retracing your steps in the unfortunate circumstance of a computer crash.

FIG. 3.10 Design lines mapped easily by hiding other grouped buildings.

Stage 10: Landscaped Mounding

Goal: To create realistic earth mounding.
Input: Turning contours into landscaped mounds suitable for the park.
Tools :Sandbox tools.

For these features, I copied the specific shape for the landform into a new SketchUp file. Then I used the From Scratch tool from the Sandbox toolbar to create a rectangle big enough to fit my shape.

When creating this grid, make sure the grid spacing is sufficiently small – the smaller the grid spacing, the better the detail available for the final mounding. I changed this by typing the required spacing in the text box found at the bottom right-hand corner of the SketchUp window. I then copied the landform base shape, and the shape was hovered directly above the grid.

I right-clicked on the grid and selected "soften/smooth edges," turned on soften coplanar and dragged the soften bar to the right.

I selected the surface above the grid, clicked on Drape, and then selected the grid below . I deleted the raised shape. Further, I double-clicked to edit the group containing the grid. Now, I edited the grid just leaving the shape of the landform and deleted any extra lines. By double-clicking on this area, it acts like a sandbox area. To mould the landform, I then used the Smoove tool.

Stage 11: Canopy Creation

Goal: To create interestingly styled canopies.
Input: Base shape for the canopy taken from main model.

FIG. 3.11

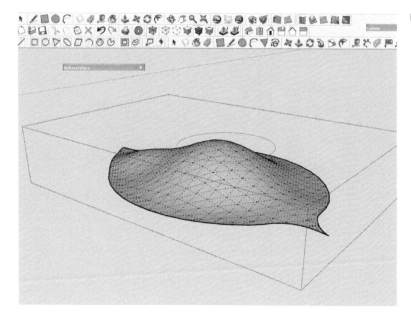

FIG. 3.12

Tip

When smooving, a good tip to create realistic landforms is after raising a point to a certain height, hover over a nearby point and double-click, as a result of which SketchUp will match the new point at the exact height. This is good for making earth bunds, ditches, and even more surfaces.

Tools: Tools on Surface plug-in and the Sandbox tool, From Contours.

In this stage, I used a simple method to create some interesting canopies. I started by taking the base plan for the shape of the canopy I wanted to create, and copied this to a new file. Then, using the Push/Pull tool, I gave the shape height and then drew curved lines on the object's sides using the Line on Surface option of the Surface Operation plug-in's toolbar.

I then deleted the box shape and all lines except the curved lines. I was then left with just the curved lines; I selected them all and then used the From Contours tool. This formed a canopy.

At this point, I turned on hidden geometry and tidied up any edges that had overlapped during the contour creation. I was then left with a unique shape for my canopy.

Tip

During this procedure, ensure all lines are in contact with the shape; else, the resulting canopy shape will not work correctly.

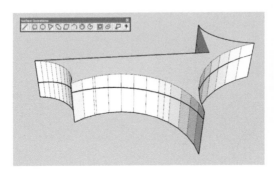

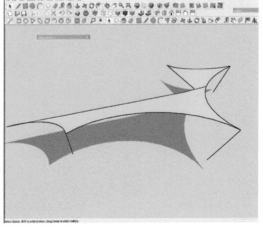

FIG. 3.13 Canopy creation.

FIG. 3.14 Canopy creation.

Stage 12: Fine Detailing

Goal: To add finishing touches to model to enhance realism.
Input: SketchUp warehouse objects.
Tools: SketchUp warehouse and the import tool.

In this stage, I added things such as vegetation, textures, model furniture, etc. All these elements helped to bring the model to life. SketchUp's 3D Warehouse is very useful for acquiring elements like benches, lamp posts, and vegetation.

FIG. 3.15 Addition of fine detailing.

FIG. 3.16 Watercolor rendering with more lifelike trees added.

Stage 13: Model Completion – Rendering

Goal: To create high-quality images of the model.
Input: The best angle for decent image exports that best demonstrate the park.
Tools :Piranesi.

With the SketchUp model complete, it was time to create some high-quality design images of the model. For this, I used a software tool called Piranesi. Piranesi is an exceptional piece of software that allows users to create single image renderings. These images can be photorealistic or similar to traditional commercial art such as watercolors, pen and ink, tempera, etc. The possibilities of Piranesi are infinite. Its ability to incorporate entourage with depth and to add artistic effects and fills without masking are unsurpassable. SketchUp models lend themselves particularly well to creating the geometry needed for an artist to create stunning works with Piranesi. Piranesi is not in competition with 2D visualization programs; it is an art medium where each artist creates unique images and develops his or her own style over time.

FIG. 3.17 Watercolor effect rendered with Piranesi.

The following steps explain the method I used to export a SketchUp file for editing with Piranesi:

1. Ensure that your SketchUp model is complete with all materials applied; this will assist in the Piranesi painting process. Spending time on creating detailed models will provide opportunities to capitalize on during the rendering process with Piranesi.
2. When your model is complete, compose your view to be rendered with an expectation of how the final rendering will look like. Pay attention to shadows and depth, and highlight points of interest. Generally speaking, renderings with the subject located slightly off center are more dynamic than those with the subject directly in the center of the view.
3. The checklist prior to exporting .epx files is as follows:
 a. Turn off "display edges" in the Styles dialog box under the Edit tab. Natural objects do not have lines at every edge or corner. Shadows and subtle changes in color will indicate to the viewer where the edges or transitions are. You can repaint the edges in Piranesi if needed during the rendering process.
 b. Turn on shadows and adjust to create drama in the image. Ensure the subject is primarily in direct sunlight with the shadows falling to the sides and/or back.
 c. SketchUp is usually displayed with the camera set in Perspective mode. As an artist, it is up to you to decide if the camera option Two-Point Perspective creates a better view.
 d. Note that your view cannot be changed once exported and the axis will not be displayed in Piranesi.
4. Exporting to a Piranesi .epx file:
 a. Select the drop-down menu "File>Export>2D graphic" in SketchUp. This will open up a dialog box.
 b. Within this box, designate the new file name and destination using standard conventions of Microsoft Windows. Select the Export Type and pick Piranesi Epix (*.epx) option.
 c. Click the Option button to enter into the parameters for this .epx file.
 d. It is recommended to uncheck the Use View Size box and input a width of 4800 pixels; the height in pixels will automatically adjust. This number of 4800 pixels will yield a 300 dpi image on an 11 × 17 (A3) page with a ½' border all around (16' × 300 pixels per inch = 4800 pixels width for this .epx file). This file size also prints well on 24' × 36' posters (A1). This pixel number works in most cases, or you can adjust as needed.
 e. Ensure the Export Edges, Export Textures, and Export Ground Plane boxes are checked.
 f. Click on the Okay button and then the Export button. This will generate the exported .epx file that is to be used in Piranesi.

The rendering process for Piranesi is not a short tutorial. The video sessions that come with the software are extremely informative and explain the software features very well. It is easy to get the hang of the software, and like many other software packages I find the best way to learn Piranesi is to use it

and play around with different tools. Piranesi also allows you to add lighting to models, which is very useful for nighttime visualizations.

FIG. 3.18 Piranesi color pencil rendering.

Stage 14: 3D Visualization Video

Goal: To create a video to better visualize the park.
Input: Piranesi images and SketchUp fly-through videos.
Tools :Sony Vegas.

I chose to also create a 3D visualization video as part of my final presentation for Lescar Park to give a real feel of what it would be like to walk around this outdoor space. SketchUp allows you to export video clips. To create a video clip, simply use the Scene Manager and select different movement locations; SketchUp will flow from one point to the next. I exported a number of videos from my model and then I was able to edit them into a full feature video by using Sony Vegas, a video editor that is easy to use.

Tip

Try and export shorter clips, especially if you want higher definition. I found the rendering time for many clips was certainly very long and put quite a lot of stress on the computer; on a number of occasions, it caused computer crashes.

So, to avoid such issues keep clips small; they can always be edited together later.

Conclusion

SketchUp has certainly helped me a great deal in modeling the park design; it allowed me to perform the following functions:

- Communicate my ideas in a clear and precise way.
- Maximize my productivity, as well as helping in the creative process.

FIG. 3.19 Another Piranesi rendering from the SketchUp model.

FIG. 3.20 Watercolor rendering.

- Create impressive visualizations to help paint a picture of the design.
- Use a versatile tool to solve a whole variety of design problems.
- Create a realistic preview of walking through the site via video animation.

Resources

Software
Photoshop CS3: From http://www.amazon.co.uk (about $200)
Piranesi 4: From http://www.cadpointdirect.co.uk (about $700)
AutoCAD LT 2005: From http://www.amazon.co.uk (about $750)
Sony Vegas 7: From Dv247.com (about $750)

Plug-ins for SketchUp
All plug-ins mentioned in the chapter are found at
http://www.smustard.com

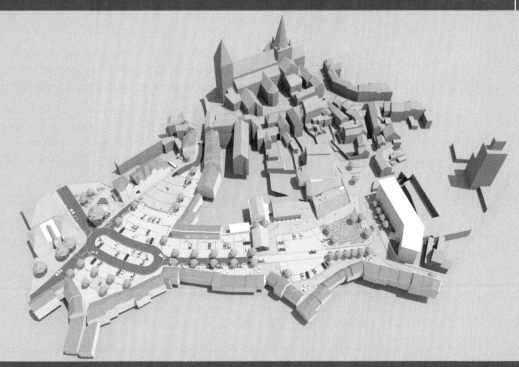

Redevelopment of Place Van Zeeland, Belgium

Nicolas Rateau

Nicolas Rateau graduated in landscape architecture in 2005 and quickly found himself a place in the Poly' Art practice as a project assistant. To better communicate the projects in which he took part, he decided to plunge into the universe of 3D modeling and turned to SketchUp. He quickly realized the program's potential for his work as a landscape architect, and SketchUp has become for him the perfect decision-making tool in facing ever-present time constraints and a wide client base.

Project: Redevelopment of Place Van Zeeland for the town of Soignies, Belgium
Tools: SketchUp 7, plug-ins, AutoCAD LT 2007, Kerkythea

This development project for Place Van Zeeland was carried out by Hugues Sirault of the Poly' Art design office under a government works contract issued by the city of Soignies in 2005. It formed part of an urban redevelopment project for the center of Soignies. The project meant many modifications to the square, and given the sensitive historic and social context of the redevelopment, a 3D model soon proved itself indispensable.

The production of a model of the existing square, the proposed development, and a video showing various perspectives allowed the Poly' Art practice to explain the project to the client and to gain approval from local residents.

The redevelopment project for Place Van Zeeland was carried out within the framework of an urban renovation initiative at the heart of the historic center of Soignies in Belgium. The model enabled us to gain approval from the clients and the residents and was a key tool in communicating the aims of the project to all concerned.

Project Context

Parking is the biggest problem in Place Van Zeeland, a consequence of its irregular, organic development over the course of its history. With a steady fall of 4 m from east to west and with building façades of varying orientations and from various periods in history, the square was very difficult to read. The project brief allowed for a reorganization of the entire square and the creation of new, clearly identifiable subzones.

Since the organization of the square was somewhat chaotic and changes are often difficult within a particular historic and social context, it was vital that we were able to communicate the project to all concerned – both the client and the residents of Place Van Zeeland.

The adoption of 3D so early in the project was done so that we could use the model as a means of communication and also as a tool to assist in taking internal design decisions. The modeling tool should, therefore, be easy to learn and have the capability to evolve with the needs of the project.

The choice of 3D modeling software depended on several factors:

- It should be able to import AutoCAD files to use as a basis for modeling.
- It should be able to model terrains efficiently and quickly.
- It should be easy to understand and have as short a learning curve as possible.

Why We Chose SketchUp?

SketchUp's ease of use and intuitive nature is almost disconcerting when you are used to other 3D software. In a professional context, where 3D training is not always possible because of time and money constraints, SketchUp is an indispensable asset and quickly finds its place in the production pipeline.

SketchUp has one extremely efficient tool that is a must-have for any landscape architect, the Sandbox. It enables you to make any terrain model quickly and precisely. The other decisive factor in the choice of SketchUp is its active and productive user community. This community contributes to the

development of numerous complementary plug-ins for SketchUp that soon become indispensable if your goal is efficiency and precision.

In this chapter, I will be revealing the working method of the Place Van Zeeland project from beginning to end, a method that is the fruit of experience garnered from various projects and of the desire not to forgo precision for productivity.

Technical Aspects

The original modeling for the Place Van Zeeland project was done with SketchUp 5, using very few additional plug-ins. Since then, however, the number of plug-ins has grown considerably. They greatly increase SketchUp's productivity and efficiency, either by implementing functions not present in the original program or by offering versions of SketchUp's tools that are more capable. To bring this project together, I used the entire suite of plug-ins that I use regularly in my day-to-day work:

- Projections version 2.0 (by Didier Bur): This plug-in allows you to extrude edges along an axis defined by a user.
- Joint Push Pull Visual Edition (by Fredo6): This plug-in improves and complements SketchUp's Push/Pull tool.
- Tools on Surface (by Fredo6): This plug-in allows you to draw and create extrusions on complex surfaces and to go back and edit them.
- Three Line Tools (by Chris Fullmer): With one simple click, this tool allows you to create vertical lines at a specified height or elevation.
- Front Face (by Tomasz): This plug-in automates the process of flipping backwards/facing faces in SketchUp.
- Drop to Intersection (by TBD): This plug-in allows you to drop components on any angled surface.
- SU2KT: This plug-in allows you to set parameters for, and to export to, the free Kerkythea rendering engine.

New Approaches

Nicolas Rateau: "This project demonstrates how landscape architects and others involved in terrain development can use SketchUp to model their projects, and how they can discover the capabilities of SketchUp's Sandbox tool and the potential of the main plug-ins to produce precise terrain models in a reasonable amount of time.

I divided the modeling work into four stages:

1. Gathering the necessary data for modeling
2. Preparation of the template files and import into SketchUp
3. Actual modeling work
4. Production of some simple scenes for export into the Kerkythea renderer

FIG 4.1 SketchUp's Sandbox tools.

In addition to the mouse and keyboard, for all my modeling work I used 3D Connexions' Space Explorer, a peripheral that allows me to navigate efficiently around the model. In addition to the main joystick, it has several programmable buttons to which you can assign SketchUp's tools and commands."

Stage 1: Gathering the Data

Objective: To bring together all the information needed for modeling
Data: Plans of the project area, photographs of the site and of the built context, surveys of the heights of the cornices of buildings surrounding the square, aerial photograph of the site
Tools: Pencil sketches, laser telemetry to measure the buildings surrounding the square, digital camera

First of all, a visit to the square and produced thorough notes of all the visible elements that needed to be modeled. Once the notes were done, the survey of cornice heights and the photographs of the square allowed the modeling of the existing elements that would be conserved throughout the project: buildings, spaces bordering on the square, street furniture or street lighting, etc.

The aerial photograph, taken from the community digital photograph survey provided by the region of Wallonia, provided additional information on the front-to-back depth of the buildings.

After this data was collected, two versions of the project plan were prepared:

- A paper version on which all the necessary levels for modeling the project were marked.
- A digital version in DWG format for import into SketchUp, which would serve as a template for modeling.

Stage 2: Preparation and Import of Plan Files

Objectives: Optimizing the files to be imported into SketchUp and adjusting the import properties
Data: Dimensioned drawing of the square
Tools: AutoCAD LT to prepare the file in DWG format

To make the template, all the existing line drawings of the square were merged into a single file. In order to cut down on the file size as much as possible before it was imported into SketchUp, all the nonmodeling elements were deleted. All the line elements were then transferred to a single layer. The file was then purged in order to delete all inessential information: empty layers, unused blocks, external references, etc.

Once the file was saved, it could be imported into SketchUp. In SketchUp's menu bar, go to File > Import; from the drop-down menu in the resulting dialog box, choose ACAD Files (*.dwg, *.dxf), and click on the Options button. In the dialog box that appears, choose meters as the unit from the Scale drop-down menu and click on OK twice. The file is now ready to serve as a template for modeling.

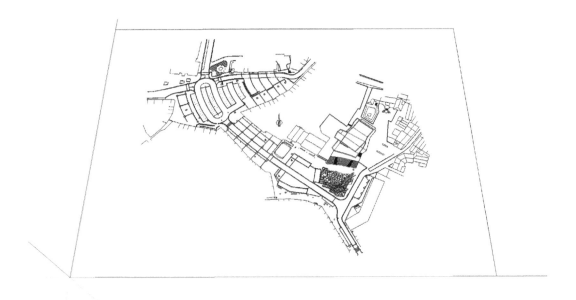

FIG 4.2 Imported project template.

Stage 3: Modeling the Project

Objectives: Modeling the entire square and organizing the elements of the model
Data: Paper plan of the project with levels; color swatch chart for the materials; supplementary components for the project entourage such as vegetation, street furniture and lighting, vehicles, and pedestrians
Tools: SketchUp, plug-ins, Google 3G Warehouse online component library

To model the whole of the projected terrain, the square was divided into logical subgroups such as roadways, sidewalks, and esplanades, which were further subdivided according to different material types or sudden changes in level (curbs, terraces, etc.).

Sidewalk curbs and any other structures were modeled and combined with the previously created surface to obtain the final terrain model.

Stage 3.1: Surface Modeling

The surfaces were modeled one-by-one in the following stages:

1. Contour elevations
2. Surface modeling
3. Any necessary retouching followed by application of materials

In order to set up the contour elevations of the surface, I used Chris Fullmer's Three Line Tools plug-in. By clicking on the Vertical Lines by

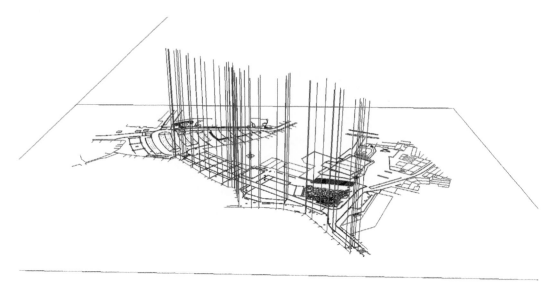

FIG 4.3 Elevating the contours with the Three Line Tools plug-in.

Length option and then on a point in the model, one can enter the elevation height of the line directly in the VCB. Then you just need to hit Enter to set the elevation of the line. I followed the same procedure for all the points that described the boundary of the square and for all the intermediate elevation points that were necessary to model the precise contours of the square's surface. In order to model the square's surface, I joined all the elevation points of the perimeter using the Line tool, and then deleted the perimeter verticals.

As there were not enough perimeter verticals to properly describe the curve of the square's perimeter, the following method was used: The curve shown in Figures 4.4–4.6 corresponded to three perimeter verticals, so the tops of these were joined using the Line tool. Then, by using the Line tool again, a line was traced in the X (red) axis from the lower perimeter vertical back to the middle perimeter vertical, forming a triangular surface. The same was done for the higher perimeter vertical (Fig. 4.5). This resulted in a triangulated surface that represented the fall across the two ends of the curve.

The Extrusion function of the Projections plug-in was used to extrude the curve on the DWG-derived plan so that it intersected with the newly created triangular surface (Fig. 4.6). Both the extruded curve and the triangulated surface were now selected and intersected using the Intersect Selected function (right-click on the selection and choose from the contextual menu). The extruded and triangulated surfaces were then deleted, leaving only the curve. This process was repeated for the entire perimeter of the square.

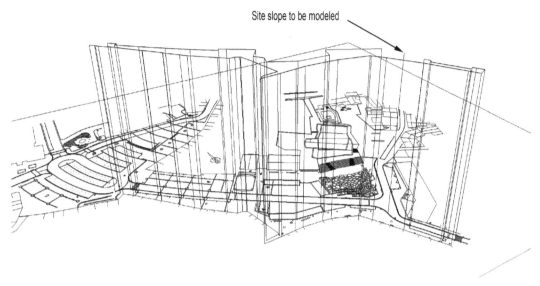

FIG 4.4 Parts of square's outline to be modeled.

FIG 4.5 Modeling the slope of the curve.

The entire perimeter was then selected, as well as any isolated verticals. Then, from the Sandbox tools, From Contours was selected. After a short wait for the calculation, the surface was created and automatically grouped.

67

FIG 4.6 Intersecting the slope with the outline.

FIG 4.7 Perimeter of the surface, raised off the plan.

Tip

The Sandbox tools only work with contours: They will not work with a cloud of isolated elevation points. You can get around this limitation by using vertical lines whose ends correspond to the isolated points. The Sandbox will then take these vertical lines into account when generating the surface, but will ignore their lower extremities.

FIG 4.8 Surface generated by the Sandbox tools.

With complex surfaces, the Sandbox tool often generates faces outside the perimeter of the desired surface. To delete these faces, you can enter the surface group and, from the menu bar, choose View > Hidden Geometry. This allows you to see any hidden edges that lie outside the contour surface. You can then delete these using the Eraser tool.

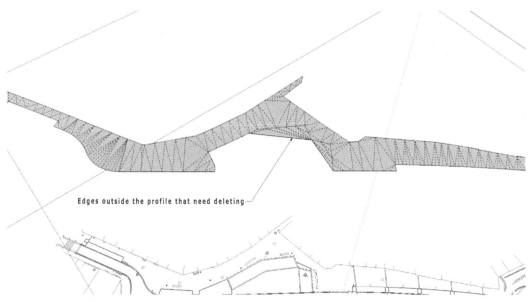

Edges outside the profile that need deleting

FIG 4.9 Cleaning up the faces outside the perimeter.

The surface was then assigned a color using the Paint Bucket tool. At this stage, you can Copy–Paste the surfaces just created into a second model inside the same file. This way, you can get the already created surfaces out of your way and begin drawing the next surfaces using the imported DWG file as a template. Any previously created contours can be easily reused if required. The bounding box around the model can also be used to put elements back rapidly and without error.

FIG 4.10 Surface moved to one side, given a material.

Stage 3.2: Modeling the Curbs

The curbs were modeled directly from the Sandbox surface derived in the previous stage, which represents the sidewalk. The edges of this sidewalk surface were selected and, using the Extrusion function of the Projections plug-in, the entire pavement surface was extruded in the Z axis up to the curb height (see Fig. 4.11). The Projections plug-in must be used here because SketchUp's normal Push/Pull tool works only on planar faces.

FIG 4.11 Extrusion of the edges of the curb.

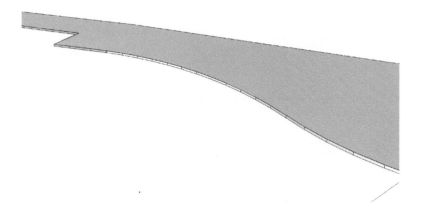

Often, this extrusion generates polygons with flipped faces – the blue back faces will point outward. For final rendering in Kerkythea, it is essential that all faces in the model have their front face showing; otherwise, Kerkythea it will not "see" the surface. The Front Face plug-in was used to flip the faces back again: By simply running the cursor over the flipped faces, they are flipped back automatically. Then you can just click on the Select tool to terminate the Front Face operation.

The Tools on Surface plug-in was then used to carry out an Offset on Surface operation for the part of the sidewalk surface that corresponds to the width of the curb. Since the offset operation is carried out all around the perimeter of the surface, the Line on Surface and Erase Contours on Surface functions of the plug-in should be used to correct any discrepancies in the offset.

FIG 4.12 Offsetting the curb.

The next stage was to create the underside of the sidewalk, corresponding to the width of the curb and the vertical extrusion corresponding to its height. These elements were selected and grouped, separating the sidewalk surfaces from those of the road.

FIG 4.13 Isolating the faces of the curb in their own group.

The same steps were taken to model stepped terraces as for the modeling of the surfaces and the curb, with the apron of each terrace being modeled like a surface and the risers between each terrace step being modeled like a curb.

FIG 4.14 The modeled terraces.

Stage 3.3: Modeling the Buildings and Other Built Elements

At the center of the model of Place Van Zeeland, three types of buildings had to be constructed that corresponded to three levels of detail, based on the size and the function of the buildings. The residential premises were modeled very quickly, since their role in the model was to show the sizes and the different sorts of openings in the façades that surround the square.

Another architect modeled the building that faces the amphitheater, imported it into SketchUp, and cleaned it up to reduce its poly count as much as possible. Materials were then applied to this model according to the color chart that was put together from on-site photographs.

The former school was modeled in more detail, since it has a very imposing presence at the southeast of the square. The same was done for the school near the covered market, reproducing the characteristic rhythm of the fenestration on the main façades.

FIG 4.15 The model of the cultural centre.

FIG 4.16 The model of the school.

FIG 4.17 The model of the former school.

The covered market, which was one of the centerpieces of the project, had been modeled in some detail since the preproject stages because of its central role in the regeneration of the square and because we wanted to put particular emphasis on its final appearance, particularly on its white-painted, tubular-steel framework (see Fig. 4.18).

FIG 4.18 The model of the covered market.

Stage 3.4: Adding the Entourage

Placing the discrete elements from the project (education, vehicles, pedestrians, and street furniture) can be fiddly and time consuming, especially if you have a lot of complex components.

Here, the positions for each type of component were marked out by using basic forms, like simple cubes. For each type of component (trees, pedestrians, etc.), a basic symbol was defined that could be placed quickly and easily into the model. This means SketchUp's graphical display does not slow down while you are working with it.

Once all these basic placeholders are in the scene, they can all be replaced by their more complex counterparts. Simply right-click, and from the contextual menu choose Reload option. Then select the replacement component from the window that opens.

If you want to work with components, you can generally find anything that you want in Google's 3D Warehouse. Any components that do not fit your needs exactly can always be reworked in SketchUp to suit your working methodsand your graphical style.

FIG 4.19 Putting in the placeholder components.

Tip

Placing components precisely on complex surfaces can prove to be difficult, mainly because of SketchUp's inference system, which can sometimes get in the way. The Drop to Intersection Ruby plug-in makes this operation easy, allowing you to drop components placed above a surface directly onto it.

FIG 4.20 Model updated with the final, detailed components.

Stage 3.5: Assigning Model Elements to Layers

If necessary, the surfaces generated can be subdivided by projecting the outlines of drainage channels, paving borders, and other landscaping elements from the imported DWG. This can be done by using the Project function from the Sandbox tools: Select the template DWG, click on Project, and click on the surface to be subdivided. At this stage, you can explode the initial surface group and regroup according to your newly created surfaces.

Since each group is associated with a particular material, the model was organized using SketchUp's Layer by Material option. Additionally, naming each group as you create it enables you to more easily find your way up and about within your model using the Outliner palette (from the Menu, choose Window > Outliner).

There is also a plug-in called Layer Manager that offers some additional options for the management and use of layers in SketchUp. In our practice, we increasingly use this plug-in on complex models like the Place Van Zeeland project.

Tip

The Project function from the Sandbox tools should be used only with caution: If too many elements are selected, it can cause SketchUp to crash. You should always save your model before using Project, and if the operation does not work as hoped at first, you can run it multiple times on the same surface to achieve the desired effect. If the same problems occur repeatedly, you can use the Extrude Edges function of the Projections plug-in, intersecting the extruded faces with the target surface.

Stage 4: Rendering Scenes in Kerkythea

Objectives: Preparing the scenes and the animation path for export into Kerkythea
Data: Color swatch chart based on the materials used in the project
Tools :SketchUp and Kerkythea

FIG 4.21 SketchUp's shadow settings palette.

For the Place Van Zeeland project, a simplified color swatch chart was chosen based on a unified range of colors. The level of detail in the project did not justify the use of more realistic textures; furthermore, photorealism was never the goal of this model.

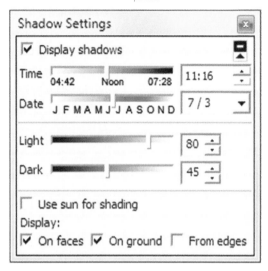

Scenes were created in SketchUp that corresponded to particular views that we wanted to render in Kerkythea. Features like the time of year, day, and shadows were then defined by clicking on the Shadow Settings icon (see Fig. 4.21). For specifying shadow settings on the Mac, from the Menu Bar choose Window > Shadows. Once all these parameters were set, the scene was added to the Scenes palette by clicking on the "+" button.

Once all the various scenes were created, the model was sent down the pipeline to Kerkythea by clicking on the Export Model to Kerkythea icon. In the dialog box that appears, click on YES to choose the options Exported Geometry and Export Lights. You should choose NO for all the other options, and then click OK. Now it is just a question of choosing an appropriate filename and clicking on the Save option. Once the export process is complete, the model can be opened directly in Kerkythea.

FIG 4.22 Kerkythea's dialog box for rapid rendering setup.

Rendering can now be started directly: From the Menu Bar, choose Render > Start. Parameters can also be set from the Camera and Settings window. For the Place Van Zeeland renders, the Ambient Occlusion setting was chosen, since this gives a good approximation of radiosity without the time and calculation overheads.

Kerkythea offers many more advanced photorealistic rendering possibilities, should you need them. It can also be used for the creation of walk-through animations: Kerkythea simply takes the scenes that are stored in the imported file and uses them as keyframes, "tweening" all the intermediate frames as necessary.

In our practice, SketchUp fits perfectly into our production pipeline: First, it imports AutoCAD DWG files directly. Also, if you are a landscape architect, its tool set, enriched by the plug-ins created by and for the user community, gives you a terrain modeling tool that is almost made to measure. SketchUp is really unmatched in efficiency and in the intuitive nature of its tools. Its approach to modeling still lets you retain the feel of traditional, hand-sketched design and is extremely easy to understand.

Still, at the end of the day, SketchUp has its limitations: As models grow in complexity, they can start to slow the program down; navigation and working on the model can become difficult, even on the most high-end graphic workstations. The limitation lies in the software, and not in the hardware.

Dealing with shadows can often prove problematic. With a complex model, shadow calculations can take several seconds, which means that navigation in real time can soon become all but impossible. On top of this, there is a bug at the heart of the OpenGL rendering engine that can create artifacts whenever a component finds itself between the camera and the source of illumination. Luckily, Kerkythea is not plagued by these problems.

FIG 4.23 View of the southwest corner of the square toward the amphitheater.

Originally intended as a tool to demonstrate the preproject design to the client, over the course of the project the model proved itself to be an indispensable means of communication on numerous occasions that we had simply not foreseen, such as meetings with other residents, project

planning, and phasing of works. Finally, it was instrumental in the town being awarded second prize in a competition organized by the Walloon Land Development Ministry for recognizing the best project among subsidized community projects.

FIG 4.24 View of Place Verte, with Place Van Zeeland in the background.

FIG 4.25 View of the square looking toward the former school.

FIG 4.26 Panorama of the final, constructed terraces.

FIG 4.27 Photograph of the covered market under construction.

FIG 4.28 View of the cultural center seen from the terraces.

Resources

Atodesk AutoCAD LT 2007
Kerkythea Echo Render Engine 2008 (free): Available at:
http://www.kerkythea.net
3D Space Explorer peripheral : http://www.3dconnexion.
com/3dmouse/spaceexplorer.php
Plug-ins (All free unless otherwise stated)
These plug-ins are available on the SketchUp community forums,
http://forums.sketchucation.com/ and on the CRAI-ENSAN site, http://
www.crai.archi.fr/RubyLibraryDepot/Ruby/fr_RUBY_Library_Depot.
html or on http://www.smustard.com
Projections version 2.0 by Didier Bur
Joint Push Pull Visual Edition by Fredo6
Tools on Surface version 1.3 by Fredo6
Three Line Tools by Chris Fullmer
Drop to Intersection by TBD
Font Face by Tomasz ($10).
Layer Manager by Didier Bur

Engineering

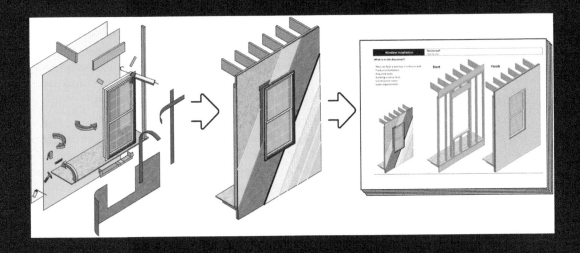

A Window Installation

James Steacy and Lauren A. May

James Steacy has a Bachelor of Architectural Science degree with a specialization in building science from Canada's Ryerson University. Today, he works for a company based in the United States that focuses on helping homebuilders improve the quality and performance of their homes. There, he is implementing a new approach to creating construction procedures using SketchUp.

Lauren A. May has a Master of Arts degree in Professional Writing from Carnegie Mellon University in the United States and a Bachelor of Arts degree in English with a concentration in professional writing from Virginia Tech. She has spent years collaborating with homebuilding experts and technical illustrators to produce content that is clear and concise and can be leveraged.

> **Project**: Documenting a Window Installation.
> **Tools**: SketchUp Pro 7, LayOut 2.0, Adobe Photoshop CS4, and Adobe Acrobat 9 Standard.

A Window Installation is a project whose core focus is to create a document that takes someone step by step through the process of installing a window in a home. The document, known as a step-by-step document, uses a

combination of words and images to successfully convey the proper techniques and processes to install the window from start to finish.

The audience of the step-by-step document is construction trades, the individuals on a construction site who build different parts of the home. Trades want practical, straightforward, and logical information that allows them to quickly grasp each step of the installation. They particularly favor using documentation that is heavily image-based and has minimal wording.

Two types of people collaborate to create a step-by-step document – a technical illustrator, James, and a technical writer, Lauren. James works on SketchUp and LayOut to create the illustrations and assemble the final output, and Lauren leads the planning, interviewing, and storyboard processes, assembles the text, and ensures the final output is consistent and correct.

The amount of time and effort it takes to complete a step-by-step document varies depending on the length and technical difficulty of the subject matter. Typically, one-third of the time is spent on modeling, one-third on writing, and one-third on document layout. The total amount of time we spent on this step-by-step document was approximately 24 hours, which included several stages of revisions. Our budget was just under US$2,000.

Project Context

The situation that surrounds a step-by-step document usually involves a homebuilder who is either proactively looking to instruct his/her trades on proper construction techniques or reactively seeking documentation on how to repair installation errors that were already made. Sometimes, a step-by-step document is part of a package of documents sent to the homebuilder; the package may have a scope of work, a checklist, and a specification sheet in addition to the step-by-step document.

Our four major constraints during the project were as follows:

1. **The varying availability of knowledge**: The subject matter expert brings a significant amount of knowledge to the step-by-step document but may not know the answer to everything. The ideal situation occurs when the expert's knowledge encompasses a subject, and he or she is able to clearly explain the steps from start to finish. Usually, most of this information is gleaned during the storyboarding, interviewing, and review/revision stage. It is realistic to expect that the expert will need to consult personal research, engage in discussions with colleagues, and conduct multiple reviews of drafts, and so it is important to build buffer time into the development schedule, particularly during the review/revision stage. In our experience, it is during this stage that experts really excel because they have a concrete object – a print or digital copy of the document – to focus on and critique.
2. **The limited resources**: Time, money, and people are not always available to create a document that reaches the highest level of quality possible.

For example, limited time to complete a model could lead to a quick decision between spending time to create a realistic building material texture using a scanner and Adobe Photoshop and taking the faster approach by simply selecting a color that is similar to the color of the building material.

3. **The 2D output**: Because the output is a print or electronic Adobe PDF document, at times, the 3D model will not translate well. More time and effort has to be spent on illustrating a 3D image when it will be in a 2D output.

4. **The varying existence of the right plug-ins**: The right plug-in can give the illustrator the ability to create whatever he or she envisions. Without the plug-in (and without the knowledge to create one), the illustrator has to develop techniques for getting around it. Usually, this translates into spending more time to manipulate the model to get the intended result. Making more plug-ins available will increase the potential to create even greater documents.

Technical Aspects

There are numerous reasons why SketchUp works well for creating the illustrations in the window installation step-by-step document, or for that matter, any homebuilding step-by-step document. SketchUp is a 3D modeling program, which allows the illustrator to create illustrations that mimic real life, rather than being 2D. SketchUp illustrations are cost effective to produce. The user interface and tools are relatively straightforward and simple. The ability to develop a library of materials and components significantly decreases the amount of time spent on modeling. Other illustration software like Adobe Illustrator and AutoCAD require each step to be an independent drawing. With SketchUp, a model can be used to illustrate all the steps, making changes easier and decreasing the number of times an item has to be illustrated.

Some additional positive attributes of SketchUp are as follows:

- The ability to use accurate and precise measurements so that objects can be drawn to real-life dimensions.
- The models can be at a 1:1 scale, mimicking real life.
- The 3D capability allows the illustrator to examine the building assembly from every angle.
- The ability to create materials that resemble real building materials helps clarify the illustration and bring real-life significance.
- The models can be drawn using as much or as little detail as needed, depending on the need to express a step properly.

To create the step-by-step document, the following SketchUp plug-ins were used: *Profile Builder* ,*Page Layers* ,*Add Hidden Layer* ,*Fredo Scale–Radial Bending* , *House Builder*, and *Hide All Unselected* .

The specific SketchUp features that were used include the basic drawing tools (line, rectangle, circle, arc), copying (arrays), snaps, referencing, sections, groups, components, layers, and scenes.

Other than SketchUp Pro 7, three other types of software were used to create the document:

- LayOut 2.0: To lay out the document;
- Adobe Photoshop CS4: To create realistic textures;
- Adobe Acrobat 9 Standard: To reduce the file size of the document and transform it into a widely used format.

New Approaches

1. **The concept**: Creating step-by-step documents is not a common practice in the homebuilding industry. Typically, this type of documentation is not cost effective. Even more uncommon is the use of 3D modeling software to create the illustrations, so using SketchUp in this manner is a fresh way of looking at construction procedures in the industry.
2. **The manner of using SketchUp**: Using scenes and layers together to control the visibility of groups and components is a new way of using SketchUp to illustrate a construction procedure in a step-by-step manner.
3. **The library**: Creating a library (database) of materials and components decreases the amount of time spent on modeling. Many of the materials and components used in this step-by-step document were first developed for other step-by-step documents; since the items were saved in a library, they were easy to leverage.
4. **The manner of using LayOut**: Creating a scrapbook and a template speeds up the process of creating the final step-by-step document. A scrapbook is much like a library, except it is for LayOut, rather than for SketchUp. In addition, LayOut is usually used for conceptual design layouts for a client instead of for step-by-step documents.

Step 1: Planning

Goal: To create a roadmap that guides the development of the step-by-step document.

Inputs: Project plan, development schedule, and style guides.

The planning stage is arguably one of the most critical steps to the success of the final step-by-step document. It is during this stage that we first sat down to discuss the project's background, set roles and responsibilities, create a development schedule, and identify resources. Typically, the background of a step-by-step document involves a homebuilder who is either proactively looking to provide his/her trades with clear instructions on how to properly install an aspect of a home or reactively looking to repair installation errors that were already made. We assigned our roles and responsibilities based on attributes like who is better equipped to interface with the client, to provide structure and scheduling, and to accomplish the end goal successfully. For this project, we built several small buffers into the development schedule to account for certain variable factors. These factors included the availability

of the subject matter expert and the length of time for the review/revision stage; both frequently vary, in our experience, from document to document. We keep a text style guide and an illustration style guide as reference tools; it is valuable to make sure both are up to date at the start of a new project to ensure consistency.

Step 2: Storyboarding

Goal: To outline each step of the story told in the step-by-step document.
Inputs: Storyboard template and research materials.

Step-by-step documents lend themselves well to storyboarding. The storyboard for this document included the following basic items: a main sketch, a secondary sketch, and a text box. Through storyboarding, we collaborated with the subject matter expert to determine the sequence of events (the steps) in the document, identify areas where more research was needed, and, most importantly, arrive at a stage where we could go away and begin to model and write.

Step 3: Classifying Objects

Goal: To make decisions about using illustrative and expressive objects and their role in the step-by-step document.
Inputs :Building material documents.

The nature of a step-by-step document is such that each step represents a snapshot of the installation. In the window installation step-by-step document, one step is to install OSB sheathing over the framing members. The next step is to install housewrap material on the exterior of the home. In both steps, the illustration only needs to show the item in one state – already installed. In other words, I needed only to model the object the way it would appear after being installed on the home. While this does not hold true in all cases, many times, trades do not need to see each individual board of the sheathing getting installed over the framing or each layer of housewrap being unrolled over the sheathing. Pairing the illustrations with the right text can give the trade an adequate amount of direction and context to complete the step. A conceptual object modeled in this manner can be classified as an *illustrative object*. Examples in the window installation step-by-step document include OSB sheathing, framing members, housewrap, and the stucco exterior finish.

 Anotherclassification of conceptual objects exists. This object displays an action that takes place, much like the unrolling of the housewrap material on the exterior of the home, or it displays an intermediate step that does not hold enough importance to receive its own step. This object can be classified as an *expressive object*, and it shows an action or something in action. They are usually used because the information being conveyed in the step is very complex. Examples

FIG 5.1 Illustrative object.

FIG 5.2 Expressive object.

FIG 5.3 The modeled objects – materials, tools, and window elements.

in our window installation step-by-step document include arrows, construction tools, and housewrap as it is being cut to create an opening in the material for the window.

Step 4: Modeling Objects at a 1:1 Scale

Goal: To model objects according to reality.
Inputs: Building material documents.
Tools: SketchUp, House Builder, Profile Builder, and Fredo Scale–Radial Bending.

The illustrations in a step-by-step document meant for a construction trade should match reality as closely as possible. I model objects in SketchUp at a 1:1 scale. This is because the trade must physically re-create on the construction site what he or she sees in the illustrations.

Building materials tend to be easy shapes to model, and their dimensions are easy to acquire from the manufacturer. A good practice is to draw the shortest dimensions using the basic SketchUp drawing tools, Line L, Rectangle R, Circle C, and Arc A, and then use the Push/ Pull tool P or Follow Me tool to extrude the length of the

object. The Profile Builder plug-in can be useful for modeling many building materials, and the House Builder plug-in can be useful when modeling a lot of wood-framed walls.

Tip

FredoScale is an excellent plug-in with many useful tools. One tool in particular, Radial Bending, allows the illustrator to bend rectilinear objects along curves, an ability that can be used to create *expressive objects* ,such as tape being applied to a surface.

Step 5: Creating Groups and Components

Goal: To make a modeled object a group or a component.
Tool :SketchUp.

Groups and components are the two types of objects created to organize a model in SketchUp. Groups are good for objects that are uncommon and need to be modified on a frequent basis, such as when you are showing the trade how to make various cuts in the housewrap. Components are good for repetitive objects that are identical in appearance, as well as objects that can be used over and over in numerous SketchUp models. Examples of components include construction tools, windows, and doors.

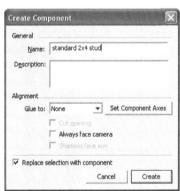

FIG 5.4 Object section.

Once an object is modeled, determine whether or not it should be a group or a component. To make it a component, select all of the geometry of the object (triple-clicking on the object is one good way), and then click Make Component. Then, type in the name of the component, making sure to be very specific about what it is, and click OK.

To make an object a group, select all of the geometry of the object, right-click on the object, and then select Make Group. A faster way is to create a shortcut key, such as **SHIFT+G**. Every time you model an object, it is important to make it a group or a component. This keeps the geometry from interfering with other geometry in the model.

FIG 5.5 SketchUp's Create Component dialog.

Step 6: Creating Materials and Making a Library

Goal: To create a realistic color or texture for a building material.
Inputs: Building materials.
Tools: Adobe Photoshop CS4, color scanner, and SketchUp.

A material in SketchUp is a color or texture. To make an illustration clear and easy to understand, it is best to use colors or textures that closely match the real-life object. Trades are then able to better associate what they see in the document with the actions they have to take on the construction site. It is important to note that standard construction drawings do not use colors or

realistic textures; instead, they use arrows with text to point out each item in the drawing, increasing the amount of time it takes for trades to grasp the concept.

Typically, using colors that closely match the real-life object will give it enough believability. However, some objects need a little more than just color – they need texture. Textures help differentiate one object from another, especially when they are similar in color. A great way to create real-life textures is to use a scanner to scan the real building material and open the image in Adobe Photoshop. In Photoshop, modify the image so that it does not look like a repeating image or have a tiled appearance. Save the image as a JPEG, and then import it into SketchUp as a texture. In SketchUp, scale the texture and save it in a material library.

> ### Tip
>
> If two or more instances of the same building material are layered over each other in a model, create a copy of the SketchUp color or texture and then lighten or darken it. This can help show that there are multiple layers of the same building material.

FIG 5.6 Creating an object.

FIG 5.7 Object with textures applied.

FIG 5.8 SketchUp's Texture library.

Step 7: Layering

Goal: To organize objects on layers.
Tool: SketchUp.

All groups and components need to be assigned a specific layer, which later allows you to create scenes. To avoid layering issues, all lines and faces should be on Layer0. Open the Layers palette by going to Window > Layers, and then also open the Entity Info palette by going to Window > Entity Info. Both should be open on screen. In the Layers palette, click on the plus symbol to add a layer. Give the new layer a name that is very specific to the object(s) that will be placed on it, such as naming it "window" for a window component. Select the object by clicking the Selection button or by hitting the spacebar on the keyboard. Then, in the Entity Info palette, select the appropriate layer from the drop-down menu. Repeat this process until each of the objects in the model exists on their own layer.

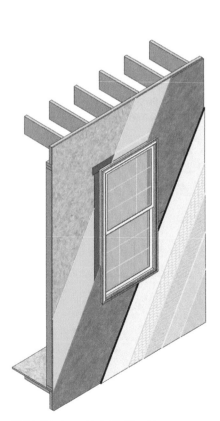

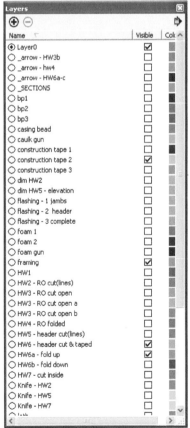

FIG 5.9 Objects associated with different layers. **FIG 5.10** The layers palette.

Step 8: Creating Scenes

Goal: To create the steps of the document using scenes.
Tools: SketchUp, Page Layers, and Add Hidden Layer.

There are two important reasons to create scenes. One is to set the viewpoint, and the other is to capture which layers are visible. The first scene represents the first step in the step-by-step document, and the final scene represents the last step in the document.

> **Tip**
>
> Try to make all the necessary layers before creating scenes. This is important because there is a default setting in SketchUp where any new layers automatically appear on all current scenes. You then have to uncheck the new layers and update the scenes. Plug-ins like Page Layers and Add Hidden Layer can help with this problem.

Label scenes using a naming convention that works for you. It is best to use short names that allow for more scene tabs to fit across the top of the screen.

Before creating a scene, select the type of viewpoint and aspect that work best for the document. Typically, 3D construction drawings are isometric, parallel projections. Most of the drawings in our window installation step-by-step document are isometric, parallel projections; at times, other viewpoints and aspects were used in order to successfully convey information to the trade.

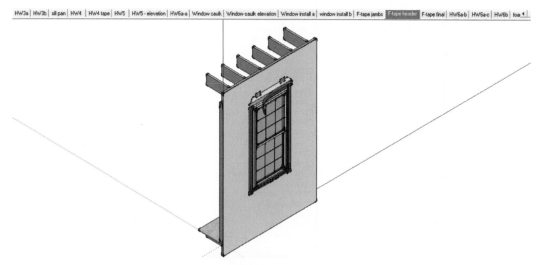

FIG 5.11 Scene tabs.

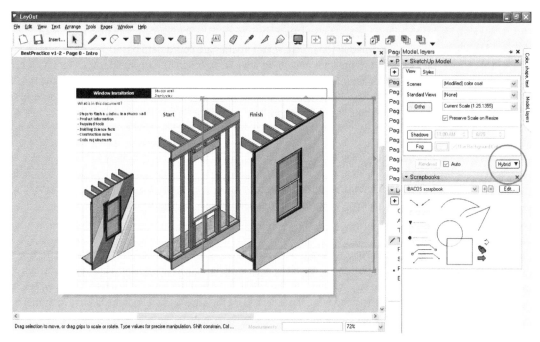

FIG 5.12 Assembling the documentation in LayOut.

After setting up the viewpoint and aspect, select the checkboxes for the layers that need to be on for the step. A good idea is to set the viewpoint to Zoom Extents. Next, it is time to create the first scene. Go to View > Animation > Add Scene. To make the following scene, repeat the process.

Step 9: Setting Up the SketchUp Model in LayOut

Goals: To set up the SketchUp model in LayOut and apply the Hybrid rendering mode.
Tool :LayOut 2.0.

First create a template for the document in LayOut. I use templates to decrease the amount of time it takes to set up, manage, and make changes to the document. The template for the window installation step-by-step document had a title block, which includes a title, subtitle, and page number, and a series of LayOut layers to help organize content in the document. The document's various layers were Guidelines, Arrows, Text, Title Block Text, Page Numbers, Secondary Graphics, Primary Graphics, and Background.

To choose a template, click on File > New From Template and then select the template. Next, to insert the SketchUp model into LayOut, click on File > Insert and then browse for the file. This places the model in the LayOut document.

95

LayOut has three different ways to render a SketchUp model: raster (default), vector, and hybrid. Raster images are pixel based and can look bad when zoomed in too much. Vector images are coordinate based, not pixel based, and so the lines and colors always look crisp. The downside to vector images is the fact that material textures are not displayed. Hybrid images have the best characteristics of both because the lines are vector based and the colors and textures are raster based.

Tip

Customize the user interface to add and remove buttons and arrange the side tray according to the palettes used the most.

In LayOut, select the SketchUp model. Then, in the SketchUp Model palette at the bottom, click on the drop-down menu in the bottom right-hand corner and select Hybrid. At this point, it is good to place the model where it will exist in the document. If necessary, set the style and scale of the SketchUp model in the SketchUp Model palette.

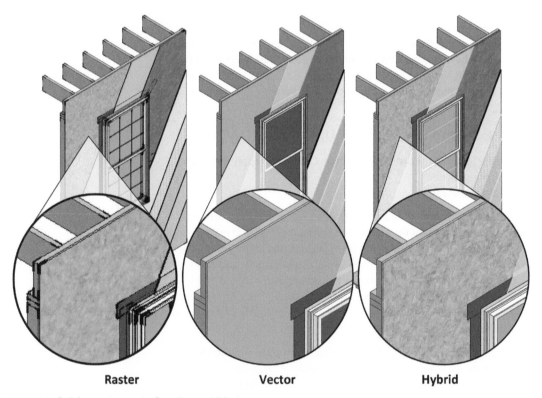

Raster **Vector** **Hybrid**

FIG 5.13 LayOut's three rendering modes: Raster, Vector and Hybrid.

Step 10: Creating the Document in LayOut

Goal: To assemble the final step-by-step document.
Input: SketchUp model.
Tool :LayOut 2.0.

To begin to set up the first page, set the model to the appropriate scene. Right-click on the model, select Scenes, and choose the scene from the list. A yellow warning sign will appear near the bottom right of the model; this means the model within the page is updating. Note that LayOut 2.0 still has a few issues, so wait until the model finishes updating before moving on to the next step. Once the model finishes updating, add the secondary illustrations, arrows, blowups (zoomed portions of the model), and text. The point of the document is to clearly illustrate a construction process so that secondary graphics, arrows, blowups, and text really help support a step.

Tip

Scrapbooks are a useful tool in LayOut for saving and reusing elements that repeat throughout the document. Common items to save in a scrapbook include arrows, text boxes that are of a specific size and font, and other illustrative objects. A scrapbook functions much like a component library in that it acts as a place to store common items.

After creating the first page, copy it by going to the Pages palette and clicking the Duplicate Selected Page button. This makes a copy of the first page and places it as the second page. Then, update the model on this new page to be the appropriate scene. The reason for making a new page by copying the page before it is that the model on the new page will be in the same location as it was in the previous page. This eliminates repeatedly having to reinsert the SketchUp model and its secondary illustrations, arrows, blowups, and text. Repeat this process until the step-by-step document is complete, and then have the subject matter expert review it for technical accuracy.

On a side note, when exporting the document to an Adobe Acrobat PDF format, the hybrid rendering of the model results in a large file size. Reduce the file size by going to Documents > Reduce File Size in Acrobat. Our 28-page window installation step-by-step document was reduced from 25.5 to 2.92 MB.

Step 11: Leveraging the Content

Goal: To repurpose the SketchUp components, models, and materials; the text; and the document.
Tools: SketchUp, Umbraco, and Canto Cumulus 7.

FIG 5.14 Example of a page in LayOut using one scene.

FIG 5.15 Example of a page in LayOut using three scenes.

Leveraging content means to repurpose it. It is great to create a single-window installation step-by-step document, but it is even greater to repurpose the SketchUp components, models, and materials; the text; and the document itself in different formats, for different clients, and so on. It is a simple concept – the more often content can be repurposed, the more value it provides.

Our SketchUp components, models, and materials from the step-by-step document exist in an organized series of folders as a library (database). We could upload the text to a content management system (CMS) and serve it to a website as, for example, a text-based series of steps or have it automatically reassembled into an article. We like Umbraco, an open-source CMS from Denmark based on Microsoft's ASP.NET. Or, we could upload the illustrations to a data asset management system (DAMS) to help manage them and allow others to readily search and locate them for future uses. We use Cumulus 7, a DAMS solution from Canto that helps arrange, share, and track different types of content. We have thousands of illustrations and photographs stored in Cumulus. These examples are just the start of a long list of tools to assist in leveraging the content. That is the end goal when creating quality content – for it to live a long life in many forms.

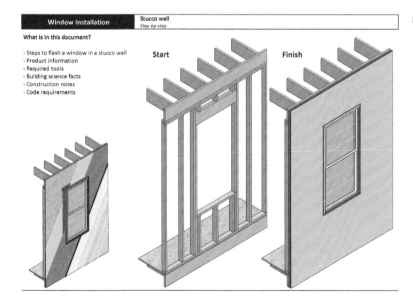

FIG 5.16 A final completed page.

Conclusion

SketchUp Pro 7 enables illustrators to create clear, in-depth, step-by-step procedures faster and easier than other common software packages, including Adobe Illustrator and AutoCAD. Considering SketchUp is a fraction of the cost; it is a very cost-effective tool to use. As for the future, there is untapped potential to take the models and documents to the next level. Models can become 2D drawings for standard construction drawings, slideshows, animations, and interactive web models, to name a few. Combine SketchUp and the various potential outputs with the smart, innovative people developing Ruby scripts and Google's program becomes a very powerful tool.

Resources

Software

SketchUp Pro 7 (includes LayOut 2.0) – US$495, excluding taxes.
Adobe Acrobat 9 Standard – US$299, excluding taxes.
Photoshop CS4 – US$699, excluding taxes.
Umbraco – US$1,146, excluding taxes.
Canto Cumulus 7 – ≈US$12,000, excluding taxes.

SketchUp Plug-ins

Profile Builder, by Dale Martens. Available at http://www.smustard
.com/script/ProfileBuilder.
Page Layers, by Rick Wilson. Available at http://www.smustard.com/
script/PageLayers .
Add Hidden Layer, by Jim Foltz. Available at http://sketchuptips
.blogspot.com/2007/08/add-hidden-layer.html .
Fredo Scale–Radial Bending, by Fredo6. Available at http://forums
.sketchucation.com/viewtopic.php?t=17948 .
House Builder, by S. Hurlbut. Available at http://www.crai.archi.fr/
RubyLibraryDepot/Ruby/em_arc_page.htm .
Hide All Unselected, by Todd Burch. Available at http://www.smustard
.com/script/HideAll .

Building in Four Dimensions!

Koenraad Nys

Since obtaining his diploma in 1984, architect–engineer Koenraad Nys has concentrated on the development and application of information and communication technologies (ICT) in the field of construction. Armed with his great experience in this field after 15 years at STAR-APIC, where he developed CAD and GIS software and BIM applications before the term was even coined, Koenraad Nys set up his practice, The Dimensions-Studio, in 1999. It now concentrates on the integration of 4D/xD and project management. The Dimensions-Studio is currently involved in several ICT and research projects, as well as with BIM working groups. He teaches at Saint Luc Grand-Bruxelles University, as well as at various other European architectural institutes.

Project: 4D visualization for architecture and infrastructure projects.
Tools: Google SketchUp 7, xD Virtual Builder Light, xD Virtual Builder r5.4, MySQL 5, MS Project.

Small construction projects often have a multitude of facets, but an experienced site foreman will draw upon experience and intuition to keep an overall view of the project: knowing that the volume of delivered material must not exceed the available storage space and the contractors must not all be put to

work at the same time. But in larger projects, it is difficult to maintain a broad overview of the project and thus keep everything under control.

As construction projects become larger and ever more complex, the need for optimal collaboration and communication grows, and these practices should be implemented from the very first planning stages of the project. Visualization in four dimensions allows you to do just that. The construction process and all its attendant parameters can be controlled in an entirely virtual, construction management-based manner.

Construction management techniques have been around for a long time. But the traditional approach, with its Gantt diagrams, can be difficult to understand for people external to the project. When the project management becomes extremely complex, containing many hundreds of rules, it is especially difficult for project managers to clearly explain the project organization to members of the team. However, by tying project management tools to SketchUp, it is possible to remedy this problem. The entire process of construction is represented in a simple and readable 3D form. In addition, SketchUp's capabilities facilitate the production of animations, presentations, or reports. These 4D models are usually used for communication between the partners involved in the construction, but they can also be used for dissemination of information to the wider public, or for the more technical aspects of construction and site management.

The Dimensions-Studio has been working since 1999 on 4D visualization techniques and, in 2008, added Google SketchUp to its suite of programs. Although at first its use was restricted to certain projects where the client had requested that SketchUp be used, gradually its use has spread to a growing number of other projects and users.

Technical Context

Visualization in four dimensions is a technique whereby the time factor is inserted into a 3D model or into a 2D drawing. The basic technique consists of giving SketchUp objects temporal characteristics that define construction activity. Thanks to certain specific functions that allow us to navigate through time, we can move the clock forward and, in this way, reproduce the process of construction. It is still possible, for example, to show which tasks have been carried out in time or have been delayed compared to the original schedule.

When 4D models are being created, it is best to get away as much as possible from the actual detailed modeling.

The basic principle consists of creating elements in SketchUp with the correct construction activities. Each activity is defined by an xD object that has, at a minimum, the following properties: start of activity, end of activity, and type of activity (construction, demolition, etc.). For each xD object, SketchUp elements belonging to this activity are assigned via a simple selection.

Thanks to the temporal navigation, these elements are sometimes shown and sometimes hidden and their color can change according to the situation. Basically, the user determines the material or the color of each element according to its type of activity and its status. For example, a shuttered concrete construction could be colored red while it is being poured and textured gray once it has cured and set.

The basic data unit in these studies is the xD Object. They can be created locally within SketchUp (xD Virtual Builder Light) or, for example, can be linked directly to a schedule generated in MS Project (xD Virtual Builder Classic). If a project date slips, this shows up directly in the 4D model, and the consequences for the rest of the project become immediately apparent.

In addition, modifications can be made to xD Objects via an interactive xD window. This allows for the selection, modification, and deletion of all the xD Objects. It also gives access to a complete series of related functions.

These 4D models are, essentially, classic SketchUp models, but they also include all the elements that take part in the construction process: cranes, site access, site closure, and all symbol designations like text labels, etc.

Any version of SketchUp above version 6 (free as well as Pro) can create 4D models. Once the model has been created, we generate all the representative scenes based on a list of key dates. These scenes can then be printed out, or an animation can be made from them.

Techniques Used

As explained earlier, Google SketchUp plays a central role in the creation of 4D models, and all of SketchUp's basic toolset can be used for their creation. Any type of SketchUp element can be used, from simple lines to 3D solids, text, scanned images, etc. Library files such as components and groups can also be used. Working with groups is always recommended because it makes management simpler when dealing with more complex phases of the project and, at the same time, keeps the performance of the program snappy. Assigning these groups to layers is not necessary at the beginning of the modeling stage. This can be done later while you are working with the model.

The xD Virtual Builder Light plug-in for SketchUp entirely functions independent of third-party software packages. The xD Objects are created in applications, and these data are also saved in the SketchUp model. The xD Virtual Builder Light plug-in works on both PC and Mac.

The xD Virtual Builder Classic module is a more complete implementation, in which all the data can be tracked via a relational database, and so it is more transparent to the end user. With this application, any existing project management material—like MS Project files—is also dynamically linked, which means that all the changes are immediately reflected directly within the 4D model. This plug-in runs only on the PC.

MS Project, Primavera, and Powerproject are applications that have been developed specifically for project management in the field of construction. All these applications are based on the same working principle that allows the manipulation of project-management data, most often using Gantt charts. However, they differentiate themselves in their power, their control functions, and their interface. The xD Virtual Builder Classic plug-in can interact with all these popular programs.

New Approaches

The originality of this solution is twofold: on the one hand, it puts complex techniques into practice within a simple 3D environment; on the other hand, it capitalizes on SketchUp's simplicity to communicate an overview of the process of construction, its various phases, and any potential difficulties to all those taking part in the project.

The possibility of running through all the aspects of the construction process in a virtual environment is particularly useful for identifying and resolving any possible problems before the construction work starts. This facility is even more interesting when there are many contractors involved in the work or if the project is either complex or one of urban design, encompassing a wide area. This not only avoids cost overruns but also greatly improves the management, upkeep, and longevity of the final building.

By taking advantage of the "best of both worlds," we have been able to uncover complex data, often buried deep within inaccessible databases, and present them in an extremely visual manner. What is more, although this works for following the progress of the construction project, it also allows us to demonstrate other visualizations, based on other approaches, thanks to the xD Virtual Builder database.

Example 1: Project Using xD Virtual Builder Light

For our first case study, we will use the SketchUp plug-in, xD Virtual Builder Light, which works completely independently within Google SketchUp. All the time-based data are input manually and are stored within the model. In order to access these data, you simply need a plug-in. This works with version 6 and above of SketchUp and is available on both Mac and PC.

Stage 1: Base Model and Preparatory SketchUp Model

Objective: To create the base model in SketchUp, including all the final elements and also including temporal or logistical elements such as cranes, site access, etc.
Data: Model created using project database. This model can, of course, be built using external files such as AutoCAD DWGs, for example.
Tools :SketchUp's modeling functions.

We started off by creating a "classic" SketchUp model, all the time keeping in mind that this was a 4D project. This means that we have to model more than just the final result: temporary elements also needed to be modeled, like, for example, bicycle parking spaces, as well as logistical elements (e.g., cranes), excavations, demolitions, etc. The presence of these elements would vary according to the project stage.

The SketchUp model can be organized any way you like in terms of layers, groups, or components, although it is better to group objects before linking them to the database and reviewing the visualization. Layers, too, can be a great help in organizing and visualizing the individual phases of the project, although, as stated, this organization has no bearing on the database functions.

As in a traditional SketchUp model, materials and textures were applied to the various elements. It should be remembered that in a 4D visualization, the colors change as the visualization progresses, according to a palette chosen by the user. Each element, however, stores its original material in the database.

FIG 6.1 Alongside "classic"-modeled entities, 4D modeling also contains logistic and temporary elements, as well as any necessary demolition work.

Stage 2: Creation of xD Objects with Start and Finish Date

Objective: To create xD Objects. Each xD Object designates one activity.
Data: Inserting tasks and activities at the same time as their start and finish dates. Defining the type of activity. All these data are entered manually into xD Virtual Builder.
Tools: xD Objects in SketchUp.

An xD Object is a virtual object defined by its name, a start and finish date, and type of activity. This xD Object possesses the necessary information, and it can be linked to other objects already created in SketchUp that have the same start and finish time for their particular activity.

The 4D data type presents the area of activity: you can choose between construction, demolition, environment, finishes, and landscaping. For each of these 4D activities, three materials are automatically created in SketchUp's materials library: *Name4DType*_pre (before the start date), *Name4DType* _act (between the start and the finish dates), and *Name4DType*_post (after the finish date). All these materials can be modified in exactly the same way as any other SketchUp material (see stage 5).

To create xD objects, you should follow these steps:

1. On the xD toolbar, click on the icon to open the Show xD Objects window.
2. Click on the New xD Object icon in the xD Objects window.
3. Enter the data that define your xD Object:
 a. Name
 b 4Dtype
 c. Start date (select it from the calendar drop-down list via the ellipses icon)
 d. End date (select it from the calendar drop-down list via the ellipses icon)
4. Click on OK.

The xD Objects window is updated and contains your newly created object.

FIG 6.2 All the creation and management functions for xD Objects can be accessed from the xD window.

Stage 3: Assigning xD Objects to a SketchUp Selection

Objective: To link selected SketchUp elements to the relevant xD Objects.
Data: The basic data are the xD Objects and the current SketchUp model.
Tools: The xD Objects window in SketchUp.

Assigning the xD Objects is carried out via the following steps:

- Slect the relevant SketchUp elements.
- Click on the icon for the desired xD Objects.
- If the above is successful, you will get the following message: The SketchUp Entities Have Been Linked.

Atfirst glance, nothing appears to have changed in the model: But, of course, all the elements are now linked together.

This assignment can also be carried out over various stages, based on different selections, either because it is easier or because there are some elements that were left out of the initial selection.

Stage 4: Navigating in Time

Objective: To show the state of construction of the project at a specific date.
Data: SketchUp xD model created in the preceding stages.
Tool: The xD toolbar in SketchUp.

As indicated in the introduction, when you navigate in time, certain elements are either visible or hidden. Their colors also change according to the prevailing situation. The color and material are chosen by the user according to the type and status of the activity. So, for example, a construction in concrete might be red while it is being poured, but textured gray once set.

All the temporal navigation functions are found in the xD Virtual Builder toolbar.

FIG 6.3 All the temporal navigation functions are easily accessible from the xD Virtual Builder toolbar.

Navigating in time can be done in several ways: either by choosing a specific date or by "scrubbing" through the entire construction process. You can choose a specific date via the Calendar tool.

Starting with a particular date, you can continue moving the process forward or rewind back to any particular point in the past:

View past or future dates, moving backwards and forwards by a defined time interval.
Show the Time Interval list.
Run the simulation automatically, stepping forward by a defined time interval.

The time intervals can be chosen by the user. The standard interval is found under the Stages list. This list gathers together all the start and the end dates of the xD Objects. Other available intervals are Every Week, Every 15 Days,

FIG 6.4 The pop-out Calendar tool allows you to easily choose any date.

Every Month, Every Quarter, Every Six Months, or Every Year. To select this, go to the Plug-Ins menu and choose xD Virtual Builder > Tools > Select Time Interval.

Attention!

To get back to the original model, click on the Restore Original Colors or Show All Scheduled Entities.
When a 4D material is removed,
When a 4D material is defined to be totally transparent, the original color or texture will be seen!

Stage 5: Changing 4D Types

Objective: Adapting the colors for the chosen types.
Data: Material automatically generated by type.
Tool :SketchUp's Materials editor.

Each 4D type has a particular activity associated with it. The basic types are as follows: Construction, Demolition, Environment, Logistics, Finishes, and

Landscaping. For each these 4D types, three materials are automatically created in SketchUp's Materials library:

- *Name4DType*_pre: The material that the 4D SketchUp object will receive before the start date for the activity (before the start date)
- *Name4DType*_act: The material that the SketchUp object will receive while its activity is being carried out (i.e., between the start and finish dates)
- *Name4DType*_post: The color that the 4D SketchUp object will receive when its activity is completed (after the finish date)

All these colors can be edited using SketchUp's Materials editor.

FIG 6.5 The 4D types are denoted by their SketchUp materials, and it is possible to modify these using SketchUp's Materials editor.

Stage 6: Improving the Image by Adjusting the Shadows

Objective: To increase the model's readability.
Data: The SketchUp xD model created in the preceding stages.
Tool :SketchUp's Shadows option.

For each visualization date chosen, the shadows are now generated. If the model is large, this can result in a slowdown.

FIG 6.6 Shadows improve the depth of the images, something which is especially true when project managing the construction phases.

Stage 7: Automatically Generating Scenes and Managing Them in the Scenes Palette

Objective: To generate scenes for certain dates within the project and to process them so that they can be used for the production of documents.
Data: The SketchUp xD document created in the previous stages.
Tool: The xD toolbar in SketchUp.

From the Plug-Ins menu, choose xD Virtual Builder > xD Scene Generator. This will allow you to generate the scene for each time interval that you have set.

FIG 6.7 Scenes can be generated simply by selecting dates; one scene is generated for each date chosen.

Once these scenes have been generated, you can manage them in SketchUp's Scenes palette. Some examples are as follows:

- The scenes can be exported in any desired file format (JPEG, PNG, PDF, etc.). From the Menu Bar, choose File > Export > 2D Graphic.
- You can use any scenes generated by xD Virtual Builder as keyframes in an animation.
- Animations can be exported by choosing File > Export > Animation.

Example 2: xD Virtual Builder Classic

When using xD Virtual Builder Classic, the same basic workflow is followed, although you have many more options at your disposal. Thanks to the dynamic linking to existing project management data, managing 4D types is much more powerful. Furthermore, the visualization capabilities are enhanced, something which allows a more accurate comparison between the current and projected situations.

The creation of the base model is identical to that in the preceding project. However, the creation and management of xD Objects is rather different. In the Light version, all the data are processed within SketchUp itself. In the Classic version, these data are processed outside SketchUp, and the quantities are handled by a relational database, a more complex level of organization, but at the same time one that offers many more possibilities. Below, we will give you an idea of these possibilities, but without going into too much technical detail.

The order in which you carry out the actions is not really crucial. In most cases, we will first input the project management data so that we can then pass them on to the xD Objects and then add the SketchUp entities. However, you could just as well do it the other way around.

Stage 1: Starting an xD Virtual Builder Classic Project

Objective: To set up an xD project.
Data: Model to be created using supplied project database. Of course, the model can also be started by using other external files such as AutoCAD DWGs.
Tool :xD Virtual Builder Classic.

Thanks to xD Virtual Builder Classic's well-thought-out interface, the database can be constructed in five key stages. The project can then begin. The organization at this stage is transparent for the user; there are no complex database manipulations to be carried out.

Stage 2: Linking to a Project Management Application (MS Project or Similar)

Objective: To link with data from MS Project.
Data: Basic MS Project file.
Tools: xD Virtual Builder Classic and MS Project.

FIG 6.8 xD Virtual Builder is a far more capable application that is set up via a web interface.

Once the project is begun, the relevant project management file can be opened in MS Project.

Linking the MS Project tasks with the xD Objects is easily carried out: After the selection of the relevant task or tasks in MS Project, they can be brought into xD Virtual Builder via drag and drop. All the xD Objects are created automatically and linked. The start and finish dates are placed into MS Project's database and synchronized. Furthermore, any other attributes from MS Project can be linked at this stage, but we will not go into this technique here.

FIG 6.9 Here, the time-based data are extracted from MS Project. The xD Virtual Builder application dynamically links them to the elements.

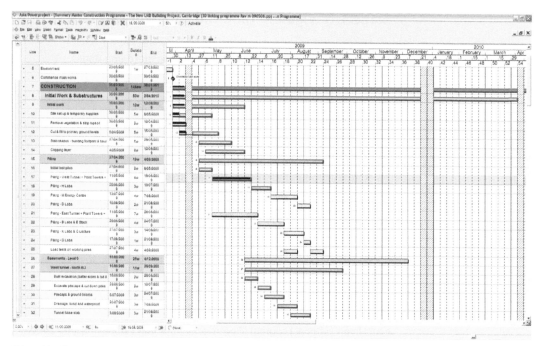

FIG 6.9 (Cont'd)

Stage 3: Linking the xD Objects to the Selection in SketchUp

Objective: To link the data to entities in SketchUp.
Data: xD Virtual Builder project and SketchUp model.
Tools: xD Virtual Builder Classic and SketchUp.

Once all the different tasks have been linked, the corresponding entities in SketchUp can be linked, too. To do this, the SketchUp entity must be selected, then it is simply a case of selecting the corresponding xD Object in xD Virtual Builder and clicking on the command Link Selected DS Item in xD Virtual Builder.

If we wanted to do this the other way around, we could, for example, start with the selection of an xD Object in SketchUp and then attach an MS Project task to it. This can be carried out by using the xD Toolbar.

To finish, a 4D type (representing a type of construction activity) needs to be selected within xD Virtual Builder. Unlike in the Light version, there is no limit on the number of types. The user may also create new types according to his or her needs.

FIG 6.10 Within xD Virtual Builder, many functions are available, which enable you to link entities together.

113

Stage 4: Navigating Time and Modifying 4D Types

Objective: To manipulate the 4D model.
Data: The xD SketchUp model created in the preceding stages.
Tool :The xD Toolbar in SketchUp.

Navigating in time and modifying the 4D types is carried out in the same way as in the Light version of the program.

Stage 5: Generating Scenes and Images

Objectives: To generate scenes for certain dates within the project and to process them so that they can be used for the production of documents.
Data: the SketchUp xD document created in the previous stages.
Tool: the xD toolbar in SketchUp.

The Scene Generator is identical to that in the Light version of the program, but it adds the possibility of automatically saving the images in a file transfer–friendly format such as JPEG, BMP, or PNG. The choice of a date is still central to this part of the process.

This is an easy way of quickly generating different images that can be processed in an external program like PowerPoint or that can be dropped directly into a webpage.

Stage 6: PowerPoint Presentation

Objective: To create a report using a PowerPoint presentation.
Data: Images generated in the preceding stage.
Tool :MS PowerPoint.

Of course, the product presented here puts the accent on the interactive processing of the SketchUp xD model, but it is still often necessary to produce

FIG 6.11 The integrated scene and image generator lets you manage all aspects of image production.

visual reports. The technique employed here makes creating and editing our report extremely easy, even for beginners.

The presentation can be put together simply by processing all the images using PowerPoint's Photo Album functions. As an alternative, the functions of xD Virtual Builder can also be used to this end. This way, it is easy to combine a timescale, colored captions, different views, etc.

Conclusion

As already stated, The Dimension-Studio has had many years of experience with 4D models. At the beginning, we made use of classic CAD and GIS software—and sometimes we still have to. But SketchUp has opened up a world of innumerable possibilities.

SketchUp has a simple, approachable interface. The visuals that it produces are comprehensible and clear, even for beginners. Because it is a simplified solution, SketchUp's toolset can sometimes be a little restrictive. But as a communication tool, it is (for the moment) unbeatable!

The combination of the Light version and the more powerful Classic version offers multiple possibilities for usage and communication. While the Classic version can be used daily by the project leaders in combination with their other usual project management software, the xD model can be easily shared with other participants via the Light version.

In the near future (the end of 2009), we also hope to have a 4D tool available for Google Earth and for the more usual channels of web publishing.

Resources

Software
Google SketchUp or Google SketchUp Pro.
xD Virtual Builder Classic – Around $3,500, excluding sales tax.
Available at http://www.dstudio.be.
Microsoft Project – Around $800, excluding sales tax.

Applications for SketchUp
xD Virtual Builder Light – Around $79, excluding sales tax. Available at
http://www.dstudio.be .

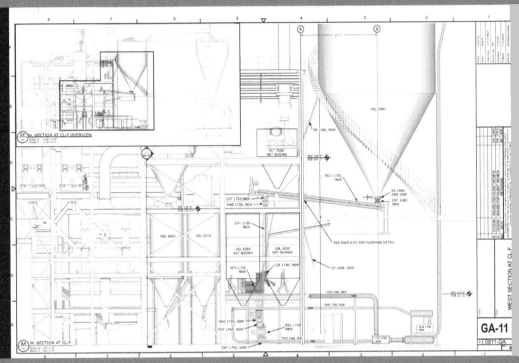

Process Plant Design

Mitchel Stangl

A graduate from the Massachusetts Institute of Technology with over 25 years of experience in process plant design and construction, Mitchel Stangl came across SketchUp in 2001 as an intuitive modeling program. Since 2003, he has used SketchUp exclusively to model process plant projects. Mitchel has spoken on working with large models and using AutoCAD with SketchUp models at the 2005 and 2008 SketchUp user group meetings.

Mitchel Stangl and Stangl Associates use SketchUp to design industrial processes. These include metal recovery systems, material handling, and mineral-processing expansions and upgrades. Stangl Associates utilize SketchUp through the entire design process. The project facility is modeled in the initial phase of all projects. This allows the design team to understand, visualize, and determine the physical constraints of projects. The model is then used as a communication and assessment tool to develop options based on client needs. Once feedback is obtained and an agreement is reached, the design process is finalized and project equipment is selected. Using the SketchUp model and LayOut, construction documents are created to convey the project to contractors for construction.

Project : The project aims to illustrate the SketchUp and LayOut techniques used by Mitchel Stangl and Stangl Associates in designing

Google SketchUp Workshop

117

industrial process plant design projects. These projects range from basic studies to detailed construction designs.

Tools: SketchUp 7.1, LayOut 2.1, scanned historic drawings (both hand-drawn and CAD drawings), digital photographs, and field surveys.

Final Output: Project model and construction drawings.

Project Context

My company works for corporations with patented and proprietary processes. Most of our work involves designing new and upgraded processes within existing facilities. This study focuses on the general design process for these types of projects, and not a particular project.

Techniques Utilized

We model to understand, visualize, and determine the physical constraints of our projects. Modeling is our essential technique and practice. We also do calculations, analysis, and other common engineering techniques as are required to design a process plant facility.

Most of our projects require a great amount of detail, which causes our SketchUp models to become very large. In response to occurrence of such large models and complexity, we have developed a technique to work with them. These methods are applicable when working with any large SketchUp model.

Because of our commitment to 3D design, we also use LayOut to create our construction documents. LayOut allows us to use 3D models as the basis for our drawings. It means that we never abandon these models. We never go to 2D drawings, or export from the SketchUp files. The 3D models are the backbone of the LayOut file and, therefore, our drawings. We do create 2D drawings, but they are really just projections of the 3D model.

New Approaches

In our industry, 2D design is still the predominant design method or tool. There are a small percentage of firms that use solid modeling programs. These programs are very complex, require intensive training, and are expensive. Our innovation has been to work in three dimensions and adapt a simple and intuitive software, that is, SketchUp/LayOut.

We became committed to the use of 3D software and eventually 3D design techniques 15 years ago. SketchUp became a part of our workflow in 2001. In 2004, it became our only 3D modeling tool. It has given us an advantage in ease of use and training. SketchUp is no longer a part of our focus; it is an integral part of our work.

SketchUp was and is considered by many people to be just a conceptual design tool. We know this is not true. It can be used for detailed design. We use it every day for detailed design. In our industry, this use of SketchUp is original.

LayOut is not a well-understood program. Use of LayOut greatly changes the uses and benefits of all SketchUp models. It allows these models to be used in the creation of construction documents. For most design professionals, the two programs can replace existing CAD use.

Step 1: Modeling the Existing Conditions

Goal: To create a model of the existing conditions or facility.
Inputs: 2D drawings of existing facility in CAD or scans, photographs, and site survey information.
Tool :SketchUp 7.1.

We start with the creation of a model of the existing conditions/facility. This facility consists of concrete/steel structures and process equipment. Generally, there are drawings of original structures and equipment, and major additions. These never form an up-to-date set of drawings that reflects the true state of a facility. We gather paper drawings, CAD files, electronic scans of the original drawing, and photograph and field survey the existing facilities.

From the existing drawings, files, and field measurements, we produce a model of existing conditions. We use many different techniques to create this model, depending on the type, quality, and complexity of the information and objects to be modeled. In general, we create the existing plant model by modeling the gathered information, which is imported into a SketchUp file. We import both CAD files and scanned drawings. These imports are used as references for creating the model. The most common use of these imports is just to provide dimensional references in one plane. We also construct virtual 3D drawings models from the 2D drawings set at the appropriate elevations and locations. Then we can model more complicated structures and equipment.

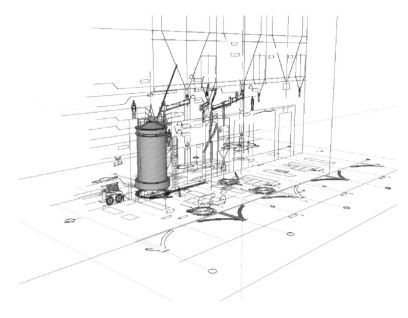

FIG 7.1 Arranging 2D imported CAD files in 3D space to create equipment models.

Photographs are also used for reference and in the SketchUp Photomatch tool. We have found the Photomatch tool to be a very powerful tool in modeling large existing structures and equipment. This is especially true for exterior shots of large buildings or for buildings that cannot be easily measured.

The existing facility model is our starting point for the new project. Since SketchUp is so intuitive, modeling using this tool feels more like constructing. The act of modeling an existing facility enhances our understanding of the facility. This is a very powerful step in our design process; as we create the model, we create a greater understanding and familiarity of the spatial constraints of the site and project.

FIG 7.2 Photographic view of an existing facility.

FIG 7.3 Model view of an existing facility.

Tips about modeling using CAD and image files:

1. It is usually easier and quicker to group the imported file and CAD or image, and model it. Using the imported geometry is more difficult because often the geometry is not always complete or accurate. Therefore SketchUp has problems recognizing CAD line work.
2. In the Style Dialog, set the edge color to "by axis," so that you can see if the lines are square to an axis. This is a great reference to ensure that you are "tracing" the lines correctly.
3. Save these development files (we suggest naming them as "Devo-" and saving them in a special folder) with the CAD files or images in place. This file organization allows you to quickly check your work against the original basis when needed.

Tips for complex models

1. Large models are just collections of many small models. Everything in your model should be a group or a component. This is the most effective way to start organizing a SketchUp model, in particular, large models.
2. Large file size and high polygon counts will slow the model response, increase saving times, and, most importantly, limit the extent of your model. So, minimize the polygon count whenever possible. For example, not every circle needs 24 sides. For example, our tanks of 10 m diameter should have 24 sides or more, whereas a 15 cm pipe should have eight sides. When you build your models, try and limit the curvature of objects as much as possible to reduce the number of faces. Another example for many projects is steel beams. Use steel beams having rectangular shapes and not rounded corners.

Wide flange steel W36×588
39 Edges
15 Faces

Wide flange steel W36×588
168 Edges
58 Faces

FIG 7.4 Simplified versus standard steel beam model.

You can check how big your model is by going to Window > Model Info > Statistics. Make sure the Show Nested Components option is checked. This will tell you how many faces and edges there are in your model.

3. Organize your model from the start. Use layers to organize your model and to control visibility. Think about creating a system for naming your layers. For example, you could make all the structure layers start with "S-___," all the architectural layers with "A-__," and so on. We like to use layers starting with "1-___" for all new work.

4. Use layers and groups/components to nest geometry. You can and should make groups/components out of smaller components. With the layers, you can create a hierarchy of geometry or nested layers.

In this example, the numerals 1, 2, 3 are individual components and are grouped together as a component called Numbers. So, you can turn off or hide all the numbers by unchecking visibility of the "0-number" layer, or you can switch off each individual number. This is same with the letters too. Also note that the Nesting layers have a zero leading their names. That way they are at the top of the list. Although this is not important when there are only nine layers, this does matter when you have 500 layers.

FIG 7.5 Nested layers/geometry.

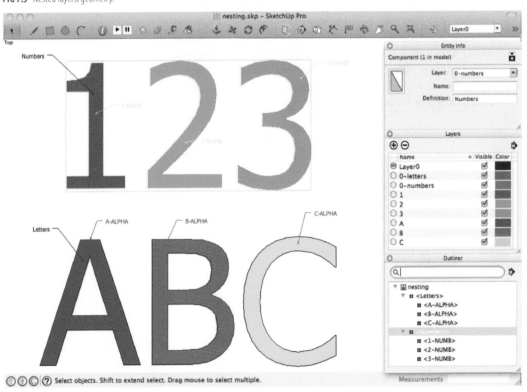

The Entity Info dialog box is also shown. It gives you the component and layer of the selection; in this example, the component is Numbers and the layer is "0-numbers." Also the Outliner dialog box shows the structure of the groups/components. You can find any group or component in the model from the Outliner. There are many options in the Outliner; just right-click a group/component to see the options.

Tip

We have created a full library of 3D structural steel shapes. If these are all created with uniform length and components axis, then substituting one shape for another is straightforward using the component context menu or the Component browser. We recently created dynamic components that have all steel dimensions embedded in them.

Step 2: Designing and Modeling New Process Plant Options

Goals: To create a process flow diagram (PFD) and conceptual model of the new process; to obtain client approval of the proposed design.
Inputs: Preliminary process flow diagram, the existing facility model developed in step 1, and basic knowledge of the proposed process equipment.
Tools: SketchUp 7.1 and GoToMeeting (web conferencing).

FIG 7.6 Process flow diagram created in LayOut.

Based on client input, review, and discussion, preliminary PFDs are created. Here, we discuss the creation of PFDs with LayOut 2.1.

We then model the process with SketchUp. SketchUp allows us to quickly model the preliminary process based on the PFD. As the model is created, process flow changes to accommodate the physical constraints of the project, which are realized while modeling the process. The PFD development and modeling are very interactive processes. While working simultaneously on the process and the model, design options quickly become apparent.

In traditional engineering projects, PFDs are developed along with simplistic 2D general arrangement drawings. The drawings are time consuming to create. In the traditional design process, this is an essential step. These 2D drawings are reviewed or marked up by the client, and returned to the engineer for approval or additional development. The 3D SketchUp models and web conferencing have eliminated this step for us.

Now, we review a model of the project. This takes much less time than creating 2D drawings. Usually, the review is done online in a web conference. The SketchUp model is reviewed, including all the model options, and changes are made during the meeting, all online. Approvals are usually given during these meetings. This has eliminated the traditional design/drawing phase of project design.

FIG 7.7 Process options in existing model.

At this step in the project, we start setting up display controls on the model using Scenes. We also start thinking about what we will be showing in the construction documents. At the end of the step, we would like the layering of the model to be 80%–90% complete.

Tip – scenes

Like all the commands and dialogs in SketchUp, the Scenes are multifaceted, and very powerful in controlling your display. Scenes form the backbone of our display controls. You can save not only a snapshot of the model but also the following:

FIG 7.8 Scene dialog box.

1. Layer states : For example, we can have a Scene for the structural steel layers, the process equipment layers, all layers, or just the new project layers. This is done by selecting only the Layer property checkbox in the Scene dialog box. Then, we set up these Scenes with names starting in "L-."
2. Scene: As you create sections that help you see within a model, you should save them as Scenes. We name these Scenes using names starting with an "S-." We typically create Scenes at every level and at many column lines.
3. Shadows: For solar projects, we always set up Scene for December 22 at 9 AM and 3 PM. Transitions between these two Scenes allow us to determine if solar panels are ever shaded.

Step 3: Equipment Selection and Process Finalization

> **Goals**: To be specific, to quote and select the process equipment for the project and to complete the SketchUp model.
> **Inputs**: The approved PFDs and preliminary proposed model of the project.
> **Tools**: SketchUp 7.1, LayOut 2.1, and a word-processing program.

We select equipment based on the client's selection of a final process. To do this, we must specify the equipment and request quotations from equipment manufacturers. We take our basic equipment models from the SketchUp project model and import them into LayOut for dimensioning and labeling. LayOut 2.1 introduces a Dimension tool. We use a word-processing program to write up specification and equipment performance standards and then combine the documents. These specification documents are sent to vendors for quotation.

Once the equipment has been selected, we use SketchUp again in approving vendor drawings. We again model the equipment. This time, the modeling is done in much greater detail. The modeling process provides us with much greater understanding of the equipment than that obtained from simply reviewing the drawings.

This process is done for all the equipment in a project until everything is approved for fabrication and their fit in the model is verified.

This step includes all subcontractor work. Our subcontractors provide us with drawings and models that we incorporate into our project model.

FIG 7.9 Sample equipment specification.

FIG 7.10 Detailed equipment model.

FIG 7.11 New process upgrade model.

Step 4: Construction Documents

Goal: To produce dimensioned construction documents (drawings) from the SketchUp model, with LayOut.
Inputs: The project SketchUp model and existing template files for LayOut.
Tools: SketchUp 7.1 and LayOut 2.1.

At this point in the project, the 3D SketchUp model is nearly complete. This project model is named by project number, for example, Project 1234's project model would be called "1234-3d.skp." This model contains the entire project, both old and new details.

All the Scenes created in the SketchUp model up to this point are used only to view the project. We now need to create Scenes in SketchUp specifically to produce drawings in LayOut.

We now set up the Scenes in a SketchUp file for use with LayOut. For most projects, unless they are very small, we do not want to add any more Scenes to the project model. So we create SketchUp files just for use with LayOut files.

Since many people need to work simultaneously on a project, we have developed the following strategy with the SketchUp and LayOut files:

1. We create drawing files from the project model.
2. The project model is imported into each drawing (LayOut) file. These are the SketchUp files on which the LayOut files are based. They are set up by discipline. The main elements that are changed from file to file are the Scenes and the styles. We name the files according to the type of drawings to be created.

127

For example:

Architectural	1234-3d.skp is inserted into	LO-1234-A.skp
Demolition	1234-3d.skp is inserted into	LO-1234-D.skp
General arrangements	1234-3d.skp is inserted into	LO-1234-GA.skp
etc.		

3. In these drawing files, one scene is set up for each model view in LayOut. We create one LayOut file for each discipline of drawings or until the file becomes too large. There are few tricks to creating these scenes. We add geometry into the "LO-" files like back-clipping planes, and some line work, that is, any line work that looks better when created in the SketchUp model than in the LayOut drawing.
4. All design changes are done in the project model, and not the "LO-" files. This process can be made more efficient and less prone to content missing if all model changes are done in the project model, that is, 1234-3d.skp in this example. This model is then reloaded into all the "LO-" files. Only geometry that is scene specific is ever added to the "LO-" files.
5. The "LO-" SketchUp files are then imported into LayOut files.
6. The dimensions are annotated and added with LayOut tools. Processes of text addition and dimensioning are straightforward in the new LayOut 2.1. The tools in LayOut are not exactly like those of SketchUp in operation, but they are just as intuitive to use.

The most important part of this process is the setting up of appropriate scenes of your SketchUp models. These scenes do not have to be drawn because you have a model already. With layering, sections,

FIG 7.12 Perspective drawings, created in LayOut.

FIG 7.13 General arrangement plan, created in LayOut.

camera, and styles, all the rendering and visibility properties of every scene can be created. As you create drawings, you may decide to make design changes. If theses change are done to the project model and reloaded into all the "LO-" files, then all the changes to the model and all the scenes → drawings are automatically updated. This is extremely powerful and quick.

These drawings demonstrate the ability of LayOut to produce high-quality construction drawings.

Conclusion

The use of SketchUp and LayOut has improved our project flow because of the following reasons:

- They do not get in the way of our design work.
- They help us to better understand the physical fit and geometry of our projects.
- The process of modeling the existing facility, conceptual models, and final detailed construction models puts us closer to our work.

This is because of the intuitive interface and great flexibility of the program. SketchUp and LayOut tools are not menu driven or restricted to the modeling of specific elements. Their only limit is human knowledge and experience.

Design

SketchUp for Woodworking

Timothy S. Killen

*After retiring from a 36-year career in the engineering and construction industry
(which involved locations in Maryland, California, London, and Baghdad), Tim
Killen pursued a lifelong interest in woodworking. He is particularly interested in
reproducing eighteenth century museum pieces, and his home is already filled
with dozens of furniture reproductions in mahogany, maple, cherry, and pine.*

*Tim has written several articles on furniture making in Woodwork Magazine and
Fine Woodworking. He is a contributing editor to http://www.finewoodworking.com/
and is involved in developing and producing the blog Design. Click. Build.
(http://www.finewoodworking.com/blog/design-click-build) on SketchUp. He also
teaches classic woodworking and SketchUp at a local adult education center.*

*Tim Killen is a graduate electrical engineer from Purdue University, Indiana. He
also has an MBA degree from Golden Gate University, San Francisco. He lives in
Orinda, California, and his email address is tkillen@killenwood.com.*

> **Project**: Reproducing an eighteenth-century mahogany bookcase.
> **Tools** :SketchUp and Layout.

I enjoy reproducing classic eighteenth-century furniture and museum pieces;
however, drawings for these pieces are usually not available. Therefore, I face

the challenge of producing detailed design from scant information available in books, and sometimes from only pictures and overall dimensions.

In the case of the mahogany bookcase, I found a front and side orthogonal view with overall dimensions in a book by Charles H. Hayward called *Period Furniture Designs*. The only dimensions were overall width, height, and depth; but these are all I need to produce a complete and detailed three-dimensional (3D) model in SketchUp.

SketchUp is an extremely valuable tool for me in breaking down difficult projects and enabling my construction in the shop. It is so valuable that I will not start a construction without first building the project in SketchUp. The shop work is facilitated by the integrity of the design and the detailed products of the model, that is, fully dimensioned details, joint information, X-ray views, and full-size templates. I save time and materials, and more importantly, eliminate rework and frustration with SketchUp.

In many cases, including this bookcase, I attempt woodworking processes never before performed by me. I like these challenges but would not have had the confidence to attempt them without SketchUp. SketchUp has a way of uncovering and exposing the details and breaking down complexity, so that the actual work is understandable and doable.

The following picture is produced from the SketchUp design file. I used SketchUp to texture the model with mahogany wood grains based on the actual finish applied by me to the bookcase. One of the most challenging components of a bookcase is the cornice. This is also shown in the figure.

Project Context

The only software used in this project is SketchUp Pro, which includes Layout. All the design modeling could have been done with the free version of SketchUp. I use Layout to produce professional drawing packages in portable document format (PDF) for my students and other customers.

Technical Aspects

Prior to using SketchUp, I used various two-dimensional (2D) computer-aided design (CAD) systems to develop design drawings. I was familiar with 3D CAD, which was extensively used for developing large-scale process plant design at my work prior to retirement. I wanted 3D capability in my woodworking hobby at the time, but found these large CAD systems very expensive and difficult to use. I wanted 3D capability so that I could create unlimited views of the project in any direction or angle. Also, I would be able to produce exploded views, and visualize all the pieces of the furniture and how they connect. The 3D model would give me the opportunity to check joint fit-up and integrity.

About 4 years ago, I found SketchUp to be the answer to my 3D interests, and since then I have not used any other system or reverted to 2D systems.

In this case of designing the mahogany bookcase, I scanned the orthogonal front and side views in the book and imported the images in JPG format into SketchUp. After scaling-up the images in SketchUp to full size, I began to trace over the components of the bookcase, including stiles, rails, muntins, doors, and moldings. With these initial traces, I was able to reconstruct each 3D component, add the joint details, and fit these parts into a whole assembly.

Tip

When importing images (File/Import), SketchUp offers three alternatives: Use as image, Use as texture, or Use as new matched photo. Most of my imports, including the ones for this case, use the first option Use as image. This is the applicable option when importing orthographic views to be used as a background for tracing over.

After importing, straighten the image to align with the red and blue axes. This is done by drawing a line on top of a long horizontal or vertical line in the image. With the image selected, pick the Rotate tool and click the mouse to place the protractor on the end of the line. Click on the image (at a point of desired alignment with the placed line) and rotate the picture until it snaps and aligns with the placed line.

Also, the image needs to be set at full scale. Draw a line at a precise length on a part of the image for which the dimensions are known. Using the Tape measure tool, it is important to check the actual length of the object of known dimension in the image. Calculate the ratio of lengths (placed line length vs. object image length). Pick the Scale tool and adjust the size of the picture by typing in this ratio. Now, the objects in the picture will measure properly to their actual dimensions.

In furniture design, I find the following SketchUp features to be the most useful:

Components (every piece of the furniture is defined as a SketchUp component)
Move/Copy tool (used to precisely connect and copy components)
Line tool (used to create the lumber pieces)
Arc tool (for making shapes and moldings)
Push/Pull tool (gives a face of lumber its thickness)
Tape measure tool for temporary guidelines (particularly useful in designing detail complex joints)
Flip-Along (used to mirror various component parts, e.g., legs of a table)
Dimension tool (to add measurement annotations).

Scenes (for saving views of the model that create the final documentation package)

Intersect (used to join odd-shaped or curved pieces or to make cabriole legs)

Follow Me tool (creates turnings and molding shapes along a path)

Step 1: Designing the Complex Gothic-Style Cornice Molding for the Bookcase

Goals: To determine all the components required to assemble the molding and define how these pieces fit together.

Inputs: The limited orthographic front and side views provided in the reference book.

Tool :Only SketchUp.

The beauty and complexity of this cornice is one of the reasons I wanted to build this piece. I had not built a construction like this previously , and was curious and motivated to try it. My first step was to reproduce the molding shape by tracing over the scanned image. I used a combination of the line and arc tools to trace over the image. Multiple connected arcs were required to match the shapes. SketchUp conveniently tells you when the connected arc is tangent to the previous arc by turning a cyan color. Connecting the right shapes together is sometimes an iterative trial-and-error process.

The first step in recreating this cornice is to make a profile face of the molding shape. The image in Figure 8.1 shows the results of this first step.

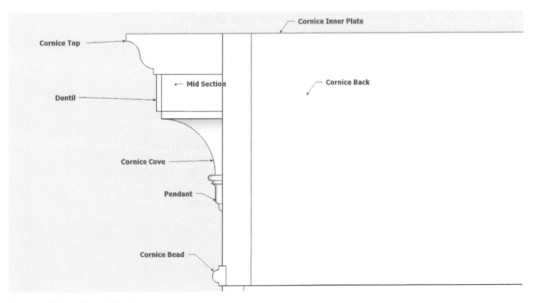

FIG 8.1 Profile face of the molding shape.

In creating this profile, I also divided the face into sections that represent individual component parts of the cornice. These parts or layers (totally seven in number) can now be extruded (minus the pendants) into solid lumber components with the Push/Pull tool, as shown in Figure 8.2.

FIG 8.2 Extruded components.

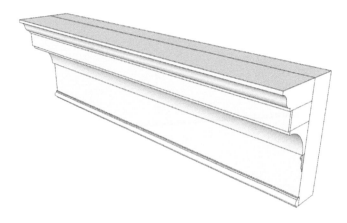

I continued to add detail to the cornice by defining the turned pendants as shown in Figures 8.3 and 8.4. The turned pendants were created in SketchUp using the Follow Me tool. A pendant-shaped half face was created by the trace-over process. A semicircular path was created with the axis at the origin of the circle. I rotated the circular path 7.5° so that the midpoints of the circle segments are aligned with the red axis. This ensures a clean Follow Me with a quality flat face on the half-pendant. Since the pendant is so small, the pendant shape and circular path should be scaled-up by a factor of 100 (SketchUp does not handle small faces well). After selecting the circular path, pick the Follow Me tool and click on the pendant shape. Figures 8.3 and 8.4 show the steps in making pendants.

The arched and hollowed-out cove was created by making a shaped block and then using the Intersect capability on the cove molding. An arch cut-out tool was created using the Push/Pull tool with the face of the arch shape as shown in Figure 8.5.

Place multiple copies of the cut-out tool spaced accurately into the solid cove molding as shown in Figure 8.6.

FIG 8.3 Preparation of pendant to use with Follow Me tool.

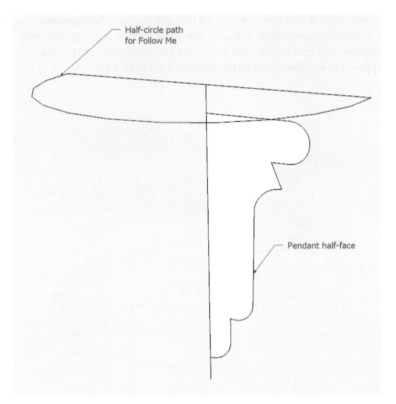

Half-circle path for Follow Me

Pendant half-face

FIG 8.4 Half-pendant results of Follow Me.

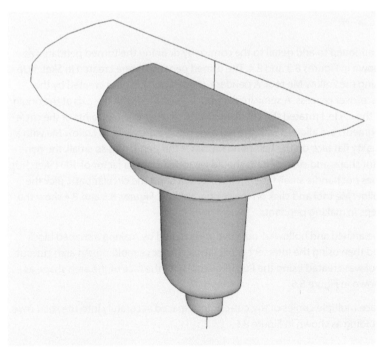

FIG 8.5 Create the arch.

FIG 8.6 Preparation for intersecting the cove with cut-out tools.

Explode all components (Cove molding and Cut-out tools); select all, right-click on the selection, and choose the option Intersect Selected from the pop-up menu. Use the Eraser tool to clean up the waste, and see the results as shown in Figure 8.7 .

Now, we are ready to assemble all the components into the completed cornice assembly as shown in Figure 8.8.

FIG 8.7 The cove molding after intersection.

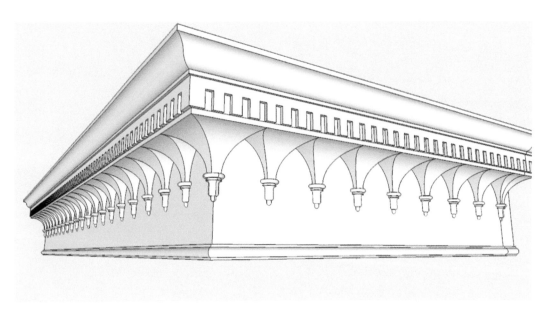

FIG 8.8 Assembled cornice.

After creating the completely assembled cornice, I began developing the drawing documentation with SketchUp to enable the actual construction in the shop. This includes an exploded view and detailed views of each cornice part. Each view of the cornice was saved to a Scene. I could easily return to each view by clicking on the Scene tab, and print the page to take to the shop.

I also saved Scenes for full-size templates. With the camera set to "parallel projection" mode and a standard view such as front view, right side, or top view, I was able to print full-scale sheets to produce templates for marking out the lumber in the shop.

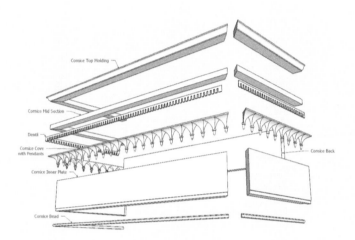

FIG 8.9 Exploded view.

Tip

The following steps are to be followed when printing full-sized templates:

1. Make sure your camera is in parallel projection, as you cannot print a full-size template in "perspective" mode.
2. You should have your camera view in one of the following standard views:
 (a) Top
 (b) Font
 (c) Right
 (d) Back
 (e) Left
3. I set up a toolbar with the camera standard views so that I can quickly set this option.
4. In this case, I do not click on the Print icon; rather, I clicked on File/Print Preview. I find that I need to adjust the view to get the least amount of tiled pages. This is an iterative process, so the Print Preview avoids wasting paper and ink.

5. After I click on Print Preview, the following dialog box pops up:

6. I check Properties of the dialog box to set the paper to Portrait or Landscape options.
7. The "fit to page" option is unchecked.
8. The Scale is set so that it is 1 in the printout, and 1 in SketchUp.
9. I look at the tiled sheet print range and note the number of pages that it will take to fully print the full-size template. In this case, it will take six pages.
10. I click the OK button, and the following view of the template will appear:

11. Note that I have a two-page view of the template, which is an option that I like, by clicking on one of the tabs in the view shown here.
12. By scrolling through all six pages, I see that I have to print only four pages to get all that I need.
13. If I like this arrangement, I can click on Print in the upper left-hand corner, or I can click on the Close button and return to SketchUp to rearrange the view on the screen (using Pan and Zoom). No orbiting is performed in this step, since you have to maintain a standard camera view. This is an iterative process of going back and forth to try out the Print Preview. You can also try a Portrait view to see if this reduces the number of pages.
14. When I click Print on this Preview, I get the dialog box again.

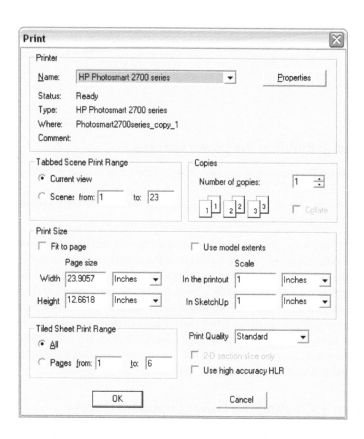

15. In this specific case, I know that I only need to print pages in the print range 1 – 4, so I change the number 6 to 4 and click the OK button.

FIG 8.10 Cove full-size template.

Step 2: Building the Lower Carcase

> **Goal**: To produce the detailed design of the lower carcase including dove-tail joints.
> **Inputs**: Overall front and side views provided in the reference book.
> **Tool** :SketchUp.

After completing the design of the cornice, my next step was to develop details for the lower carcase. Again I used the scanned images from the book to obtain the width, depth, and height of the lower carcase. I started the SketchUp model from the sides, adding the top, bottom, and finally the shelf. The initial modeling is done without joinery, and thus focuses on component creation and carcase sizing. When I was finally satisfied with the overall structure, sizing, and proportion, I detailed the joints including dovetails. The dovetails are first defined on the top piece, then with the top properly positioned on the side, and finally pins are created on the side component.

Step 3: Creating the Lower Cupboard Doors

> **Goal**: To produce the detailed design of the lower cupboard doors including all mortise and tenon joints.
> **Inputs**: Overall front and side views provided in the reference book.
> **Tool** :SketchUp.

The lower cupboard doors are more complicated than they seem. There is a solid, flat panel with separate corner pieces and an applied bead covering the

FIG 8.11 Carcase construction.

joint between the panel and the other door components, the stiles and rails. In SketchUp, I worked on various alternatives to accommodate expansion/contraction of the center panel. I settled on having the corner pieces with tongues glued into grooves in the stiles and rails. Then I allowed an expansion gap surrounding the perimeter of the panel. The final SketchUp design of the door is shown in Figure 8.12 in an exploded view.

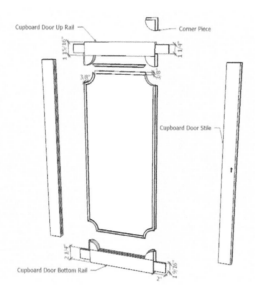

FIG 8.12 Lower cupboard door.

Step 4: Creating the Upper Muntined Doors

Goal: To produce the detailed design of the upper muntined doors including the angled muntins and accommodating the glass inserts.
Inputs: Overall front and side views provided in the reference book.
Tool :SketchUp.

Upper muntined doors comprise standard eighteenth-century-configured stiles and rails. These are connected through tenons. Also, a 3/16" bead is milled into the inner edges of stiles and rails. These beads are mitered at the corners. I started designing the SketchUp model with the construction of the stiles and rails as shown in the following illustrations (Figures 8.13, 8.14). The beads are created in SketchUp using the Push/Pull tool, and the miters are made by introducing an oversized surface plane at a 45° angle at the location of the miter joint. Then, using the Intersection with Model feature, the bead is cut with a miter joint.

FIG 8.13 Door rail.

FIG 8.14 Door stiles.

The upper door stile is designed with mortises for connecting the rails. After outlining with the Line tool, the mortises are created with the Push/Pull tool. The stile also has the mitered bead on the inside edge and fits the mitered bead on the rails.

After completing the SketchUp model of stiles and rails, I moved on to the muntins. I extruded a muntin shape using the Push/Pull tool. Then I worked on the method of connecting muntins to the rails and stiles. The result is shown in Figure 8.15, in which the muntin end is fitted with a small tenon that fits into 1/8"-wide slots in the stiles and rails. Also, the bead end of the muntin is mitered to a socket into a V-shaped cut at the edge bead of the stiles and rails. These V-shaped cuts again required placement of an oversized rectangular face on 45°; then using the tool Intersect with Model, the V-shaped notches are cut. You can see this connection in Figure 8.15.

FIG 8.15 Muntin connections.

Again I used SketchUp's capability to produce orthographic and cross-sectional views to help with the construction of muntin shapes. Figure 8.16 gives an illustration and a full-sized template that I used in the shop.

After working out the muntin connections at the stiles and rails, I began to develop the muntin-to-muntin angled intersections. After positioning (in SketchUp) the muntin pieces into their respective places in the array, I made the precise angled cuts on these muntin pieces at their intersections. See the following close-up illustration (Figure 8.17) of one of these muntin intersections. Again, I made the angled cuts on the end of the muntin pieces

FIG 8.16 Muntin shape.

FIG 8.17 Angled muntin-to-muntin connections.

by placing a rectangular plane at the intersection and using the Intersection with Model tool. It is very helpful when SketchUp provides these various angle measurements (as no further geometric calculations necessary) using the Protractor tool.

Conclusion

Increasingly, woodworkers around the world are adopting SketchUp as a design tool. This application opens up new 3D capabilities that were previously unavailable, except to a few professional CAD designers and illustrators with esoteric, hard-to-use, expensive systems. Now, woodworkers can "build" and assemble their furniture on the computer (prior to real construction in the shop) using SketchUp's components representing each separate lumber piece. The joint details are also developed in the furniture model, and these details can be easily viewed and checked with SketchUp's unlimited viewing options. Exploded views, which are so helpful for illustrating the piece-by-piece assembly and simplifying the construction, are now easy to create.

FIG 8.18 Final, complete SketchUp model.

FIG 8.19 The constructed reproduction in mahogany.

When you design in SketchUp, you are "fabricating" and connecting furniture parts, not simply drawing lines and arcs. You are in 3D space and using the components you create for a close correspondence between shop work and the computer design process.

The basic design strategy is the same irrespective of whether you design from scratch; work from a picture, a rough sketch, or a detailed-scale drawing; or take measurements from an actual piece. The different levels of detail in these sources affect the ease of design in SketchUp, but they do not neces-sarily change the basic approach. Begin at the foundation and work your way upward, adding details as you go. Think in terms of the procedure you would use in the shop to construct this piece of furniture. Which parts would you build first? How would you sequence the construction? Working in SketchUp is startlingly similar.

Even when I have access to detailed drawings, I find it beneficial to build a SketchUp model. Too often, drawings are incomplete and full of errors. I save time, frustration, and materials in the shop if I construct a SketchUp model first. As a by-product, SketchUp provides full-sized templates that I can use to lay out joints or specific shapes. Working in SketchUp also gives you time to preview the actual construction steps as you build the model. You get a good picture of how to make parts and fit them together.

PART 4

Set Design

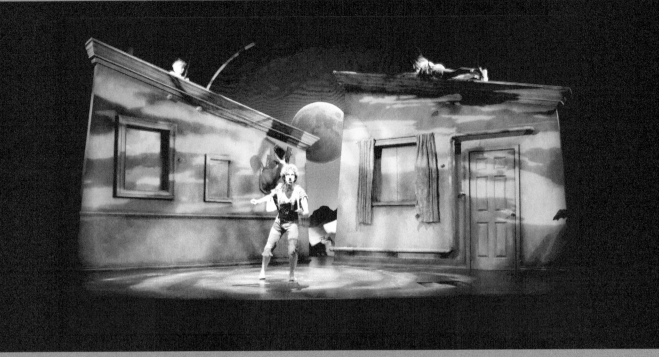

SketchUp Powers Theatre Scenic Design

Kim A. Tolman

Kim A. Tolman, a native of Germany, is an award-winning scenic designer. She relocated from Cologne, Germany, to the San Francisco Bay Area, California, in 2001. Kim brought along her scenic design and hand-drafting skills that she had refined in German theatre and opera to California, where she quickly made the transition to computer-aided design. Kim became a user and advocate of SketchUp, which she enjoys for its power and ease of use. She was one of the only 300 individuals worldwide who were chosen to attend Google SketchUp 3D Basecamp 2008.

Kim designs at theatres throughout the United States and is a member of the United Scenic Artists, Local United Scenic Artists (USA) 829, and International Alliance of Theatrical Stage Employees (IATSE). Her Web site is http://www.kimtolmandesign.com

> **Project**: Scenic design for *A Midsummer Night's Dream* at Center REP Theatre, Walnut Creek, California.

Google SketchUp Workshop

153

Tools: SketchUp Pro 7; Style Builder; LayOut; Render Plus RpTools; various Ruby Scripts, including Move to Origin and Angular Dimension; AutoCAD; Photoshop CS; Adobe Acrobat.

In theatrical productions, the primary client is the director. It is the task of the scenic designer to collaborate with the director to help bring the director's vision for the production to the stage. The director relies on the scenic designer to create and develop visual concepts. Director Michael Butler wished to stage the classic play, Shakespeare's *A Midsummer Night's Dream*, in a nontraditional way. Butler says, "Midsummer has two distinct worlds: that of the Court with all its rules and constraints, and the forest, which is anarchic, mischievous, erotic. I thought of the play as a gleeful and unruly rebellion of the imagination against all those forces that tell us what we are supposed to do. I wanted also to play with strange intersections of dream world with real world, like vines invading our hair while we sleep. So rather than keep the two worlds separate, Kim and I wanted the world of the Court to be taken over and transformed by the forest, much the way it might happen in a dream where the familiar can suddenly alter in strange ways."

Additionally, the director and scenic designer were inspired by pop-up books. Butler continues "Kim has an extraordinary collection of macabre pop-up books from all over the world and we both loved the two-dimensional (2D) and yet weirdly convincing effect of their transformations."

Scenic Designer Kim A. Tolman, who often uses SketchUp in her design work, introduced Butler to the 3D modeling software, which they used as a collaborative tool. Kim says she likes the ability of SketchUp by which she can quickly communicate creative ideas with the software, as well as SketchUp's ease of editing for instant manipulation of designs.

Project Context

For *A Midsummer Night's Dream*, I had approximately one month to deliver my first concept sketches. I worked in collaborative sessions with Director Butler, inputting and manipulating our ideas in SketchUp and exporting the images to PDF with Adobe Acrobat to generate concept color renderings .

When designing for theatre productions, the scenic designer has a standard set of deliverables (specified in the following list). After the design is approved by the director, the scenic designer needs to produce the drawings and renderings from which the technical director's team of carpenters can build the scenery and the scenic artists can paint. The scenic designer typically has 1–3 months from the approval of the design till the delivery of all drawings and renderings. The final deliverables are as follows:

- Set concept color renderings
- 3D computer model (or to-scale physical model)

- Ground plans, centerline sections, elevation drawings and sections (AutoCAD or hand-drafted ones)
- Paint elevations (computer-generated and/or hand-painted ones)
- Color samples

Technical Aspects

SketchUp has a primary place in my design toolbox. I find it not only an excellent means of visualizing and creating a design but also a powerful tool for communicating stage design concepts, as well as the final design to the director and other members of the production team (lighting designer, costume designer, technical director, property designer, scenic artist, and others).

The scenery for *A Midsummer Night's Dream* prominently featured two walls that leaned back from their upright positions via the use of pneumatic piston supports. SketchUp allowed me to effectively and easily communicate this function to the technical director, who was charged with the task of devising the system for moving the walls down and then back up, representing both the chaotic world of the forest and the rigid Athenian court.

I use SketchUp to deliver the 3D computer model to the director and the creative team. On the 3D computer model, I used Render Plus RpTools for easy layout of 3D components. RpTools allows me to Select, Place, Move, Copy, Rotate, Mirror, Stretch, and Aim components.

And because I create to-scale with accurate measurements, I can also export the SketchUp model to AutoCAD to use as the basis of the ground plan, centerline section, and elevation drawings. This is a major labor-saving benefit of using SketchUp.

For the paint elevations, I export from SketchUp to Photoshop, where I manipulate color and shading and then obtain a printout on paper. I then paint over the paper printouts to get the final desired colors, shading, and textures. These paint elevations are used by the scenic artist as a guideline in painting the finished scenery pieces that were built by the technical director's team.

New Approaches

In theatre applications as a scenic design tool, SketchUp is not only a time-saver for the scenic designer but also a powerful creative and communica-tive tool. Director Michael Butler is typical of the collaborators with whom I have worked and introduced the power and flexibility of SketchUp. Another collaborator, Director Jon Tracy says, "SketchUp revolutionized the preproduc-tion process for me." Director Robin Stanton says, "It takes the collaboration to another level. The aesthetics and mechanics can be easily and effectively communicated to industry veterans as well as early career artists effortlessly." Director Joy Carlin adds, "It taught me how to look at the performing space

from every conceivable depth and angle, making it so much easier for me to imagine how the actors could move around, make exits and entrances, where the best focus points might be, and so on."

Director Nancy Engle had even more to say about the software: "SketchUp has made scenic design discussions infinitely more productive. It clearly communicates the look and feel of the design and facilitates instant feedback from directors and other members of the design team. As a director, I appreciate the ability to take a 3D look at the complete stage setting. I can see everything the audience sees and everything they cannot. SketchUp allows me to live in the scenic environment, before I ask the actors to inhabit it. And SketchUp saves time, money, and energy in communicating the scenic design to the craftsmen who must implement the design."

Step 1: Preparation/Start of Scenic Design Project

Objective: To initiate the project.
Data: Script, project time line.
Tools: Internet, word processor (to read digital script), pencil and paper.

The first steps to be followed in starting the design process are as follows:

- Reading the script: digital and/or hard copy
- Meeting the director
- Deciding on a design concept
- Performing research
- Reading the script again: digital and/or hard copy (generating very rough, first sketches/ideas/ground plans on paper)

Step 2: 3D White to-Scale Model

Objective: To get familiar with the theatre space.
Data: Documents submitted by the theatre: ground plan, centerline section, additional important house measurements, stock inventory list, etc.
Tools: Supplies to build a physical 1/2"-scale model of the theatre.

I built the model from drawings received from the theatre. The physical "white" model helped the director and me to "play" with the space. I created rough set pieces and a rough layout.

Note: In most scenic design projects, the use of SketchUp to build a 3D computer model has replaced the need to build the to-scale physical model described here.

Step 3: Recreating the Theatre Building in SketchUp

Objective: To get familiar with the space – an essential step in creating a concept/design – and check possible reuse of 3D theatre model for future projects at the same venue.

Data: Documents submitted by the theatre: digital ground plan, digital centerline section, additional important house measurements, stock inventory list, etc.
Tools :AutoCAD, SketchUp Pro.

I import the ground plan and centerline section into SketchUp, and then scale the model with the Tape measure tool. The crossing point of the ground plan's centerline and the plaster line should be the origin. I turn each plan into a group. Then I right click on the plans and choose Lock from the pull-down menu to lock the important documents. (Note: Locked plan will turn red.) This step will protect the imported drawings and prevent me from erasing lines accidently. I start drawing on top of the ground plan, referring to the centerline section for height dimensions.

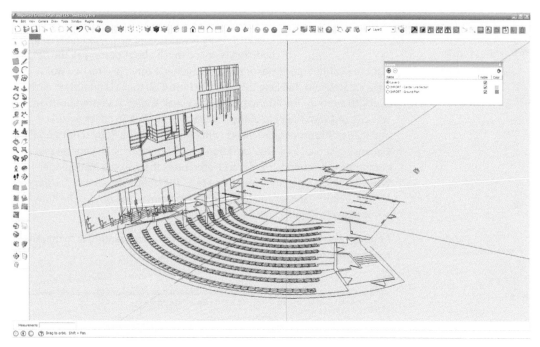

FIG 9.1 Image of the ground plan and centerline section in place.

Tip

From the very beginning, I put everything on layers, grouping things by adding a word or a letter in front of the layer name, for example, IMPORT– Ground Plan and IMPORT–Centerline Section. All theatre architecture starts with "T–" (T–Proscenium, T–Walls, etc.). All furniture starts with "F–" (F–Sofa, F–Bed, etc.). This is a good way to keep the model organized by grouping similar items. I start recreating the space step by step, putting objects on layers using the method outlined in Step 3.

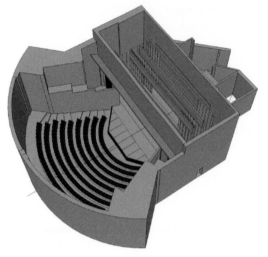

FIG 9.2 Empty model box.

Step 4: 2D Sketch

Objective: To communicate a preliminary concept/idea to the director (and possibly other members of the production team) and also provide support for discussions about design process.

Data: SketchUp model of theatre, first hand-drawn sketches, notes from meetings with director.

Tools: SketchUp Pro, SU Style Builder.

I started modeling first concept ideas using initial hand-drawn sketches as support. I first created a scene for each point of view: top view, section cuts, and work view (a view of the model with unnecessary layers turned off). This first step of modeling is not so much about getting all the details right than about quickly expressing the general concept. The two walls were created with the Line tool and the Push/Pull tool. I then turned each wall into a group. The arrangement of the wall angles in slanted position was created with the help of the compass command. To check accuracy and take printouts of quick views with dimensions, the Ruby script Angular Dimension served as a great additional tool. Sometimes, I create set pieces and props in a separate model and later insert them to the main model. When I create a separate component (e.g., the potion flower in *A Midsummer Night's Dream*), I always create the insertion point at the origin. The Ruby script Move To Origin can be very helpful in this.

Another great help is Render Plus RpTools, which I constantly use to quickly resize components, groups, and other elements.

FIG 9.3 The model at Step 4.

Nearly everything in the model is either a group or a component. I worked with standard theatre component measurements from the beginning (e.g., 4" × 8" flats and the 18" rule for step units). Because standard component dimensions were used, when the preliminary design concept was approved, I could build the rough model without redoing everything. When the design was finished to the point where design ideas could be communicated and presented, I printed one or several views of the model as images. Before doing so, I created a new scene and named it Midsummer/Sketch. I then created a new style that applies only to this scene. The style was created in SketchUp Style Builder. I created the style by using hand-drawn sketchy strokes first and scanning them to create an image file, which I edited in Photoshop and pasted back to the confines of the template boxes in SU Style Builder.

FIG 9.4 Rough sketch.

Tip

The rough "sketchiness" of this particular style helps to keep the creative process more open and not so "nailed down" when presenting it to the director and the rest of the production team. It looks very much like a hand-rendered sketch, rather than a technical drawing. In fact, SketchUp lets you create images that look as if they were sketched with all the beautiful imperfection of the human hand. In addition, rough ground plans can be printed simply by using the Top View option in SketchUp. These sketches and preliminary grounds plans are usually enough information for an early design meeting.

Step 5: Presenting Preliminary Design Sketches and Ground Plans

Objectives: To obtain support for discussion with the director and the creative team, and approval before more detailed 3D modeling and design continuation.
Data: Printed sketches and ground plans.
Tools :SketchUp Pro.

I bring the preliminary computer model to the production meeting in case clarification or possible instant manipulation/modification/editing are needed.

Step 6: Preliminary Design Approved – More Detailed Modeling

Objectives: To refine and, possibly, revise design.
Data: Meeting notes, preliminary SketchUp model.
Tools :SketchUp Pro.

I start adding more detail to the design, for example, using the Follow Me tool for all trim, crown moldings, and pipe.

> **Tip**
>
> When I work on a particular group or component within the model, I usually isolate it from the rest of the model. This makes all-around access easy. Also, it is less taxing on CPU and RAM resources. I go to View, select Component Edit from the drop-down menu, and select Hide Rest of Model. To Unhide, I need to only uncheck the latter option.

To create crown molding, I simply draw a profile or pick one from the molding supplier's catalog (check if a CAD drawing is available on their Web site for importing purposes) and attach it to the top of the wall. I then select the edges to which I want to apply the molding, and then pick the Follow Me tool and select the profile.

Step 7: Adding Colors and Textures

Objectives: To refine and, possibly, revise design.
Data: Meeting notes, preliminary SketchUp model.
Tools :SketchUp Pro, Photoshop.

I apply materials from the expanded SketchUp library. I then export the front view of each set element as a JPG image.

In Photoshop, I add highlight and shadow, and modify textures as needed. I then project images back into their original space in the model.

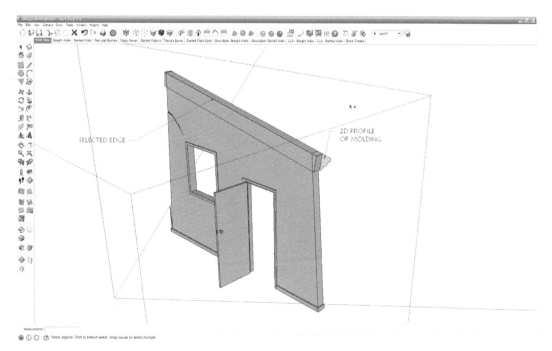

SELECTED EDGE

2D PROFILE
OF MOLDING

FIG 9.5 Creation of crown molding.

Tip

It is a good idea to always be on the lookout for images to expand your SketchUp library. For example, I had a photograph of a stone wall with cracks and textures that I wanted to use for my *A Midsummer Night's Dream* model and possibly for future projects. To use this photograph, I opened a new SketchUp file, went to Top View, selected File, and browsed for the image. I checked Use as image option and imported it to the model. I then right-clicked and exploded the image. Then I clicked on the Paint Bucket to display Materials, selected the Home (In Model) tab, and saw the imported image in the Materials display. To display the secondary selection pane with existing Libraries, I clicked the button near the top right of the Materials display. The display expanded to show existing libraries and I dragged the new material image into the appropriate category. Categories (new directory folders) can be created within the Materials folder that lies within SketchUp's program files on the root directory, for example, C:\Program Files\Google\Google SketchUp 7\Materials\Stone.

I then used SketchUp LayOut to create the design presentation.

FIG 9.6 Model without walls.

Step 8: Presenting Final Design, 3D Computer Model, SU LayOut Presentation, and Updated Ground Plans

Objectives: To present the final design, 3D computer model, SketchUp LayOut presentation, and updated ground plans to the director and the creative team.
Data: Printed LayOut color renderings and ground plans, and CDs with model and SketchUp viewer for production team.
Tools :SketchUp Pro.

I use the finished SketchUp 3D model to present the design. Because scenes have been created, the slideshow option in SketchUp can be used for presentation. On some occasions, I project the presentation onto a screen.

Step 9: Final Design Approved – Final Ground Plans and Center Line Section to Be Created

Objective: Create technical drawings.
Data: SketchUp model.
Tools :SketchUp Pro, AutoCAD.

The ground plan is created as follows: From the Top View in SketchUp, I go to File, Export, and 2D Image, and select.dwg file. I then open the .dwg file in AutoCAD and finalize the drawing. Usually, I "clean up" the drawing a bit. A few examples for this are given here. Often, there are extra lines stacked on top of each other that are remnants of the conversion from 3D to 2D that I need to erase. I redraw circles and arches (they are segments when imported from SketchUp and it is difficult to put dimensions on them), and I put areas of the drawing on different layers in order to organize the drawing and create line weights. For example, I put all scenery on its own layer to differentiate it from other elements.

FIG 9.7 Layout presentation.

The centerline section is created as follows: I create a section plane at the centerline in SketchUp. I then go to File, Export, 2D Image, and select .dwg file. I open the .dwg file in AutoCAD and finalize the drawing.

Step 10: Final Design Approved – Elevation Drawings to Be Created

Objective: Create technical drawings.
Data: SketchUp model.
Tools :SketchUp Pro, AutoCAD.

I exported the components from SketchUp into my project folder called Set Elements. Each set piece was processed separately. I selected Camera > Parallel Projection. I then opened each component as a new model and exported plan, side, front, and section views, each as a separate .dwg file. I then imported each .dwg file into AutoCAD and arranged the elevation drawings.

SketchUp also allows the exporting of isometric views to AutoCAD for more complicated pieces and better communication with the technical director. Simply select the Iso View Command, go to File option, and select Export from the drop-down menu; further, select 2D Graphic, destination folder, and Export Type as AutoCAD DWG.

Step 11: Final Design Approved – Paint Elevations and Color Samples to Be Created

Objective: Create guidelines for the scenic artist.
Data: SketchUp model.
Tools: SketchUp Pro, Photoshop, brushes and paint.

FIG 9.8 Show pictures.

From the folder Set Elements, I processed each element separately by opening the element in SketchUp. I selected Camera > Parallel Projection. I then exported desired views to JPG image format. Then I opened JPG in Photoshop and added desired colors, shadow, highlight, and texture. I printed out to scale on high-resolution paper. Then I did final modifications with brushes and paint.

Further, I used brushes and paint to create color samples to be used by scenic artists.

FIG 9.9

FIG 9.10

Conclusion

SketchUp was a natural choice for this project, and it is useful for any scenic design project. SketchUp was especially helpful in

- Allowing me as the scenic designer to quickly prepare the layout and edit multiple scenic concepts during collaborative creative sessions with the director
- Easily communicating the scenic design to all members of the production creative team
- Exporting SketchUp models to AutoCAD, which is a major time- and labor-saving feature for a scenic designer

A Midsummer Night's Dream opened at Center REP Theatre on April 1, 2008, for a very successful run. Both Director Michael Butler and the audiences were quite pleased and charmed by the set I designed with the help of SketchUp.

Resources

Software

Atodesk AutoCAD

Aobe Photoshop CS

Aobe Acrobat

SketchUp Plug-ins

SUStyle Builder

LyOut

RendePlus RpTools

Various Ruby scripts, including Move to Origin and Angular Dimension

Architectural Graphics

A Virtual House

Laurent Brixius

*After receiving his architectural diploma in 1996, Laurent Brixius set up the ARCH'image
practice in 1997 with two other partners who are as passionate as he is about
information technology and architecture. The bulk of his work is taken up with the
creation of computer-generated perspectives and animations to help architects and
property developers communicate with their clients and to promote their own projects.
He shares his passion for graphics on the ARCH'image blog, where he posts articles
dedicated to computer-generated imagery, several of which focus on SketchUp.*

Project: Virtual house for the Belgian Federal Interior Services Ministry.
Tools: SketchUp 7, 3D Studio Max 9, Pano2VR, Photoshop CS, and Notepad2.

Project Context

The Virtual House was a project carried out for the Belgian Federal Department for
Interior Affairs. The aim of the project was to make Belgian citizens aware of the
means available for protecting and securing their homes against break-ins and fire.
The details of the project are available at http://www.vps.fgov.be/virtualhouse.

The ministry first wanted an animation put together that would present, in a
sequential fashion, the available means of prevention and security.

Because of the drawbacks associated with this approach (production cost, difficulties with updating it and incorporating future developments, lack of engagement from passive viewers, and a small prospective audience), we proposed improving the visitor experience by using a virtual-reality, interactive tour embedded in a website.

Available on interactive terminals at exhibitions and trade fairs, the Virtual House would allow people to access information at their own pace and according to their personal requirements. Initially intended to go on display at the Batibouw Brussels construction trade fair in the Belgian capital, the project is now available for everybody to use via the Internet at the following address: http://www.besafe.be/virtualhouse .

Technical Context

The project was subject to numerous constraints:

1. Three-month deadline;
2. Limited budget;
3. The innovative nature of the project meant that there was a lack of existing information about how best to implement it.

Therefore, this project needed very tight organization and a clear definition of the tasks to be accomplished by the various people involved in it. In order to gain an overall view of the project, a heuristic chart or "Mind Map" was used. This enabled those taking part to clearly see how the various elements of the project interacted with each other.

A storyboard was then put together to present to the clients, detailing all the different security methods in their contexts. The storyboard was also used to plan a walkthrough. For the modeling, SketchUp Pro was used from the initial sketches to the modeling of the details. The model was then imported into 3D Studio Max for the application of textures, a realistic lighting setup, the setup of still and animated cameras, and the production of 360° VR panoramas and the walkthrough.

For the VR panoramas and the placing of hotspots, QuickTime was used first. However, because of compatibility issues, Flash was subsequently chosen and the placing of hotspots was done with Pano2VR software.

For the production of the website, an improved version of Notepad, Notepad2, was used.

Why Choose SketchUp?

First of all, because it is fun to work with. Its intuitive nature, speed, and ease-of-use have made SketchUp our practice's tool of choice for quick 3D modeling. It is also used for modeling a large number of detailed projects, images from which go on to be entered into architectural competitions or used in real estate advertising. However, 3D Studio Max is still used for certain

elements that would be difficult to model in SketchUp, for example, objects that need to have parametric data input.

The second argument in favor of SketchUp is the lower number of faces that are produced when modeling, something that can greatly reduce the calculation time for a rendered image.

Third is SketchUp's ability to communicate a project clearly and unambiguously, either with a client or with those involved in the construction process. The fact that the client can understand the project immediately means that decisions are made more quickly.

Techniques Used

Many users make great use of layers when they work with SketchUp; however, SketchUp's layers do not work in the same way as those in other CAD programs. In SketchUp, the following approach should be employed: All faces and edges should be drawn on Layer0. Then, they should be either grouped or made into components and then assigned to a particular layer. Only groups or components should ever be placed on a layer other than Layer0. Layers are used for project organization and to simplify the workspace by only showing the elements being worked on at any given moment.

For this project, two Ruby plug-in scripts were used:

- Push–Pull Z: This plug-in saves an enormous amount of time when modeling roofs. The roof pitches are first modeled as simple faces. Then the faces that are to be push-pulled (i.e., given thickness) are selected. The plug-in is then chosen from the Plug-Ins menu, and a dialog box appears. The desired thickness is entered here, OK is clicked, and the roof pitches will be extruded in the Z axis (not perpendicular to the surface, as the standard Push–Pull tool does). Any other modeling can be carried out using SketchUp's own Push–Pull tool.
- Reverse Faces: After choosing it from the Plug-Ins menu, this Ruby script allows you to change the orientation of a face by using a simple left-click. With the default material, the face is either beige (exterior) or blue-gray (interior). Most rendering engines will not "see" a face if its interior is pointing outwards (if it is "flipped"). If a face in the SketchUp model is flipped, it will simply be ignored during the render calculation, and your model will appear to be full of "holes."

Tip

If you have applied materials to faces, you cannot tell whether they have been flipped or not. If this is the case, change the Face Styles display mode to Monochrome to see all faces in the default color. You will then be able to see each face's orientation and to change any flipped faces using the Reverse Faces plug-in.

New Approaches

If you have a well-organized 3D model, you can avoid making lots of errors and save many hours of work. One of the most important things that you can do is to clearly name all the elements that make up your scene. Our practice has developed a naming system that allows us to very rapidly identify any architectural element. To avoid having to rename each element when it is imported into 3D Studio Max, a three-stage preparation method is used:

1. A materials library is created in which each material corresponds to the layers that will be used for export. Our practice has a ready-made library of materials, and we add new ones as necessary.
2. The materials are then added to the different elements in the SketchUp model using the Paint Bucket tool. These materials have names such as 41 brick, 31 framing, 37 facia, 47 roofing, etc.
3. Before export, the plug-in Layer by Material is run. As its name suggests, this creates a layer for each type of material used in the model and moves all elements that have that material applied to the relevant layer.

The model is now ready to be exported in DWG or 3DS format.

> **Tip**
>
> Sometimes, groups and components may need to be exploded before using this plug-in. If this needs to be done, the original model should be saved and a copy should be made. This will conserve the working organization of the original model. In the copy, all the groups and components should then be exploded. This process can be automated by using the Bomb plug-in by Rick Wilson.

Stage 1: Draw Up a Schedule

Objectives: To draw up a list of key project stages and a list of fire protection and security measures to be shown in the Virtual House. To define the extent of the project and the submission dates for the intermediate stages. To create a storyboard showing each element in place.
Data: Documents provided by the client and information collected during initial client meetings.
Tools: Pencil and paper; copies of storyboard pages; and Mind Mapping software.

As essential element for the smooth running of the project, the schedule allows you to clearly define the expectations of your clients and what you need to deliver.

Using Mind Maps gave a global overview of the project, enabling a clear visualization of the complex interactions between the different webpages that need to be created.

The creation of a storyboard meant that certain views could be agreed upon with the client. The level of detail of certain elements within the Virtual House could also be set at this stage, according to their distance from the camera in each storyboard view.

Stage 2: Hand Sketches of the House

Objective: To clarify the volumes in the spaces that need to be created.
Data: Data obtained in the previous stage.
Tools: Pencil, eraser, and paper.

Even if SketchUp is an extremely intuitive sketching tool, it is often best to start off with hand drawings.

Stage 3: 3D Roughs of the House in SketchUp

Objective: To create models that would aid in client discussions and validation with clients before more detailed 3D modeling takes place.
Data: Hand sketches, storyboard showing key elements, and Mind Map.
Tool :SketchUp Pro.

Modeling starts off with the exterior envelope of the house: The outline of the house is drawn with the Line tool, then the Push–Pull tool is used to extrude the newly created face, forming a volume. The volume is then further sculpted using guides and the Line and Push–Pull tools.

Screenshots of this first stage were then sent to the client for approval, and the date for a consultation meeting was fixed.

FIG 10.1 3D sketch.

At the same time, modeling of the immediate surroundings of the house in SketchUp was started. In order to speed up the OpenGL display, the house

and the surroundings were initially modeled in separate files. Modeling the surrounding wooded hills would be carried out in 3D Studio Max at a later stage.

Stage 4: Consultation Meeting with the Client

Objective: To evaluate the suitability of the 3D sketch in terms of the methods of fire prevention and household security to be presented. Determine what modifications need to be made to the project.
Data: Visualization of the 3D model in SketchUp and print images.
Tool :SketchUp Pro.

At the meeting, the 3D model was viewed from all angles within SketchUp using the Orbit tool. A list of modifications was drawn up.

Stage 5: New 3D Rough and Client Validation

Objective: Adapting the 3D model according to the constraints defined during the consultation meeting.
Data: Notes from the meeting and annotated images from the client meeting.
Tool :SketchUp Pro.

A new model was made, taking into account remarks made during the client meeting. The project was then tweaked to better respond to the client's demands.

At the same time, a schematic development of the interior of the house was carried out, based upon the new exterior volume.

FIG 10.2 New 3D sketch.

After viewing the amended model, the client gave their approval, which meant that the model could be further detailed.

Stage 6: Detailed 3D Modeling in SketchUp

Objective: To create a detailed 3D model that would be used as the basis for computer-generated renders.
Data: 3D sketch approved by the client.
Tool :SketchUp Pro.

After an inconclusive attempt to separately model the interior and exterior of the house, the modeling was started anew. The client-approved 3D rough was loaded into SketchUp and the whole thing was grouped and placed onto its own layer. This model would serve as a reference for any subsequent modeling and its visibility could be easily turn on and off by unticking the Visibility checkbox on the layer.

Modeling was started by drawing the outline of the house using the Line tool. Once this outline was complete, the wall thicknesses were added by using the Offset tool.

FIG 10.3 Tracing the outline.

First, the walls and interior partitions were modeled, along with the stairwell. To make. subsequent modeling work easier, materials from the 'Layers' library were assigned to all the different materials in the model: One for the stone wall work, another for brickwork, another for stud partitions, etc.

With this stitch over, the walls and partitions were extruded using the Push–Pull tool to a height a yard or two greater than the ridgeline of the roof.

Next, the two roof pitches were modeled by simply drawing two lines and then rotating them to the correct pitch using SketchUp's Rotation tool. These lines were then Copy-Moved so that the resulting roof pitch would completely

FIG 10.4 Modeling the walls.

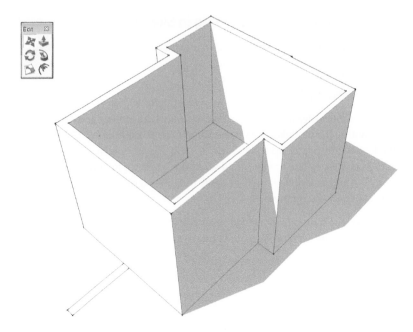

overlap the house model. The ends of the lines were then joined using the Line tool, which automatically created the faces.

In this stage, the extruded walls and partitions were selected, as well as the two faces that defined the roof pitch. Since SketchUp does not have any native Boolean tools, the Intersect with Selection command was used (right-click and choose Intersect > Intersect with Selection from the contextual menu). This resulted in cuts being made to the model that correspond to the roof pitch and to the gable ends. The next step is to select all the geometry above the roof pitches and to erase them using the Delete key.

FIG 10.5 Cutting the walls using the roof pitches.

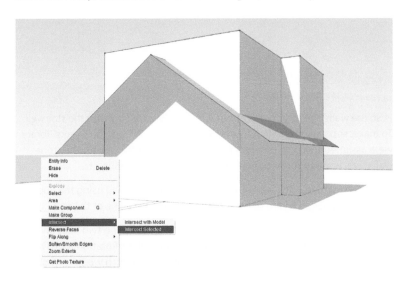

FIG 10.6 Cutting the walls using the roof pitches.

Tip

Choosing the Intersect with Selection option instead of the straight Intersect option places less stress on the processor and produces a quicker result.

To produce the roof thickness, the Push–Pull tool was used on each of the pitches. Guidelines were used to locate the precise intersection of the ridge line. The upper edge of a single pitch was selected, then, using the Move tool, the end point of the edge (look for the green Endpoint snap dot) was moved until it snapped to the intersection of the guidelines.

FIG 10.7 Push-pulling the roof pitches directly in the Z axis.

Tip

A quicker and easier solution would be to extrude the roof pitches directly up in the *Z* axis, something that is not possible with SketchUp's own Push–Pull tool. Luckily, Didier Bur has created a plug-in, Push–Pull Z, that allows you to do just that. See under section "Techniques Used."

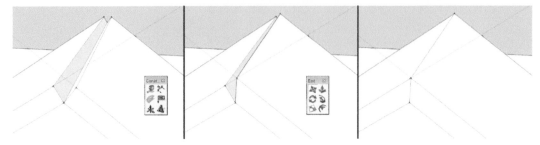

FIG 10.8 Closing the ridgeline using the Move tool with guidelines.

With the basic roof shape completed, the fascias and soffits were then modeled, as well as the garden wall and the sunscreen canopy. Next followed the modeling of the window and door openings, simply by drawing them onto the exterior surfaces and push-pulling them through. For the circular window, the Circle tool was used, but with its number of sides set to 96 to avoid any jagged edges in the final renders.

Tip

By default, circles are made up of only 24 segments and arcs of 12 segments, which is insufficient for getting a smooth outline. This value can be increased either in the VCB before you start drawing or at any time from the Entity Info palette. Once a face is extruded, the number of circles or arc segments cannot be changed. Arc segments can, however, be changed if the arc is part of a face.

The door and window frames were modeled independently. Each frame was created as a component in order to make any future modifications easier.

The chimney pipe was modeled simply by drawing a circle of the required diameter and extruding it. The conical end was achieved by extruding the upper face using the Push–Pull tool holding down the Alt/Option key (Mac) or the Ctrl key (Windows). This creates a new pipe segment that can be selected separately. The conical end was achieved by selecting the upper surface of the

FIG 10.9 Modeling the canopy and the garden wall.

FIG 10.10 The window openings push-pulled through.

FIG 10.11 The door and window frames modeled.

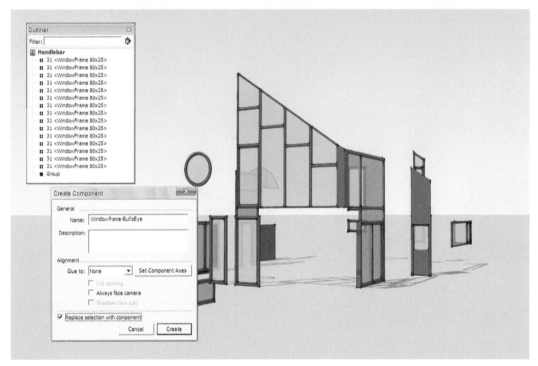

FIG 10.12 Creating the window frame components.

new segment and doing a uniform X, Y scale – about the center (hold down the Alt/Option key on the Mac or the Ctrl key in Windows).

Stage 7: Preparing and Exporting the Model from SketchUp

Just before exporting, the Layer by Material plug-in was run. This creates a number of layers corresponding to the number of different materials in your model and then places all elements that have the same material into the corresponding layer (see under section "New Approaches").

The model can now be exported to DWG format. To do this, in the Menu Bar, go to File > Export > 3D Model… and then choose AutoCAD DWG from the Export Type: drop-down menu. In the Options… sub-dialog, make sure that only Export: Faces is ticked. This will avoid exporting unwanted geometry like stray lines, etc.

For the balustrade, a separate SketchUp file was created by copying only the edges and pasting them in a new file using the Paste in place command. For this file, the export options were set to Edges only. These could then be used as paths for the Lofts or Sweep commands, or simply be given parametric thickness.

Tip

SketchUp remembers the last export options that were used. Always remember to check your export options before your next export operation.

Stage 8: Detailing the Model in 3D Studio Max

Objective: To continue modeling the house and its surroundings in more detail.

Data: Model exported from the SketchUp in DWG format.

Tool :3D Studio Max.

The DWG files were imported into 3D Studio Max, choosing the AutoCAD Drawing import option.

Tip

If you need to work in metric, remember that SketchUp7 exports files with metric units as if they were inches (this was corrected in 7.1). You can correct this if you have a copy of AutoCAD: enter "_units" in the command line, indicating the correct units in place of "Inches." If you do not have AutoCAD, the AutoCAD Drawing format allows you to configure the imported file units manually and so this should be your preferred export format.

In order to keep all modeling options open, only the edges that correspond to the central axis of the balustrade were imported. They were converted into editable splines and then the edges of the handrail were attached along with those for the horizontal elements and the balusters. Display in Viewport was activated to show the thickness of the splines. Next, a thickness was given to each element of the balustrade. The Display in Render option was then chosen to make the baluster elements visible at render time.

A wing-shaped element of the brise-soleil was created from an ellipse that was in turn created by deforming a circle. The Extrude modifier was then applied to this profile, and the element copied using the Instance option. Once each pane was in place, they were selected and the orientation was varied using the Rotation tool, set to Use Pivot Center.

The hedges in the garden were created by extruding a profile along a path using the Loft tool, then applying an Edit Poly modifier to the resulting object. The resulting mesh was then edited to give a more natural look. Using the Loft tool has many advantages over a mesh created in SketchUp, then imported into 3D Studio Max. The first advantage is the ability to apply mapping coordinates that follow the extrusion path of the loft. The second is the ability to vary the profile of the hedge after the loft has been created, by choosing the Instance option when choosing the spline profile. This proved to be extremely useful since the height of the hedge needed to be modified later.

To model the surrounding hills, highly subdivided planes were used. The Soft Selection option was chosen in order to produce a gradual and homogeneous deformation when the vertices corresponding to the summits of the hills were displaced.

Stage 9: Apply Materials to the Detailed Model

Objective: To get the materials looking as realistic as possible for the final render.
Data: Materials Library and photos of materials.
Tool :3D Studio Max.

Since all the elements in the scene are named according to scheme based on architectural elements, it is simple to select each type of element by name, then to apply the corresponding material. Mapping coordinates are then applied to give the correct scale to the different textures.

Stage 10: Setting Up the Lighting Using "Fakiosity"

Objective: To produce a photorealistic render extremely quickly, without resorting to a global illumination rendering engine.
Data: Textured 3D model.
Tool :3D Studio Max.

Lighting is the most important factor in obtaining a high-quality rendering. Today's photorealistic rendering engines can produce images that are practically indistinguishable from photos, but at the cost of extremely long rendering times. Since time was short, the "fakiosity" lighting technique was chosen, which simulates the indirect lighting received from surfaces by using attenuated lights.

For the external lighting, an array of spotlights was chosen that would simulate the lighting from the sky component. A directional spot was also added to simulate the sun. These "sky dome" spots were given a slight blue hue and were set to project very soft shadows using shadow mapping (size: 512, sample range: 40). The directional "sun" spotlight (parallel rays) used more sharp-edged, raytraced shadows. In order to reduce the rendering time further, none of the glasswork was set to cast shadows (right-click on an object and under Object Properties, uncheck Cast Shadows).

Stage 11: Camera Placement

Objective: To produce renders that would clearly show the position of the VR hotspots.
Data: A list of the hotspots to be shown.
Tool :3D Studio Max.

This stage is extremely simple: The essential thing to keep in mind is to have the hotspot exactly at the same height as the camera to avoid any parallax effects.

Stage 12: Positioning the Hotspots and the Direction Arrows

Objective: To increase the visibility of the hotspots in the VR panoramas.
Data: List of hotspots to be shown.
Tool :3D Studio Max.

The images that are used to create VR panoramas are highly distorted. Therefore, the hotspots and direction arrows could not be added in later in Photoshop because they would have to show exactly the same distortion as the VR panorama image. It was therefore decided to model these elements directly in 3D and to place them around each camera in the position that they should be in the final panorama (see Figure 10.13). To make things easier, each of these 3D elements had the LookAtMe constraint applied. This means that they would always face square to the camera, whatever be the camera's position. The Planes Look modifier was also used: This is a part of the Itoosoft Forest Pro plug-in covered in the following stage.

FIG 10.13 Placing the 3D hotspots and direction arrows.

Stage 13: Adding the Vegetation

Objective: To increase the realism of the project. The height of the vegetation also needed to be shown.
Data: Photos of trees and plants.
Tools: 3D Studio Max and Itoosoft Forest Pro plug-in.

Adding true 3D vegetation greatly increases rendering time. It was therefore decided to use simple rectangular polygons oriented toward the camera. These polygons had a tree or bush texture applied to them. These textures also had an alpha channel applied to them in the material's Opacity Map field. This knocked out the background of the texture, leaving only the vegetation on a transparent background.

Tip

In view of the number of trees needed for the garden and for the surrounding hills, we had to fall back on Itoosoft's Forest Pro plug-in. This plants vertical rectangular faces that are automatically oriented toward the current camera and provides an enormous time saving, especially given the number of different cameras used. The plantation density is provided by a black-and-white texture map, where each white pixel represents the position of a tree or plant.

FIG 10.14 Placing vegetation using Forest Pro.

Stage 14: Rendering the VR Panoramas

Objective: To produce the panoramas for the virtual interactive visit.
Data: Illuminated and textured 3D scene.
Tool :3D Studio Max.

The Panorama Exporter tool was used, which automatically renders and composites the six different views necessary to make a VR panorama image. It is extremely simple to use, and the user needs only to specify the resolution of the final image (the aspect ratio is always 2:1). The choice of image formats depends upon the software used to produce the 360° interactive views. For Pano2VR, the PNG format is preferred.

As explained in stage 12, the rendered VR panorama is extremely distorted (see Figure 10.14). This is why the direction arrows and hotspots were calculated in 3D.

Stage 15: Putting the Virtual Interactive Visit Together

Objective: To produce and link the panoramic views in flash format.
Data: Panoramic images in PNG format and list of webpages to be linked.
Tool :Pano2VR.

FIG 10.15 VR panorama render.

Each panoramic image was imported into the Pano2VR software where the setup of the initial viewpoint and the hotspots can be configured. The click-able fields are either a question mark (leading to a page of advice on either fire or break-in protection) or a direction arrow (brings up a webpage with a new viewpoint).

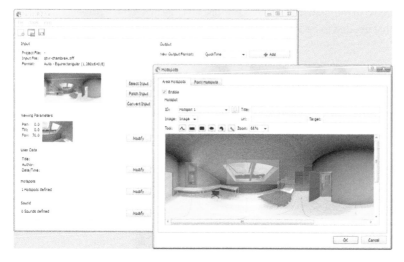

FIG 10.16 Putting the virtual visits together using Pano2VR.

After an initial user test, it was decided to control the flow of the visit by placing only one direction arrow in any exterior panoramas. This makes sure that the visitor does not end up facing in the wrong direction, unable to gain access to the Virtual House.

In order that the visitor does not get lost in the Virtual House, an interactive plan of the current floor was displayed below the panoramic view. A colored dot indicated the visitor's current position. Clicking on the other buttons enables direct access to the corresponding viewpoint. All the viewpoints were

also accessible from a webpage that displayed them, all sorted according to their environment (exterior, interior first floor, interior second story, etc.).

Stage 16: Creating the Website

Objective: To produce a standards-compliant website.
Data: Text in French and Flemish and photographs and illustrations from the Virtual House.
Tools :Photoshop and Notepad2.

A mock-up of the website was first put together in Photoshop. The various elements of the visual design were then cropped and exported in JPEG format with a compression ratio suitable for the web.

The site structure was constructed in XHTML 1.0 Strict, and the visual aspects were programmed using CSS.

Unlike certain web designers who use website creation software like Adobe Dreamweaver, our practice prefers to work directly on the code in a text editor. To this end, Notepad2 was used, since it formats and indents XHTML and CSS code.

Some parts of the site were developed in JavaScript, noticeably the drop-down menu, something that was indispensable given the number of pages that needed to be accessed. It was also used to embed the Flash animations.

FIG 10.17 The website in use.

Conclusion

Choosing SketchUp was a wise move in view of the extremely tight deadlines for a project in which there was a lot of ground to cover. SketchUp allowed us to

- ommunicate effectively with the client and accelerate the decision-making process;
- evaluate concepts in real time;
- put together the rough models and the final, detailed one;
- reduce the number of polygons to a minimum, and therefore
- reduce the rendering time for each image, and therefore
- put together an animation extremely quickly.

Our initial choice of SketchUp proved to be sound: The entire project could have been modeled in 3D Studio Max, but the process would have been less intuitive and more work would have been needed to advance each stage of the project.

The Virtual House project has been evolving since the end of 2005, and today, it is in its fifth iteration, with the addition of animations showing the implementation of the prevention and protection methods.

This first experience with interactive virtual reality allowed us to offer a more groundbreaking service. This was the first commission for the Federal Department for Interior Affairs, and the client's satisfaction has brought with it numerous other commissions, including some in areas outside of architecture. We can say without fear of contradiction that this project has greatly expanded our practice's sphere of activity and has actively promoted our professional activities.

Resources

Software

Autodesk 3D Studio Max 2010 – Retails for $3,495.
Garden Gnome Software Pano2VR – prices start from €59 (about $84), excluding sales tax. Available at http://gardengnomesoftware.com/pano2vr_license.php .
Adobe Photoshop CS5 – price around €840, excluding sales tax.

SketchUp Plug-ins

Push–Pull Z by Didier Bur. Available at http://www.crai.archi.fr/RubyLibraryDepot/Ruby/fr_push_pull_z.rb .
Reverse Faces tool by Todd Burch. Available at http://www.smustard.com/script/ReverseFaces .
Layer by Material by Tim Bertschinger. Available at http://www.crai.archi.fr/RubyLibraryDepot/Ruby/fr_layerbymaterial.rb .

3D Studio Max Plug-in

ItooSoft Forest Pro 3 – €250 (about $350), excluding sales tax. Available at http://www.itoosoft.com/english/menu.php?id=forest_register .

Compositing Images Using SketchUp and Artlantis

Fédéric Blanc

For 7 years, Frédéric Blanc occupied the post of Product Manager, Graphics & Design, at Abvent, the French distributor of SketchUp and creator of Artlantis. During his time there, he developed a considerable level of expertise in modeling, rendering, and animation. Using this experience to good effect, he created Mr. White SAS, a practice whose principal areas are modeling, rendering, and animation for architects, interior designers, product designers, and advertising agencies.
This project deals with the creation of renders for a project for the conversion and renovation of a derelict apartment building and the construction of a new housing block.

www.misterwhite.net

Project: Open architectural competition, compositing of winning entry onto site photographs.
Tools: SketchUp 7, Artlantis 2.1, Photoshop CS, and SketchUp–Artlantis export plug-in.

In May 2009, the Argenteuil-Bezons Environment Agency launched an open competition for the design of a block of social housing. The focus of

this competition was the conversion and renovation of a derelict, 10-unit apartment block and the construction of a new complex containing 28 apartments.

The architects Jean Filhol and Mathieu Guéroult of the SEPRA practice – an office with wide-ranging experience in public-sector architecture – decided to enter the competition and called upon Frédéric Blanc's expertise to create the renders for the competition entry.

Project Context

In an open competition, the architect has to respond quickly and decisively to the client's brief.

Using plans, sections, and elevations, architects tried their best to respond to the expectations of the client and to describe the solutions that they put forward. Perspective renders of the project allow those involved to judge the esthetic quality of the building and, if needs be, to get an idea of its integration into the existing built environment.

The SEPRA practice uses PowerCADD drafting software on the Mac. This technical drawing package allows them to produce all the necessary plans, sections, and elevations for a project. The first step in this development was to create a 3D model using the 2D technical drawings provided by SEPRA. In a public competition, the time factor is vital, since the deadline for submission cannot be missed. It is also not unusual for architects to be making modifications to their proposals right up until the last moment.

In the case under consideration here, only 3 days were penciled in for building the model, creating two perspectives and compositing the model onto a site photograph: an extremely tight deadline.

Techniques Used

Before beginning a job, it is essential to choose the tools that best meet the constraints of the project. SketchUp showed itself to be the best choice for modeling for the following reasons:

- It can easily import plans, sections, and elevations in DWG format that can then be used as reference drawings. For this project, only the building facades needed to be modeled: there would be no interior perspectives.
- SketchUp allows you to work quickly and efficiently.
- Creating repeating elements in the project as SketchUp components helps to manage any changes made to those elements as the project

progresses: changes made to one component will be reflected in all the instances of that component.

• Using the free version of SketchUp or the SketchUp Viewer application, the model can be sent quickly and easily to the client to evaluate the project's progress.

• SketchUp and Artlantis (a photorealistic rendering application) work synergistically with each other. Artlantis is able to create extremely realistic images, thanks to a lighting model based on real-world physics, its ability to produce realistic-looking materials, and its tools for compositing a 3D model onto a site photograph (one of the stipulations of competition entry). Using Artlantis you move from SketchUp's somewhat hand-drawn rendering style into a new world of photorealism.

• The pipeline between the two programs functions particularly well. You do not have to completely finish your modeling in SketchUp before you can carry out your first test renders in Artlantis. Artlantis can also add realism to the project with its library of objects such as street furniture, trees and vegetation, vehicles, people, etc. Also, changes made to the original SketchUp model can be easily passed on to the Artlantis project.

New Approaches

Frédéric Blanc: "SketchUp is used in a large number of projects in my work, since it's a modeling tool completely unlike traditional modelers."

"The fact that you are always working in 3D, that you can explore the model from every angle using a simple flick of the mouse, that you don't have a screen cluttered up with complex dialog boxes, that you can edit geometry simply by moving faces, that you can construct on top of already existing geometry....SketchUp's ability to pick up inferences from geometry and use them to guide your modeling makes working with the program simple and intuitive. Also, SketchUp's signature, hand-drawn rendering style lends an approachable aspect to the models."

"I mostly use SketchUp's basic toolset; plug-ins are rarely used. The features of the program I use most are groups, components and layers."

"Artlantis is used as a complement to SketchUp. You could almost describe it as the SketchUp of the rendering world. It can import almost any 3D format and can produce high-quality renders quickly and easily. One of its great advantages is its ability to control and display the changes to lighting and material effects in real time in a preview window, and at a quality close to that of the final render. This cuts down greatly on the

number of intermediate renders that need to be performed, with all the time savings that that brings."

Stage 1: Importing Plans and Elevations in DWG Format

Objective: Bringing together the existing 2D drawings and data; creation of facade volumes; and standardization of the project.
Data: DWG and PDF files.
Tool :SketchUp.

In this stage, the DWG files were imported (see Figure 11.1) and used as reference drawings. In order to work as quickly as possible, a group was created for each elevation. The imported drawings were grouped so that their individual elements could not be selected or altered. The goal here was to re-create the plans from scratch by tracing over the DWGs: it is the easiest and most efficient method. The original document is also kept as a reference for the subsequent modeling work. Also, it is not uncommon that there are problems with the 2D documents arising from the import/export process, and you do not want to copy these over into the 3D model.

FIG 11.1 Imported DWG.

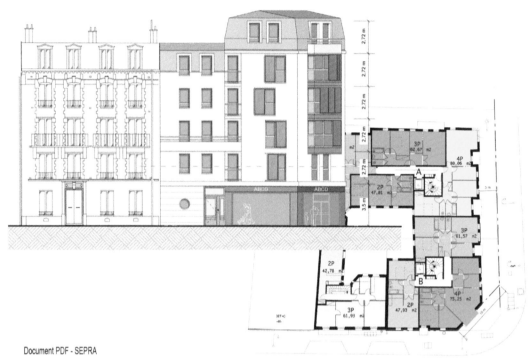

Document PDF - SEPRA

FIG 11.2 Color reference document in PDF format.

When importing a DWG into SketchUp, there is always a loss of some information: the colors of lines and hatchings are not preserved, for example. However, any layer structure present is maintained. In order to see any original color information in the file, it is essential to have a PDF reference document of the file (See Figure 11.2).

Tip

When importing a DXF or DWG file, it is vital to know the units of measurement in the original file in order to get the correct scale (meters, centimeters, millimeters, feet, inches, etc.) in the SketchUp file. If this information is not known, it is possible to rescale after importing the drawing.

If, for example, you have imported a file in inches instead of feet, use the Tape Measure tool to measure a line segment in the drawing, then type directly on the keyboard the length of the segment multiplied by 12, and hit return. SketchUp will then ask you if you want to rescale the whole model (See Figure 11.4).

FIG 11.3 DWG file import options.

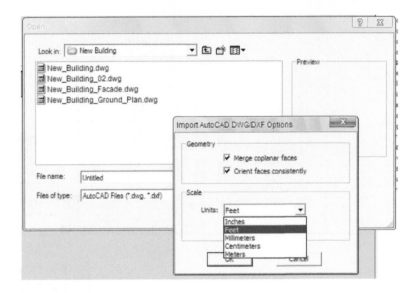

FIG 11.4 Rescaling the file.

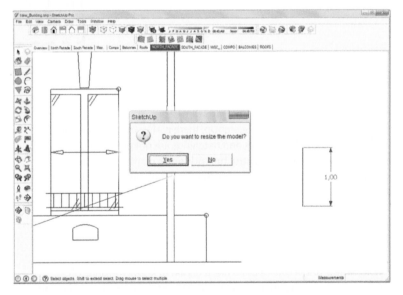

Stage 2: Identifying the Materials and Preparing the File for Export

> **Objective**: To export the file to a rendering program or to another model.
> **Data**: 3D model.
> **Tool**: SketchUp's Material Selection tool.

When a SketchUp file needs to be exported to a rendering program or to another modeler, it is essential to identify all the different materials in the project. SketchUp's tools allow you to assign different colors to different

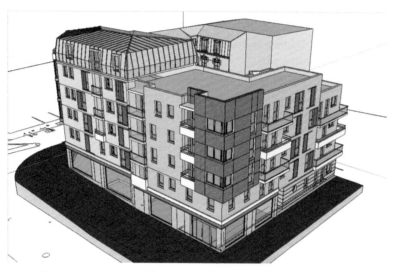

FIG 11.5 Textures and materials in SketchUp.

materials in the project, and the best method is to make sure that these colors are easily distinguishable one from the other (See Figure 11.5).

In SketchUp, colors or materials can be assigned directly to a surface or to a collection of selected surfaces. Colors and materials can also be applied directly to groups or to collections of groups. In this case, it is still always possible to enter the groups and to change the colors or materials of individual surfaces within the group.

Attention

SketchUp allows you to assign different colors or materials to both the inside and outside surface of a face, something that can create problems when you come to export, since most rendering engines can only deal with one material on any one face. Generally, the material that is "seen" by the renderer is the one applied to the exterior surface (the one with the surface normal). You therefore need to check that the correct material is applied to the correct surface. To do this, you need to select the surface and right-click > Entity Info from the contextual menu. In the Entity Info palette, you will see two swatches, indicating the materials present on the surface. The left swatch indicates the material on the exterior surface, and the right swatch indicates that on the interior surface.

Applying the material to a group allows you to get over this problem since, whatever the face orientation, the material is applied uniformly to all faces, front and back.

Stage 3: Exporting to Artlantis Format

Objective: To get the SketchUp model into Artlantis.
Data: SketchUp model.
Tool :Artlantis export plug-in.

It is possible to export directly to Artlantis format if you have the correct plug-in installed. The plug-in can be downloaded from Artlantis's website (www.Artlantis.com)under **Downloads > Plug-Ins**. Once installed in SketchUp's plug-ins directory, the program can export in native Artlantis format.

Before the model is exported, it is good practice to select all the elements in the model (Ctrl-A in Windows and Cmd-A on the Mac) before calling up the export dialog box (see Figure 11.6). Doing this will prevent you from exporting hidden layers or groups. Once everything is selected, from the Menu Bar, choose File > Export > 3D Model… and choose ATL format from the drop-down menu.

Stage 4: Modifying the SketchUp Model and Updating the Artlantis Scene

Objectives: To modify and add detail to the SketchUp model and to update these changes in Artlantis.
Data: Imported 3D model.
Tool: Artlantis' Use Reference File… function.

When using a third-party piece of software with SketchUp, it is extremely important to make sure that any changes made to the SketchUp a model can be easily reflected in the external software (in this case Artlantis). This enables both projects to develop in parallel.

Luckily, Artlantis has just such a function, and it can be found under the File menu as Use Reference File…. (See Figure 11.7). The following describes how to use this function:

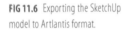
FIG 11.6 Exporting the SketchUp model to Artlantis format.

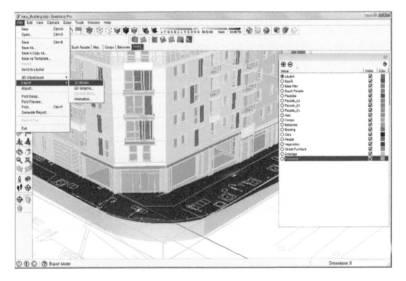

1. The SketchUp file is exported to Artlantis format and is given a name, for example, Project_01.atl.
2. The file can now be worked on in Artlantis, adding point light sources, creating materials, adding reflection and bump mapping, adding 3D objects from Artlantis' own libraries, etc.
3. Because of a demand from the client, drastic changes have to be made to the original SketchUp model. However, the work already done in Artlantis will not have to be repeated.
4. A new Artlantis file is exported from SketchUp and given the name Project_02.atl.
5. This new file is now opened in Artlantis and saved.
6. Now, from the File menu, Use Reference File… is chosen. A dialog box opens that allows you to navigate to your reference file, in this case the Project_01. atl file. Certain options appear in the dialog, which allow some or all of the changes made in the first Artlantis file to be copied over to the new file, such as camera views, applied textures, placed objects, and sources of illumination.

Thanks to this method, work already carried out never has to be repeated and no time is wasted. The Artlantis and SketchUp files are linked, and work on the model's geometry and render setup can be carried out in parallel.

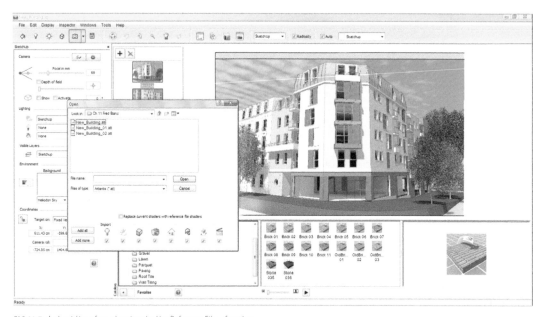

FIG 11.7 Artlantis' interface, showing the Use Reference File... function.

Stage 5: Artlantis' Site Insertion Module

Objective: To place the virtual building in context using a site photograph.
Data: Site photography and textured 3D model.
Tool: Artlantis' Site Insertion function.

At this point, the principal difficulty is the absence of a magic and totally automatic tool that allows you to painlessly composite a 3D vector model onto a 2D bitmapped photograph. There are, however, some tools that can ease the task of matching the perspective of the virtual building to that of a photograph (see Figure 11.8).

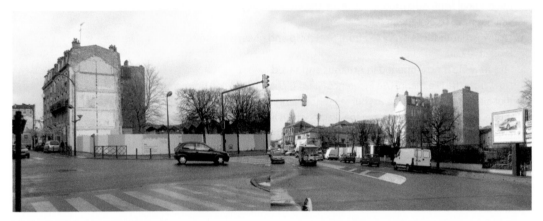

FIG 11.8 Site photos taken from various angles.

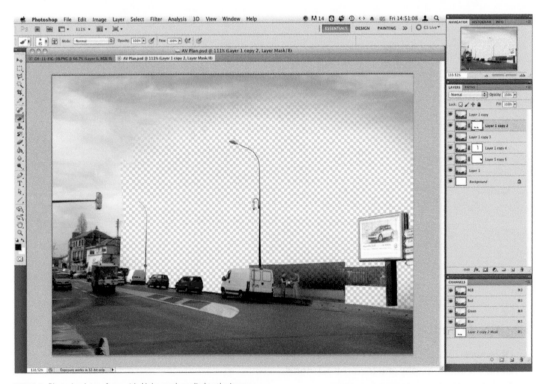

FIG 11.9 Photoshop's interface, with Alpha mask applied to the image.

As a first step, some preparatory work needs to be done on the site photo in an image editor, such as Photoshop (see Figure 11.9), and items in the foreground, such as vehicles, people, vegetation or even street furniture, need to be cut or masked out.

Attention

It is fundamental to choose your viewpoints wisely, to take photos that are not cluttered by nonessential elements, to use a digital camera that will give you a good, high-resolution image, and to use lenses with as little distortion or aberration as possible. You should also make sure that the daylighting is good and that your photo contains some elements that you can use to establish a sense of scale.

In Artlantis, the site photo is placed as a background image in the preview window. In the Site Insertion module, the 3D and 2D control windows appear. The X, Y, and Z axis guides are also shown in both these windows (See Figure 11.10).

1. ih the 2D View, find an edge of the building that is prominent in the site photo and use it to place the axis origin.
2. In the site photo (3D View), line up the X, Y, and Z axes with guide edges, such as pavements, roadways, and the horizontals and verticals of neighboring buildings.
3. Start the insertion calculation. The 3D building will be composited over the site photo. The position of the three axes can now be tweaked in real time to fine-tune how the building sits in the site photograph. The focal length of the virtual camera can also be adjusted to refine the positioning of the building.
4. Now, it is just a matter of placing the image prepared in Photoshop in the foreground. This will mask out any parts of the building that should be in the background.

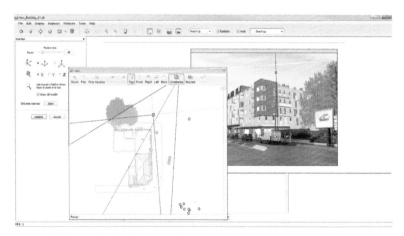

FIG 11.10 Artlantis studio — Site Insertion interface.

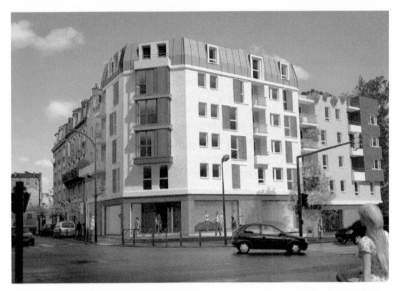

FIG 11.11 Final render – Perspective view of the building in its site context.

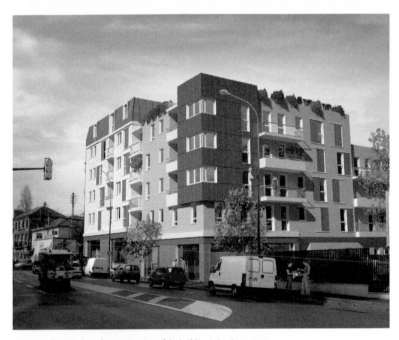

FIG 11.12 Final render – Perspective view of the building in its site context.

Once the base image is created, it will more often than not need to be retouched in an image editor to obtain the final presentation image: Photoshop is often a 3D artist's best friend.

Conclusion

In this type of project, SketchUp demonstrates all of its simplicity and efficiency. Other than the Artlantis export script, no other plug-ins were used: the basic toolset was more than sufficient to model this type of building.

Regular communication with a client is always vital in any project to keep abreast of the latest demands and to keep the client informed about the state of the project. SketchUp is an ideal tool for this type of communication.

 SketchUp fits in perfectly into the graphics pipeline and can be used to feed data into much more sophisticated modeling or rendering programs.

In this project, the combination of SketchUp and Artlantis allowed some extremely tight deadlines to be met and allowed the production of images of the highest quality of a virtual project within a real urban context.

Resources

SketchUp to Artlantis export plug-in. Available at
http://www.artlantis.com/.
Artlantis Render. Available at http://www.artlantis.com/.
Adobe Photoshop. Available at http://www.adobe.com/ .

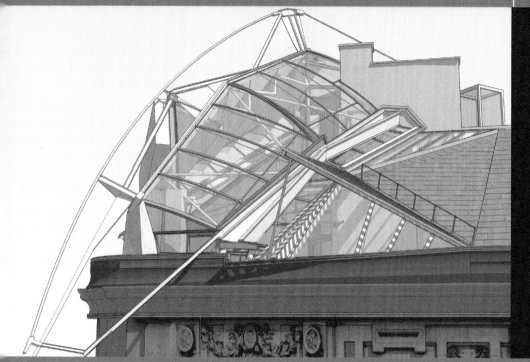

Modeling a Complex Structure

Tim Danaher

After studying architecture at Bath and Oxford, Tim Danaher took the architectural visualization route, producing 3D perspectives and animations. He has also produced numerous illustrations for the computer press in Great Britain and has written articles on computer graphics and architecture for the Architect's Journal. *At present, he lives in Cologne, Germany, where he teaches courses on design issues and, naturally, SketchUp at KISD (Cologne International School of Design). He is also developing a parallel career as a translator for architecture and design (he translated the chapters of this book that were originally in French).*

Project: Lawyers' chambers, Falkestrasse, Vienna (by Coop Himmelb(l)au)
Tools: SketchUp 7, Cheetah3D 4.7, Photoshop CS, Make Cubic

Project Context

Danaher: "This project was chosen for several reasons: to test the limits of the software (I was sick and tired of hearing people say "you can't do that with SketchUp!"), to test my own abilities with the software and, hopefully, to learn

some new techniques along the way. I also wanted to use the model to test the rendering capabilities of a piece of software that I had not yet used but about which I had heard a lot of good things, Cheetah3D.

But probably the most important factor that pushed me into modeling this project was a long-held desire to understand the structure: I started at architecture school the same year (1987) that this icon of deconstruction hit the architectural headlines. When you first look at it, it seems impossible to understand – a tangle of cranked beams and glass canopy perched precariously on the edge of a roof. And just how did they make it waterproof?

Using photographs sourced from the Web, I was able to put together a first rough draft, and as I found new photographs or plans, I refined the model bit by bit. The method presented here is necessarily different from the one that I used for the first models, since here I will be using other information that I have gathered over the years, including an original plan and section.

So what did I get from this project? The satisfaction of a job well done (I hope), a mystery solved… but also a little disappointment: I can never look at this wonder again through the same eyes; it has given up (almost) all its secrets to me.

Since this was a private project, there was no deadline. Modeling was carried out as and when time allowed. If there was one major constraint, it was the lack of information: It is difficult to believe that after more than 20 years, there are so few images in circulation of such iconic structure; there is not even a single monograph on it!

I started modeling by studying the images obtained up close. Several attempts were made (including many false starts) before a model was produced that could serve as the basis for further analysis.

All the initial modeling was carried out in SketchUp 5 (the project was started nearly four years ago). Only SketchUp's basic tool set was used – no modeling plug-ins were used, and only the Bomb.rb Ruby was used to prepare the model for export. The version 5 model was exported to version 4 to make the animations. This got around the well-known "flickering shadows" problem. Version 4 was the only version to avoid this problem. The infamous "shadow problem" came back with version 5, and it is still with us today. All the textures were applied in SketchUp, with Cheetah3D providing features like lighting, rendering, camera animation, and panorama preparation. Apple's free MakeCubic.app was used to process the panoramic images into QTVR panoramas. Photoshop was used in the preparation of some of the textures and also in scanning and preparing the plan and section."

Tip

If you still have a copy of SketchUp 4, guard it zealously since it is the only version that does not suffer from the flickering shadows problem. Unfortunately, version 4 does not run on Mac with versions of the

operating system later than Leopard (MacOS X 10.5.x), although it is possible – with a bit of tinkering – to run Tiger (MacOS X 10.4.x) in a Parallels or VMWare virtual machine.

Why Choose SketchUp?

SketchUp was chosen for its speed and its fluid modeling ability. It was also chosen because previous attempts to build this with two traditional modeling heavyweights – LightWave and form•Z – had to be abandoned in desperation. The idea was that SketchUp's simpler approach might not get in the way – something that proved, indeed, to be the case.

Cheetah3D – a full-featured 3D modeling, rendering, and animation application – was chosen for postprocessing because of its unequaled render management and its blazingly fast, multitasking, multi-processor, hyperthreading rendering engine. It was also chosen because of the speed with which it can produce QTVR panoramas. After long days (and nights) of modeling, I did not want to have to wait a couple of days more for the results of a camera animation. Rendering a QuickTime panorama can be done in minutes with Cheetah. Also, it exchanges data with SketchUp very easily thanks to its FBX format support and Smart Folders feature. Oh, and did I mention that it costs only $149?

Techniques Used

As previously stated, only SketchUp's basic modeling tools were used in this project. However, probably more important than SketchUp's tools were observation, reflection, and a lot of head-scratching. A two-monitor setup also helped, with a second monitor dedicated to displaying the drawings and photographs that needed to be consulted constantly. The second monitor usually holds all of SketchUp's palettes, so a shortcut was assigned to the Hide Dialogs command (from the Menu Bar, choose Windows > Hide Dialogs), enabling all of SketchUp's floating palettes to be hidden or displayed with a single key press.

Great use was made of the Outliner palette for organizing this model (I have a motto: Group early, group often). For a model as complex as this one, clear organization is of the utmost importance. I *never* use Layers: they just confuse me.

Tip

The only plug-in utilized was Bomb.rb. This free plug-in (available at http://www.smustard.com) explodes every group in a model so that only "raw geometry" – edges and faces – are left. It is then simply a matter of right-clicking on any particular surface, and choosing Select > All with Same Material from the contextual menu. Once all surfaces with the same material are selected, they can be easily grouped. Grouping makes setting up and managing materials in Cheetah3D much easier.

New Approaches

In this model, certain elements were built in free space – something that is not the usual approach in SketchUp. It was necessary to fake a feature that exists in almost all other modeling programs: working planes. These are virtual surfaces – normally defined by three coplanar points – that allow you to draw in "midair." Normally, in SketchUp, you can only draw upon already existing surfaces, so the approach here was to draw some simple faces and then move and rotate them until they were in the correct position. They would then act as virtual "drawing boards" on which most of the main structure could be drawn in situ. Drawing these main structural elements orthogonal to the X, Y, and Z axes and trying subsequently to rotate them into place would have been a recipe for disaster.

> **Tip**
>
> Although SketchUp Pro was used for this project, all the modeling can just as easily be done with the free Google SketchUp version.

Stage 1: Preparing a 1:1 Scale Plan

Objectives: To bring together all the photographs, plans, sections, and axonometrics from various sources (by downloading, scanning, etc.) and ensure that the imported plan and section are at 1:1 scale.
Data: JPEG images.
Tool :SketchUp Pro.

After the two JPEG scans of the plan and the section were imported, the first problem was one of scale: They both needed to be at 1:1, since a lot of the modeling was going to be eyeballed and having everything at true scale meant there would be one thing less to worry about. Once the plan

FIG 12.1 The Rescale dialog box.

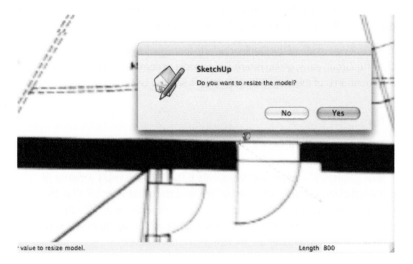

was imported (where the plan's size was arbitrarily set), a feature on the drawing was chosen whose dimensions were known (more or less). In this case, the feature was a door opening, and it was assumed that it would be around 2' 9" wide. A line was drawn across this door opening, and then the Tape measure tool was used to measure the line. The value for this line length appeared in the VCB, and then it was simply a matter of typing in the real-world measurement. At this point, SketchUp asks if you want to rescale the whole model. Click on OK, and the plan will now be at 1:1 scale (you can verify this by using the Tape Measure tool to measure the line just drawn).

Stage 2: Constructing the Base Building and Placing the Section

Objectives: To construct a floor of the original building to act as a base and to place the section.
Data: Scale plan obtained in stage 1.
Tool :SketchUp Pro.

The original building and the existing partition walls were constructed by tracing over the imported plan, whereas the cornice was modeled using the Follow Me tool. The main building structure and the interior partition walls were then assigned to different, named groups. The next stage was importing the section, and then placing it in the correct position on the model. This was rather tricky and had to be eyeballed using features that appear on both the plan and the section. In this case, the stairs and the Beak of the main girder were used.

FIG 12.2 The section and the plan in place on a textured model of the original building.

Tip

Once imported, the plan and section JPEGs are "quasigroups": Although they can be selected with a single mouse click, they do not appear in the Outliner. Resist the temptation to Explode and Group them so that you can name them. If you do that, you will not be able to see the plan and section images when you are inside other groups, which can make modeling a little tricky, to say the least.

Stage 3: Constructing the Path of the First Girder on Plan

Objectives: To construct the "scaffolding" for the path of the first girder.
Data: The model obtained in stage 2.
Tool :SketchUp Pro.

The problem that now needs to be confronted is that all the girders in the construction are "cranked": They are bent both on plan and elevation. Working planes now have to be constructed that will allow the paths of the girders to be drawn in situ. As previously stated, drawing a straight girder and then trying to bend it will get you nowhere.

The first step is to draw the path of the girder on the plan. What we are trying to achieve here is a simple vertical face bent at some point along its length. Unfortunately, SketchUp does not allow you to extrude simple lines, so a 2D surface containing the bent line must be created and then Push/Pulled to the required height. This produces a volume, but only a simple surface is required; so any unwanted edges can simply be deleted using the Eraser tool. Group the working plane and give it a name.

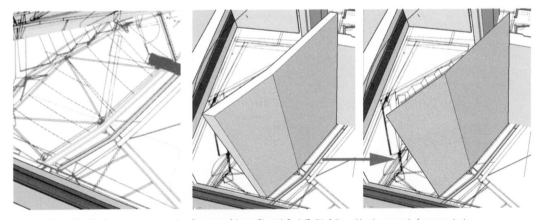

FIG 12.3 The profile of the first girder traced on plan: Extrusion of the profile with Push/Pull is followed by the removal of unwanted edges.

Tip

In this stage – and especially in stage 4 – orthogonal views need to be used to align the paths with the plan and the section. Two scenes should be created, one for the plan and one for the section, and perspective should be turned off for both of them (from the Menu Bar, choose Camera > Perspective [unticked]). To make sure that there is a square-on view of these working planes, enter the working plane group, select one of the surfaces, right-click, and choose Align View from the contextual menu. These two scenes will be used often in this project.

Stage 4: The Construction of the Path of the First Girder on Elevation

Objective: To construct the "scaffolding" for the profile of the first girder.
Data: Model obtained in the previous stage.
Tool :SketchUp Pro.

The first step is to reduce the opacity of the working plane surface, so that the section can be seen behind it. Then, starting on either the left- or the right-hand edge of the surface, the path of the girder is traced using the Line tool, making sure that the line drawn adheres to the surface (SketchUp's inferencing engine should do this automatically: Look out for the On Surface tooltip). The working plane surface can now be deleted or hidden; only the line is needed for the next stages. Use the Orbit tool here to verify that the line follows the path of the girder both on plan and on elevation (see Fig. 12.4).

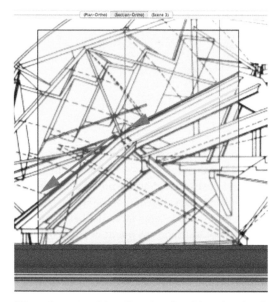

FIG 12.4 Construction of the profile on the surface of the working plane: Final profile, showing the crank in two planes.

Stage 5: Extruding the First Girder

Objective: To create the 3D form of the first girder.
Data: Model obtained in the previous stage.
Tool :SketchUp Pro.

Next, a suitable girder cross section was chosen from the Components library (Components palette > Construction > Steel Cross-Sections > Wide Flange). It was positioned using the Move and the Rotate tools. One problem is that components align themselves either to the principal axes or to the geometry of the model, which can often mean that once they are placed they lie "flat on their back." Luckily, since version 6, you can define an axis of rotation simply by clicking and dragging between two points with the Rotate tool. This makes rotation of off-axis groups or components much easier.

Once the girder profile was in the correct position in relation to the path, the Follow Me tool was used to extrude it along the path. And there you go. Now the girder just needed to be grouped and named.

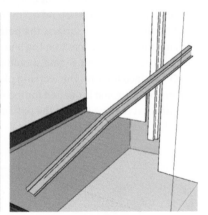

FIG 12.5 The girder profile in situ: The girder is created with the Follow Me tool.

Tip

When performing an extrusion, it is best to select the path first, select the Follow Me tool, and then select the profile. The extrusion will then complete automatically, without the need to drag the profile along the path. Doing it this way avoids many of the problems of the Follow Me tool, such as badly formed extrusions and faceted faces. It is best to make sure that the end of your path is not touching any points or edges of the profile: If the end point of the path is impinging on a face, the path can be selected independently of the profile by double- or triple-clicking on it (if only we could use groups or components as profiles for the Follow Me tool!)

Stage 6: Modeling the Other Main Girders

Objective :To finish the modeling of the remaining simple girders.
Data: Model obtained in the previous stage.
Tool :SketchUp Pro.

Exactly the same technique was used to model the remaining girders. In Figure 12.6, they have each been given a different color, to better distinguish them.

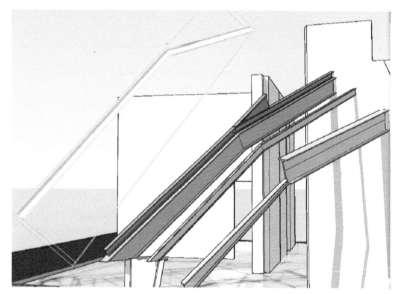

FIG 12.6 The four main girders in situ.

Tip

SketchUp's bounding boxes are always created orthogonal to the principal axes. This can make moving, rotating, and especially scaling nonorthogonal elements rather difficult. To avoid this pitfall, before grouping a nonorthogonal element, select one of its surfaces, right-click on the surface, and choose Align Axes from the contextual menu. The principal axes will now be orthogonal to that surface, so that when you group the geometry, the bounding box will be perfectly orthogonal to it, making it easier to manipulate (see the white girder on the left in Fig. 12.6).

Stage 7: Additional Modeling on the Main Bow Truss

Objective: To add more details to the main girder using working planes.
Data: Model obtained in the previous stage.
Tool :SketchUp Pro.

To add supplementary modeling of the bow truss to the main girder, additional working planes had to be constructed. Using the Axis tool, the red,

green, and blue axes were aligned with the top surface of the upper flange of the lower part of the main girder. Use of the Axis tool, rather than the right-click method used in stage 6, verifies that the axes are perfectly aligned with the flange surface. The results of the right-click method can sometimes be not quite what you are expecting. Next, a working plane was constructed perpendicular to the top flange of the girder, simply by drawing in the new green and blue axes. The same method was used to construct a working plane for the upper part of the girder.

Tip

To move easily from one the working plane to the other, a scene was created for each one, making sure that the Axes Position option was checked. Now, moving from one scene to the other, the axes would always be orthogonal to the working plane in that scene.

To avoid any inadvertent modifications to the working planes, they should be grouped and, most importantly, locked.

The path for the upper triangulating girder is a bit complicated: The working plane was built on the external edge of the upper flange, but the path for this element should start on the *internal* edge of the upper flange. The next two clicks (where the middle strut would be built) should be on the working plane itself. Then, the end of the line should terminate

FIG 12.7 The constructed working plane in place: Note the position of the axes.

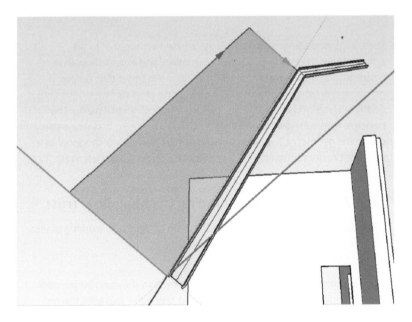

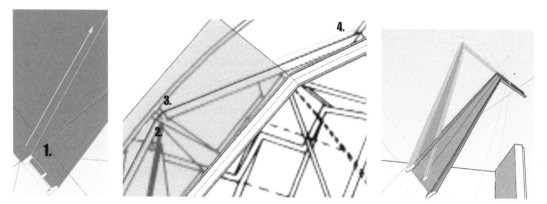

FIG 12.8 The triangulating girder after its extrusion using the Follow Me tool: The line starts on the interior edge of the girder. Points two and three are on the working plane itself, and the fourth point terminates on the external edge.

on the external edge of the upper flange of the upper part of the girder. Care needed to be taken here that the end of the line does not stick to any other surface in the model (e.g., the section). This was a bit of a painstaking procedure; but because of the slight kink in the main girder, it was impossible to put a planar triangulating girder in place. Once the path was drawn, the triangulating girder was extruded using the Follow Me tool (see Fig. 12.8).

Next, three additional elements were constructed. These were given nicknames in order to be able to refer to them more easily: the Beak, the Pawn, and the Swim Fin (see Fig. 12.9). These elements were constructed using the two working planes and the section, and – in conjunction with the working planes – they serve as guides for the construction of the bow. The path for the

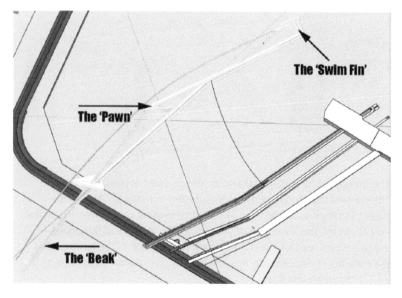

The 'Swim Fin'

The 'Pawn'

The 'Beak'

FIG 12.9 The completed main bow truss.

bow was constructed in two stages, starting with the Beak and constrained to the lower working plane, then up to the position of the Pawn strut (first arc), then toward the upper part of the Swim Fin (second arc), and finishing with the end of the arc constrained to the upper working plane (you should see the On Surface tooltip). Again, care has to be taken with the paths of these two arcs to avoid any kinks in the middle. Once the path was complete, a circle was extruded along it using the Follow Me tool to complete the bow.

Stage 8: Modeling the Lower Part of the Glass Canopy

Objective: To model the main glazing using the Push/Pull tool and working planes.
Data: Model obtained in the previous stage.
Tool :SketchUp Pro.

A working plane was constructed (yes, another one) for the panes of the lower part of the central glass canopy, bounded by the two girders on either side of it (the white and pink girders in Fig. 12.6). The axes were aligned with the central web of the main bow truss girder, and the working plane was drawn and rotated into place, scaling it as required so that it fits between the two main girders. The position of this working plane was determined by the bend on the main bow truss girder and the Shark Fin protrusion on top of the other main girder (see Figs. 12.6 and 12.11). The angle of the working plane was judged by eye, using the photographic material already collected.

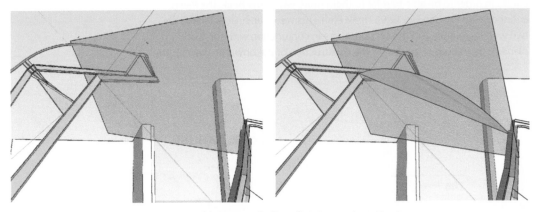

FIG 12.10 The working plane used for the construction of the canopy profile: The profile is drawn on the working plane.

The canopy profile was now drawn on the grouped, locked working plane. The curve of the canopy profile was eyeballed from the photographs and a closed surface was created, since in the next step we would need to use the Push/Pull tool. The lower part of the canopy is composed of five panes, so the correct value was arrived at by dividing the length of the lower part of the main bow truss girder by five. The canopy profile was Push/Pulled by this amount to create the first pane.

The remaining four panes were created by using the Push/Pull tool on the first pane extrusion, but by double-clicking while holding down the Ctrl key (for Microsoft Windows) or the Alt key (for Mac). This applies the same Push/Pull offset as in the previous operation, creating a new segment each time. Doing this four times gave the required five panes. The canopy geometry was then grouped and named.

This is where the process got a bit tricky: The canopy needed to be rotated into place so that it lay between the two main girders. This required quite a few rotations to find the right spot (see Fig. 12.12).

Attention

When rotating the canopy into place, rotate it about only one axis at a time, otherwise you are asking for trouble. This is where the click–drag behavior of the Rotate tool to set a nonorthogonal axis of rotation comes in really handy.

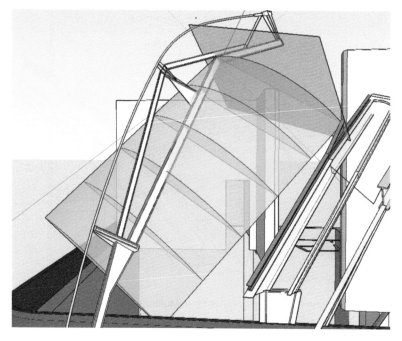

FIG 12.11 The canopy after extruding it multiple times with the Push/Pull tool.

Once the canopy was finally in its correct position, the overlapping edges needed to be trimmed using the Intersection tool. The canopy group was entered, and all the geometry inside was selected by triple-clicking it and then right-clicking to give Intersect > Intersect with Selection. The unwanted geometry was then simply trimmed using the Eraser tool (see Fig. 12.13).

FIG 12.12 The canopy in position (after quite a few rotations).

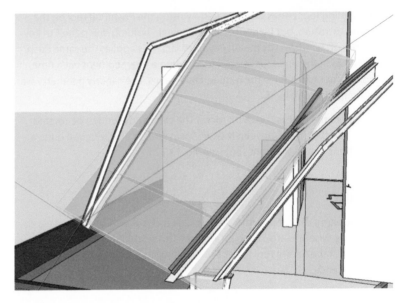

FIG 12.13 The canopy after trimming it with the Intersection and Eraser tools.

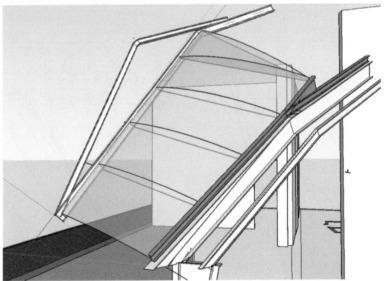

Next, some more detailing was carried out: Mullions were added by using the Follow Me tool, using the curves between each canopy segment as a path. This was done using a copy of the canopy glazing, positioned using the Edit > Paste in Place option and keeping the original hidden. Once the mullions were constructed, the glass in this copy of the canopy could simply be deleted, leaving the mullions in their own group that was separate from the original canopy glazing group. The upper canopy was built using the same technique as the lower. All the difficulty in constructing this model resides in getting the relationships between the central glazed canopy and the main girders correct. After that, in comparison with the other steps, everything is plain sailing.

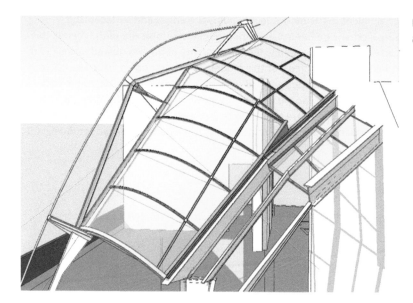

FIG 12.14 The mullions and some additional glazing structure in place.

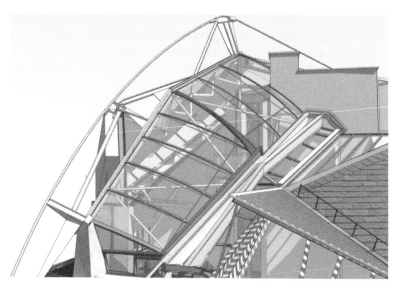

FIG 12.15 The final model.

The final result can be seen in Figure 12.15. This model represents maybe three months of work spread out over a period of three years.

Stage 9: Preparing the Model for Export from SketchUp

Objective: To prepare the model for export.
Data: The completed 3D model.
Tools :SketchUp Pro, Bomb.rb.

As soon as the model was completed, a copy was made and the Bomb.rb Ruby plug-in was run on it. This plug-in explodes every group and

217

component in the model, leaving only the edges and surfaces (the so-called raw geometry). Depending on the complexity of the model, this can take a while: Certainly, there was plenty of time to go and make – and drink – a cup of coffee. For this model, it took around an hour. Next, all the surfaces were grouped according to their material. To do this, right-click on a surface and choose the option Select > All with Same Material. The selected surfaces were then grouped, named according to material, and then hidden. When you cannot see any more geometry in your model, you are done.

Tip

When all the surfaces are grouped according to material and then hidden, you will probably still be left with a lot of stray lines and points that do not belong to any particular material group – SketchUp's so-called, dreaded "dust." Hiding all the groups reveals this dust, so you can simply do a Select All (Ctrl-A in Windows, and Cmd-A on the Mac) and delete it all before you export the model.

FBX was chosen as the export format. From the Menu Bar, choose File > Export > 3D Model … > FBX. In the Export Options dialog, make sure that only the Export Texture Maps and Swap YZ Coordinates (Y is up) tick boxes are checked. This last option is important, since SketchUp, like all CAD programs, treats the blue (Z) axis as "up," whereas Cheetah, like all digital content creation applications, treats the Y axis as up.

FIG 12.16 SketchUp's Export Options dialog box.

Export Options

Geometry
- ☐ Export only current selection
- ☐ Triangulate all faces
- ☐ Export two-sided faces
- ☐ Separate disconnected faces

Materials
- ☑ Export texture maps

Scale
- ☑ Swap YZ coordinates (Y is up)

Units: Model Units ▾

Cancel OK

Stage 10: Importing the Model into Cheetah3D

Objective: To import the FBX file into Cheetah using a Smart Folder.
Data: FBX file obtained in stage 9.
Tool :Cheetah3D.

If you have a Mac, Cheetah3D (available at http://www.cheetah3d.com) is the perfect partner for SketchUp. This extremely capable 3D program has an incredibly fast rendering engine – one that has become even faster since the release of version 5. This is due to the fact that it can utilize all the cores of the Mac's CPUs and now makes use of the hyperthreading capabilities in Intel's new chips. With an 8- or 12-core Mac Pro, rendering speeds that were unthinkable only a few years ago can be achieved. The rendering engine also supports the Radiosity/Ambient Occlusion and high dynamic range image (HDRI)/Global Illumination lighting models for an unequaled level of realism. Render management is also extremely well thought out: The number of simultaneous renders (even from different scenes) is only limited by the available RAM in your computer, and all completed renders and those that are being currently calculated are shown in a graphical browser.

Before importing the model into Cheetah, a Smart Folder was created. Smart Folders are one of the greatest advantages of Cheetah for SketchUp users, since they create a pipeline between the two programs. Placing an FBX file (or 3DS or any other format) into a Smart Folder means that every time the model is changed in SketchUp and reexported, the copy in Cheetah will update automatically to reflect those changes.

FIG 12.17 Cheetah's Smart Folder feature makes the management and updating of exported models easy.

Properties			🔒
	Light		
name:	Area Light–Sun		
▸ position:			
▸ rotation:			
axis:	–Y	▲▼	
	Properties		
light type:	area	▲▼	
color:			
intensity:	1.000	▲▼	
attenuation:	none	▲▼	
clamp attenuation:	☑		
geometry:	☐		
	Size		
width:	2.500	▲▼	
height:	2.500	▲▼	
radius:	0.100		
	Shadow		
type:	raytrace...	▲▼	
color:			
samples:	12	▲▼	
	Cut off		
spot type:	round	▲▼	
cut off angle:	30.000		
smooth cut off:	1.000		
	Caustics		
caustic photons:	10000	▲▼	
pure photon light:	☐		

FIG 12.18 Parameters for the Area light in the Cheetah scene.

Stage 11: Setting Up the Initial Lighting in Cheetah3D

Objective: To create a photorealistic rendering using Radiosity and HDRI illumination.
Data: Cheetah scene created in stage 10.
Tools :Cheetah3D, Photoshop (optional).

As is always the case, lighting is the essential step in obtaining a convincing rendering. An Area light and an HDR image were chosen as the principal sources of illumination, combined with Radiosity rendering. This combination provides very natural lighting; the shadows in particular have an extremely real feel to them with natural, soft edges. Luckily – and completely by accident – the Area light was placed so that the shadow direction in the Cheetah scene corresponded almost exactly to that in the SketchUp scene. The Area light setup can be seen in Figure 12.18.

Although the choice of an Area light is essential for proper lighting, falloff, and shadows, an appropriate rendering technique must also be chosen to ensure best results. Cheetah's rendering engine is basically a raytracer at heart, but this technology is taken to another level by the incorporation of two further technologies: Radiosity and HDRI/Global Illumination. Radiosity is a technique that simulates very accurately the effects of diffuse and scattered light, whereas HDRI/Global Illumination uses HDR images as a source of illumination. The combination of these two techniques is able to produce images of the very highest quality. Of course, there is always a compromise: In this case, it is an increased rendering time (although the multicore, hyperthreading capabilities of the renderer do much to mitigate this).

In Cheetah, all the rendering setup is done through the Camera object, and the number of cameras that you can have in any one scene is practically limitless. Each camera in Cheetah is basically a raytracing engine that can be augmented by the addition of "tags." In Figure 12.19, from left to right these are Camera, Radiosity, and HDRI.

FIG 12.19 Camera object with Radiosity and HDRI tags attached.

Clicking on each tag reveals the setup options: For Radiosity, the most important option is Type. Here, you can choose between Radiosity and Ambient Occlusion. The latter produces results that are almost indistinguishable from Radiosity, but with significantly faster rendering times. The other two parameters that need to be noted are Intensity (brightness) and Samples. The Samples parameter is particularly important, because the higher its value, the fewer rendering artifacts there will be in the final image – but, of course, rendering time will increase. Values of around 150–200 produced the best trade-off between quality and rendering time for this project. Values of around 40 were used to run quick lighting test renders.

FIG 12.20 Choosing Ambient Occlusion reduces rendering time: Typical values for Radiosity are shown.

To set up the HDRI render, a file in .hdr format needs to be loaded into the HDRI tag. Images with the .hdr extension are high dynamic range images. They contain 32 bits per R, G, and B channels, as opposed to the standard 8 bits for formats such as JPEG and TIFF. Since the primary source of illumination in this model is daylight, an image of a partially covered sky was chosen. If the image is already in .hdr format, so much the better. If not, and if you have a Photoshop license, you can convert any 8-bit image to .hdr format in the following manner: From the Menu Bar, choose Image > Mode > 16-Bit, and then Image > Mode > 32-Bit. This has to be done in two stages, because 8-bit images cannot be converted directly into 32-bit images.

FIG 12.21 Setting up the HDRI tag.

For architectural projects, Panoramic projection for the HDR image is the correct choice in 99% of the cases: It avoids any "seams" in the image when it is used as a backdrop to the scene. The values for the Power and Clamp Power parameters will be different for each scene, according to the already existing illumination, the intensity of the Radiosity setting, etc.

Tip

There are many websites where you can find HDR images that you can download for free. The following list names just a few:

http://www.debevec.org/Probes/ (the website of Paul Debevec, the inventor of the HDRI technique)
http://www.wiredchild.net/portold/resource.htm
http://www.yboo.net/hdri/
http://www.hdrmill.com/Freebies.htm
http://www.cgindia.org/2006/06/download-58-free-hdri.html

After several attempts, a satisfactory initial lighting setup was achieved (this is the product of the illumination from the Area light and from the HDR image; see Fig. 12.22).

FIG 12.22 Initial lighting: The shadow quality is extremely convincing.

Stage 12: Setting Up Supplementary Lighting in Cheetah3D

Objective: To set up accent lighting for the interior shots.
Data: Cheetah scene created in the previous stage.
Tool :Cheetah3D.

At first glance, the interior illumination seems to be pretty simple: The main source of illumination is the sky and the sun. This may be true, but there are light sources everywhere in the space itself that add ambience, accent, and atmosphere – probably around 40 in total, and among them are spotlights, uplighters, and neon tubes. In Figure 12.23, each red spot represents a single luminaire. You can see the results of all this combined lighting in the second picture.

FIG 12.23 Position and number of (some) supplementary light sources: A new scene with supplementary lighting in place is shown.

Tip

For supplementary lighting, the attenuation of the light sources needs to be set at $1/r$ or even $1/r^2$, so as not to "wash out" the scene.

Stage 13: Generation of a QTVR Panorama in Cheetah3D

Objective: To generate a QTVR panorama to enable the viewer to look around the interior space.
Data: Cheetah scene created in stage 12.
Tools :Cheetah3D, Apple MakeCubic.app.

The greatest advantage of making a QTVR panorama is the speed with which usable results can be obtained. Although the calculation of a frame-by-frame animation can take days, a fully navigable QTVR panorama that lets the viewer look around the entire space may take only a quarter of an hour to generate.

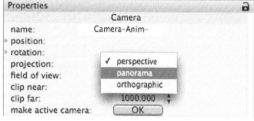

To generate the panorama, the Panorama projection was chosen for one of the cameras in the Cheetah3D scene. The location of the camera will determine the pivot point about which the QTVR panorama turns; so a camera was set up in the middle of the space to give a good, all-around 360° view. The height of the camera also influences the view obtained; so this camera was set at 5' 6" off the ground (average eye height). It was then just a matter of clicking Cheetah's Render button and waiting for the result.

FIG 12.24 Setting up a Cheetah camera to record a panorama.

Once the render was complete, an image like the one shown in Figure 12.25 was obtained.

FIG 12.25 The panoramic image
produced by Cheetah's camera.

FIG 12.25 The panoramic image
produced by Cheetah's camera.

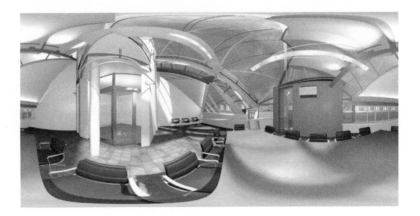

The next step is to turn this panoramic image into a fully navigable QTVR panorama. To do this, Apple's own MakeCubic.app was downloaded, started up and the image obtained in stage 12 was loaded into it. Although MakeCubic's interface is – it must be said – a little antediluvian, it does the job quickly and is free. By sticking to the default configuration, a navigable panorama was

FIG 12.26 Setting up MakeCubic.

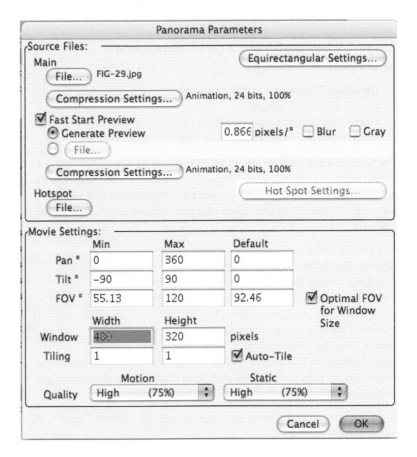

obtained with just two clicks of the mouse (from the Menu Bar choose File > Convert, then click OK in the dialog box that appears; see Fig. 12.26). Another option is to simply drag and drop the panorama onto MakeCubic's icon.

The QTVR panorama can now be viewed in Apple's QuickTime Player.app. More can be found at http://vizarch.blogspot.com

FIG 12.27 Navigating the QTVR panorama in Apple's QuickTime Player.

Resources

Software
Cheetah3D 5.5 is a full-featured 3D program for the Mac, featuring NURBS modeling, inverse kinematics, particle systems, animation, and an extremely fast rendering engine: $149
Available at www.cheetah3D.com
MakeCubic 1.1.6 is a free application from Apple (that runs using Rosetta) that allows the quick creation of QTVR panoramas for navigable 360° views.
Available at http://download.cnet.com/Make-Cubic/3000-18553_4-8657.html
http://www.versiontracker.com/dyn/moreinfo/mac/11644
http://downloads.zdnet.com/abstract.aspx?docid=445243

Plug-in for SketchUp
Bomb.rb by Rick Wilson: It explodes all groups and components in a SketchUp model.
Available at http://www.smustard.com/script/Bomb.

Graphic Design

Road Rage Book

David Allan

David Harned (who writes under the pen name David Allan) is an author; businessman; and the former president of Wolf Coach, Inc. (www.wolfcoach.com), a premier manufacturer of communications vehicles for the military and television industries. He founded FNA Publishing in 2008 to market and distribute his first book Why We Feel "Road Rage" ... And Why It's Your Fault!, *which is the subject of this case study. When he is not working on the second book in this series* Why I Throw My Golf Clubs ... And Why It's Your Fault!, *Harned suffers through paid employment in the financial services industry.*

> **Project**: 3D illustrations for a satirical book about road rage
> **Tools**: SketchUp 6, Adobe CS3 (Illustrator, Photoshop, and In-Design), Microsoft Excel and Word (2003), Microsoft Windows Live

The writing of *Road Rage* (www.roadragebook.com) began in earnest in the fall of 2006, with the final product hitting the presses in November 2008. An original hand-written draft had been created 20 years earlier, carrying the working title *The Idiot Driver Book*. But like most of the competitive books on the market today, that early version seemed too whimsical for my liking and, therefore, I shelved (and subsequently lost) my original manuscript.

I suppose my primary reason for resurrecting this project in 2006 is that I had endured 20 more years of frustrated driving and I finally "couldn't take it anymore!" Whereas society and the media continued to vilify frustrated drivers, I, on the other hand, empathized with them. Through my admittedly informal market research, I found that virtually all good drivers became perturbed on a regular basis. Furthermore, their frustrations were rarely self-induced; instead such frustrations were invariably caused by the ridiculous antics of clueless, careless, and reckless drivers. *Road Rage* was written to expose idiot drivers, at the same time showing compassion for all the good people affected by them.

Since this was a work of passion and not one for hire, its budget was strictly self-imposed (although, as one might suspect, "approval" from my lovely wife Amy was a prerequisite). To fund the purchase of an upgraded computer, associated software, book design and printing costs, website design and hosting expenses, and miscellaneous supplies, I managed to keep spending under my target of U.S. $25,000.

Other than myself, those who directly contributed to the project included Michael Coogan (a marketing, branding, and positioning guru; cooganmf@yahoo.com), Pete Stoppel (a SketchUp genius and forum moderator who provided tips, guidance, and book cover art; www.solosplace.com), and Cecile Kaufman (my book designer; www.x-heightstudio.com).

Project Context

Road Rage is essentially a coffee-table book or a "bathroom reader," with its 112 episodes drafted and laid out in Microsoft Word. Although it is perfectly fine for a working draft, Word is not suitable for use in the publishing world; so prior to project completion, the entire book's content was transferred to Adobe's In-Design CS3. The Word file had pages of size 7" × 9", which were ultimately resized to 8" × 10" by my book designer in order to create adequate white space on each page.

And because I happen to be an expert user of Microsoft Excel, all the book's illustrations were mocked up inside spreadsheet tabs. This was done for the sake of speed and ease of modification (plus the fact that I had not yet learned to use Photoshop). As each SketchUp scene was created and camera position finalized, a screenshot was taken, pasted into a blank spreadsheet as an Enhanced Metafile, and then cropped to an appropriate size and aspect ratio. Excel comes with a phenomenal array of "autoshapes," each of which can be modified easily and quickly. These autoshapes were laid over screenshots to create arrows, lighting effects, exploded views, callouts with text, fade outs, and so on (again, all of which were re-created in Adobe Illustrator, Photoshop, and In-Design prior to submission to the printer).

Technical Aspects

I mentioned earlier that many books about road rage, bad drivers, etc., are whimsical in nature. In addition to their light-hearted writing, their illustrations tend to be cartoonish, which is much worse. I contend that this type of humor is downright inappropriate when discussing a topic as serious as road rage. Instead, I chose to impart a sense of realism to my book's writing and illustrations. Its humor leans toward satire and ridicule, akin to the works of my comedic idols Denis Leary and Lewis Black. And my exposure to the flexibility of Wolf Coach's 3D designs led me to conclude that *Road Rage* must have realistic, 3D illustrations and not simple 2D cartoons.

Almost 90% of the book's text was completed in about four months; so in early 2007, I began my search for an illustrator. I soon learned that very few of them worked in 3D space, and those that did were prohibitively expensive. But two of them asked me if I had ever heard of a program called SketchUp and suggested that I take a look. I downloaded a trial version, viewed some tutorials, and I was hooked. In a few short weeks, I found myself creating fairly complex models, although I had never before used 3D CAD software.

The most significant advantage of using SketchUp was the ability to infinitely modify each model's camera position until its scene was "just right." Second, most SketchUp models were exported into multiple illustrations. The ability to orbit around a model, zoom in and out, add and subtract components, etc., using SketchUp can never be replicated by even the most experienced 2D artist. This invaluable flexibility allowed for a trial-and-error approach until each scene had the perfect size, shape, and tone. Best of all, the ability to make these modifications myself saved five figures, if not six figures, in cost (the book's 240 pages include over 400 illustrations).

This project being literally my first exposure to SketchUp, most illustrations in the book were created using standard features. Although these features were essentially straightforward, a few were especially important since most scenes were viewed from a distance:

- Shadows – not only to add necessary depth to each scene but also used often to highlight certain components within a model
- Fog – critical for low-angle camera positions where I wanted to limit the size of the overall model and also restrict readers' focus on closer objects
- Softening of edges – necessary to make dotted lines and other street markings look as though they have been painted on, without black edges distorting this view

In virtually every final illustration, certain overlays were created within Photoshop, including lens flares for approaching headlights; gradient-filled ovals, semiovals, and custom shapes to represent headlights and taillights from other angles; and semitransparent shapes to infer motion. Other overlays were best handled in Illustrator, including straight and curved block

arrows, callouts with text, various solid- and dotted-line Bezier curves, and even water droplets and musical notes. No SketchUp plug-in was used for this project.

New Approaches

The originality of my *Road Rage* project has far more to do with its application than with the advanced features of SketchUp, per se. A testament to the excellence of SketchUp as a software package is that a complete novice like me could learn to create hundreds of illustrations in a relatively short time frame, without having ever touched the software before. SketchUp is intuitive, stable, and powerful. For my needs, it was the perfect combination of high quality and ease of use, allowing my readers to project themselves into realistic scenes to better understand the accompanying text.

Step 1: Episode Listing

Goal: To create a comprehensive episode listing.
Input: Real-life experience on the road.
Tool :Pen and notepad.

I mentioned earlier that my 20-year-old, hand-written *Idiot Driver Book* manuscript had been lost; so when the decision was made to re-create it, I needed to start from scratch. But here is the surprising part: Of the book's 112 episodes, I experienced about 75 of them in the very first day! That is right; in one day's commute, 35 miles each way, I encountered 75 idiots and documented each one of them. Of course, being one of the world's best drivers, I did so without taking my eyes off the road, which meant that some of my notes were darned near impossible to read.

Step 2: Chapter and Episode Titles

Goal: To organize episodes into logical chapters with clever titles.
Inputs: My imagination and the aforementioned episode listing.
Tool :Microsoft Excel.

The book was organized into 15 chapters (called EXITs), which allowed the reader to enjoy similar topics grouped together. For example, EXIT 3 is titled *The Importance of an Exit Strategy* and it covers all the silly things bad drivers do as they attempt to enter and exit from a highway. EXIT 8 is titled *Park Place and Bored Walk*, which is all about parking lot indiscretions.

Each episode, varying from one to four pages, has its own title as well. A few favorites are the following:

- *Make Up Your Mind, Not Your Face*: About morons who apply makeup (or shave) while driving
- *Wrong Turn on Red*: About those who do not seem to know how to make a *right* turn on red

- *The Cart Behind the Horse's Ass*: About inconsiderate twits who leave their shopping carts in the middle of their vacated parking spaces
- *I Wish You Would Shut Your Trap*: About the overuse of speed traps

Step 3: Episode Models

Goal: To create an initial SketchUp model or models for each episode.
Input: Visualization of actual locations in which each encounter occurred.
Tool :SketchUp 6.

Note: Steps 3–6 apply to each of the book's 112 episodes.

Virtually every *Road Rage* episode depicts an actual experience by me; therefore, most of the book's illustrations and their supporting SketchUp models depict actual locations in Massachusetts, my state of residence.

This first model was created for the *Wrong Turn on Red* episode, and it represents an actual intersection near my home. Although the gas pumps were imported from SketchUp's 3D warehouse, the rest of the scene was drawn from scratch. A few things to note are as follows:

- Gray scale: Since the book's interior was printed in black and white, most components within models were drawn in gray scale (an exception in this case was the traffic lights).
- White background: The original intent was to have most illustrations fade into white paper stock; therefore, for simplicity, a white ground color was used in most scenes.
- Softened edges: In order for lines to appear painted on, each edge had to be softened one at a time. Otherwise, all the white lines appearing in this scene would have had black edges, which would not have reflected a realistic view.

Note: Once these edges are softened, it is necessary to use the View > Hidden Geometry menu to select them. Use caution, though, because depending on your computing power, viewing hidden geometry in a complex model can be terribly slow and may even lock up your computer .

Tip

You will notice at the top of Figure 13.1 that the road comes to an abrupt stop. This is because after drawing a few initial scenes, I realized that significant portions of them were extraneous. If the camera angle and distance was going to crop that portion of the model anyway, why extend it? Once I learned that lesson – to only draw what would be viewable in the final image – model creation speed improved dramatically. When a road edge like this ended up being viewable by a lower camera angle, it would either be extended beyond the edge of the scene or masked with fog (Window > Fog) so that it faded to white before the edge could be seen.

FIG 13.1 Modeling a crossroads.

Step 4: Stage the Scene

> **Goal**: Add components to each model to mirror that scene's associated text.
> **Input**: Self-created and/or downloaded models.
> **Tool** :SketchUp 6.

Once each overall scene was created, it was necessary to position components (typically vehicles and/or people) to correspond with that episode's text. In this case, only vehicles were added. One of the book's conventions was that bad drivers owned boxy, gray vehicles (downloaded directly from SketchUp's 3D warehouse), whereas good drivers owned better-looking, white vehicles (downloaded from FormFonts and modified slightly).

Note: FormFonts (http://www.formfonts.com) was a phenomenal resource, led by people who went out of their way to be helpful, cooperative, and fair when it came to the use of their models.

This particular scene (Figure 13.2) depicts an inconsiderate driver (the gray SUV) who has positioned himself in the right-hand lane even though he is not going right, thereby preventing me (in the Jeep) from taking a right turn on red light. The white truck has started moving through the intersection, whereas the SUV behind it remains still. Movement in the truck is inferred since its wheels appear to be spinning, which was done by grabbing the right edge of each spoke and rotating them all into the next spoke.

Since the camera position in this illustration is relatively close-up, the abrupt road edge discussed in step 3 is not viewable and is, therefore, inconsequential.

Step 5: Export the Image

> **Goal**: To export the image to a JPG and resize it to an acceptable resolution.
> **Input**: SketchUp model.
> **Tools**: SketchUp 6, Photoshop CS3.

FIG 13.2 Modeling an episode.

Once each SketchUp scene was finalized and saved, it was exported (File > Export > 2D Graphic) as a high-resolution JPEG. In the Options dialog box, Width was set to 3000 pixels, Anti-alias was checked (thereby adequately smoothing all edges), and the JPEG Compression slider bar was moved all the way toward Better Quality. This resulted in a 41.667" wide, 72-dpi JPEG (I was unable to successfully export from SketchUp at resolutions higher than 72 dpi).

This image was then opened with Photoshop, and reduced by a factor of about 4, *without* resampling the image. This resulted in an image with ¼ the

FIG 13.3 SketchUp's 2D bitmap export options.

FIG 13.4 Photoshop's Image Size dialog.

size (10" wide) and 4× the resolution (300 dpi) of the original image. When images were reduced below a width of 10", they were resampled in order to maintain a resolution of 300 dpi.

Note: Anything less than 300 dpi will be unacceptable to book printers, because those images will be noticeably inferior to the naked eye. Fortunately, with a book 8" wide, I never had to worry about images lower than 300 dpi.

Step 6: Add Overlays

Goal: Add overlays as discussed in the section Technical Aspects.
Inputs: Overlays created within Adobe's Creative Suite 3.
Tools: Adobe CS3 Photoshop and Illustrator.

The last step in each illustration before creating its final TIFF image was to add the necessary overlays to augment the basic scene. Figure 13.2 included arrows and text created in Illustrator, and an "illuminated" traffic light and brake lights created in Photoshop. This was done in the following steps:

1. Create a new layer.
2. Select the gradient toolbar (see arrow).
3. Select the Diamond Gradient tool (see circle).
4. Then drag from the center of the "light" to the point where you would like the fadeout to end. This is how the lighting effect was added to the traffic light in Figure 13.5 .

Finally, the image as it appears in the book is shown in Figure 13.6. You may have noticed that the traffic lights are no longer green and vehicle taillights no longer red? This is because the entire image had to be converted from RGB to gray scale (in Photoshop) since the book's interior was printed in black and white.

FIG 13.5 Post-processing in Photoshop.

FIG 13.6 The final image.

A Full-Page Example

Here is a sample page from the book, created in Adobe CS3 In-Design. Note a few of the book's conventions:

- A watermarked scene down the outside of each page
- Random street signs before each episode title
- Page numbering using a vehicle odometer
- Images are framed with rounded corners

Some additional comments on this page's illustrations – top image – include the following:

- Flooring was taken straight from SketchUp's Paint Bucket, and wood texturing was lightened to show contrast with other components in the model.
- The babies (tremendous models) came from SketchUp's 3D warehouse.
- The nurse, clipboard, nursery carts, and other miscellaneous items in the drawer (rolled towels, syringes, bottles, etc.) all came from FormFonts.
- I turned the nurse's head, changed her hair color to black, moved her arm to hold the added clipboard, and changed her garb from green to white.
- The nursery carts came with cushions, on which I laid the babies. I created "blankets" over the babies with simple curved shapes, stretched and sized them to fit over their bodies and inside the carts, and tucked them beneath their chins. The cushions and blankets all used the same texture so that one blended into the other.

Bottom image had the following features:

- Road, curb, and driveway came from a prior model.
- House, steps, and fence came from SketchUp's 3D warehouse.
- The tree was e-mailed to me by another SketchUp user.

Tip

Most trees in the book were actually "2.5D." These were created with 2D trunks and branches, with leaf clusters mounted on a series of transparent shadow planes that were set to face me in the components' options. No matter what the camera angle, the trees appeared to have hundreds of individual leaves and always cast a shadow. This technique significantly reduced each model's size. (Unfortunately in this case, I know only enough to be "dangerous." I believe the person who pioneered this technique is "Tomsdesk," and this individual's trees can be seen on www.solosplace.com .)

- The women, child, tricycle, infants, and strollers all came from FormFonts.
- The women's heads were turned to face each other slightly, and arms were positioned to appear as if they were pushing the strollers.
- The child's arms and legs were positioned to appear as if he was riding the tricycle.
- Hair, clothing, and stroller colors were all modified to provide sufficient contrast against their respective backgrounds.

In the Beginning . . .

As far back as I can recall, I've been aggravated by inconsiderate, annoying, and just plain stupid people.

For example, I can remember my first drawer ding like it was yesterday.

And I'll never forget the first time I was stuck behind a left-lane hog.

Yes . . . this book has been a very, very long time in the making.

Why We Feel "Road Rage" . . . And Why It's Your Fault!

FIG 13.7 Extract from the book.

Conclusion

I truly believe that without SketchUp, *Road Rage* would have not yet been completed, would have been a far inferior product than it is today, or would have cost thousands more to complete. SketchUp was intuitive to learn, extremely powerful and stable to use, and, at approximately $500, almost ridiculously inexpensive. I have been involved in the purchase, implementation, and use of numerous software applications, from simple products like task managers to complex ERP and MRP systems and even the purchase (though not the use) of CAD systems like AutoCAD and Solidworks. Without question, SketchUp provides the best bang for the buck, without even a close second.

For my particular project, SketchUp allowed me to create models that could be used over and over for different scenes and episodes. I was therefore able to quickly illustrate, in a truly realistic manner, the scenes described by my book's text. There probably is not one illustration in the entire book that was not modified numerous times before getting it right, whether that be changing the camera position, moving components, changing shadow settings, etc. SketchUp allowed me to continuously tweak the scenes with little time and at no cost. It allowed me to focus on creativity without being hindered by software.

I would recommend SketchUp to anyone engaged in the business of illustrating, even those who typically think in a 2D world like graphic designers and Web site creators. The perspectives that can be easily achieved with SketchUp cannot be achieved realistically with traditional graphics tools. I used SketchUp to create images for my Web site, www.roadragebook.com. We are in the process of creating a Web site and a marketing brochure for my job in the financial services industry, and I fully intend to create unique, 3D images in support of both.

I am also in the process of learning more about SketchUp's Sandbox tools, as I am helping my brother-in-law design a house and position it on his lot. SketchUp will allow us to hand his architect a high-level draft of what the house could/should look like, including realistic walkthroughs.

Whether for professional or personal use, SketchUp is definitely a life-changer.

Resources
Software
SketchUp Plug-Ins
Others Plug-Ins

Concept Art Techniques

Alex Jenyon

Alex Jenyon is a concept artist and matte painter working in the visual effects industry in London. He has produced concept designs, storyboards, background paintings, and illustrations for commercials, TV shows, and feature films. Credits include the features Rock'n'Rolla; Telstar *and* Stardust; Human Body: Pushing the Limits *for the Discovery Channel; and commercials for Toyota, Hyundai, and UEFA. At the time of this writing, he is working on designs and matte paintings for* The Day of the Triffids *miniseries. His website is www.aj-concepts.net*

> **Project**: Using SketchUp to plan and compose a concept painting
> **Tools**: SketchUp Pro 6, Painter X, Photoshop CS4

I am often hired in the early stages of a project to produce concept illustrations that will help "sell" the pitch to potential clients or investors, and help get the project off the ground. As you can imagine, these images are often highly confidential and become valuable intellectual properties of the company that has hired me.

It is, therefore, not possible to do a case study of one of the illustrations I have produced commercially. So instead, I have chosen one of my personal projects as a study of my workflow.

The CGSociety (which you may be familiar with from their popular forum http://www.cgtalk.com) runs regular online competitions (or challenges), and this painting was created for their "Steampunk Myths and Legends" challenge.

This represents a good facsimile of a commercial project: This painting project has a set brief and a set deadline, rather than being simply an open-ended personal exercise.

The brief here is to take a classic myth or legend and "reimagine it" in a "Steampunk" style. The deliverable is a single image, and because I was working on it in my own time, I had about four days in which to create it.

Project Context

I am using exactly the same techniques here that I would use on a commercial project. SketchUp is used to plan and compose my scene, and the illustration is finished using a combination of Painter and Photoshop. The planning, design, and layout stage normally takes about 50% of the time, so I would spend 2 days on this, and 2 days on painting the final image.

Technical Aspects

SketchUp is the perfect choice for this project because of its sheer speed. It is simply one of the fastest modeling applications on the planet, and offers one of the quickest ways I know to develop my design ideas. There are some downsides to this high speed: slightly messy geometry and difficulty in producing nice UV maps. But because I am not going to render my model in another package, these are not of any concern to me at all.

It is also a great tool because of my background as a 2D artist. SketchUp is the closest thing I have found to actually "drawing" in 3D. I do not have to worry about pushing individual polygons around; I just draw the edges with a WACOM pen, and SketchUp does the rest for me. Therefore, there is not so much of a mental boundary between the different stages of my work. Working in 3D requires a similar mind-set and approach to working in 2D when SketchUp is involved.

When I used to paint manually (i.e., with paper and "hairy sticks"), the first stage of any painting would be a black and white line drawing, usually black ink on watercolor paper. I would then paint over the line drawing using ink washes, and finish off the details in gouache or acrylic.

A large WACOM tablet and a copy of Painter has taken away the need to mix colors and wash brushes (which I am very thankful for), and SketchUp now provides me with a line drawing in perfect perspective on which I can start laying down color. There is no need to work out vanishing

points, which could sometimes be meters outside the canvas, and no need for endless thumbnails to plan the composition. I can look at my scene through a realistic camera, and even choose the focal length of the virtual lens I am using.

I can also use SketchUp to experiment with different light directions, seeing where the shadows fall, and plan how to use light to enhance my scene or the composition of the painting. I do not really use that many plug-ins, since all I am interested in is laying down rough forms as quickly as possible. It does not matter if a curved surface is rather jagged and low poly. I can just smooth it out when I come to paint over it. In some respects, I am producing a massing study rather than a polished model and do not really need many advanced tools to do this.

New Approaches

I used the Film and Stage plug-in to help position my camera. It is really useful to have a physical object to drag around the scene, rather than just judging the position using viewport. The script is getting a bit old now (it was created before Google bought @last), but it still seems to work reasonably well with SketchUp 6.

I made use of 3D warehouse while creating the 3D model, picking and choosing elements that might be useful in my design. I never use models exactly as they are downloaded; using parts of prebuilt models can save a lot of valuable time without compromising on the creative vision of a scene.

Step 1: Rough Sketch

Goal: To create a rough sketch that contains all the elements that will be in the final image, as well as an idea of the atmosphere and colors that will be used.

Inputs: I have chosen as my source material the epic from Greek mythology *The Odyssey* – the story of Odysseus' troubled journey back from Troy at the end of the Trojan War. I am going to specifically choose the scene in the story where Odysseus' ship passes through a narrow strait between high cliffs. On one side of the strait lies the whirlpool "Charybdis," and high up in the cliffs opposite lives the six-headed sea monster "Scylla." Avoiding one hazard will cause the ship to pass close to the other. Odysseus chooses to pass close to the sea monster (and lose six men) rather than the whirlpool (and risk losing the entire ship).

Tool :Painter.

This image is created very quickly (in an hour or so), straight from my imagination, without requiring any reference materials. Although the composition, perspective, and detailing of the image, therefore, leaves a lot to be desired

(there is a reason we use reference materials, after all), I have now got a defi-
nite idea of where I want the image to end up and what elements I need to
start modeling the image in SketchUp.

FIG 14.1

Step 2: Refined Sketches and Elevations

Goal: To gather together any sketches or drawings that will aid the 3D
modeling process
Inputs: Research into the construction and design of mythological and con-
temporary Greek warships (the trireme), nineteenth-century paddle steamers,
as well as a steam engine of the type known as a "reciprocating beam engine"
Tools :Pen, paper, Painter.

Although the scene I am creating is quite clearly one of fantasy, I like to
ground my work in reality wherever possible as this always helps to sell the
final image. I could simply turn straightaway to modeling (which is quite good
fun), but it is not a very efficient way of working. I, therefore, create a rough
elevation of the ship, as well as a more refined sketch of my sea-monster head,
which I will import to SketchUp to aid the modeling process.

FIG 14.2

Step 3: Constructing the Hull

Goal: To construct the main forms of Odysseus' ship.
Inputs: Elevation sketch, reference photographs of reconstructed Greek warships, Greek art.
Tool :SketchUp.

Using the elevation sketch I imported to SketchUp, as well as other reference materials, I create a series of construction lines using the Line and Arc tools.

I then create the solid form of the hull by joining the construction curves by hand. I could have used the Skin.rb plug-in for this purpose, but since I am working quite low poly, it is not a time-consuming process to manually "loft" the hull. I select the partial hull and make it a component.

Tip

Because it is a symmetrical object, I only have to model one half of the hull to complete the base of the ship. I select the half-hull component and use the Scale tool with a value of –1 while holding down the Shift key to create a mirrored copy. I move the new mirrored copy to its place. Now, every modification I make on one half is mirrored automatically on the other half.

Then I construct the deck plate on top of it as a separate object. I also construct the gunwales (the rails along the edge of the deck) by extruding a low-poly circle along a curve using the Follow Me tool, and then duplicating it several times.

FIG 14.3

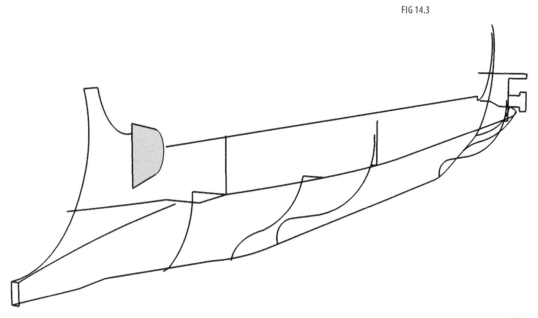

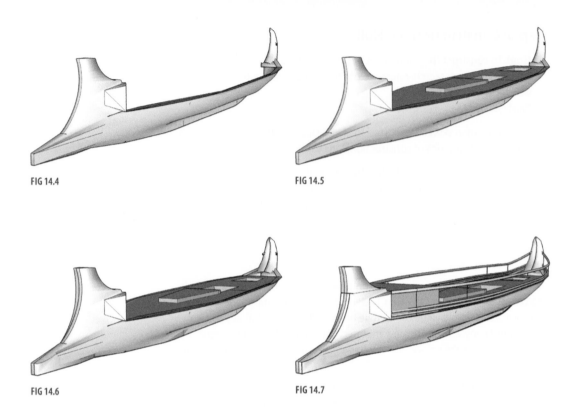

FIG 14.4

FIG 14.5

FIG 14.6

FIG 14.7

Step 4: Ship Details

Goal: To add the superstructure and finishing details to the ship.
Inputs: Research into paddle steamers and beam engines, Ballista model from 3D warehouse.
Tool :SketchUp.

The steam engine and paddle wheels are created from groups of simple primitives (primarily cylinders) or extruded from a 2D profile using the Push/Pull tool.

The Ballista model on the prow is a (reasonably) historically accurate model that I downloaded from 3D warehouse. Since parts of this model fitted my purposes perfectly, it made sense to save time by using prebuilt geometry rather than making my own identical copy from scratch. With a bit of scaling and some simple tweaks to the prow, the Ballista model fitted into my model just fine, saving valuable time.

After some consideration, I felt that the balance of the ship design was not quite right, and reversed the layout of the steam engine and boiler. Because I had grouped all the relevant objects when I built them, this process took only a matter of seconds, unlike for a 2D drawing.

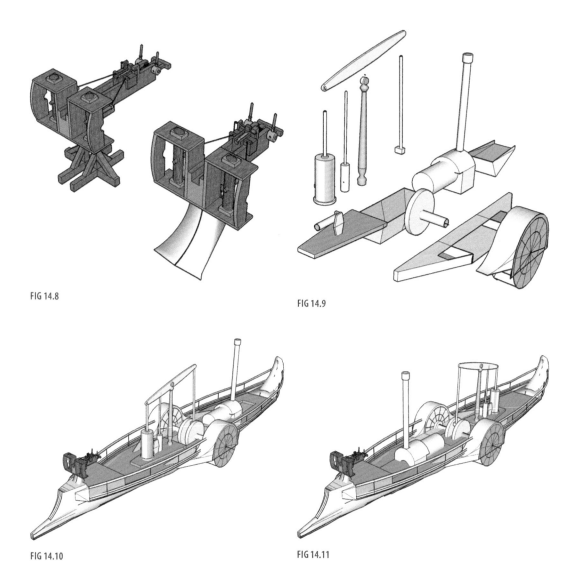

FIG 14.8

FIG 14.9

FIG 14.10

FIG 14.11

Step 5: Background Objects

Goal: To add some context to the scene by creating some rough background geometry.
Input: My original rough sketch.
Tool :SketchUp.

I created rough geometry for the cliffs and the wave surface by using the free-form curve tool to create an organic shape, and extruding it along a path. The result was not pretty, and certainly would not stand up to texturing or rendering. However, it took only a matter of minutes to create, and was more than sufficient for my purposes.

FIG 14.12

Step 6: Scylla

Goal: To create a 3D model of one of Scylla's heads.
Inputs: My refined sketch; reference images of snakes, lizards, and Victorian clockwork automatons.
Tool :SketchUp.

To fit in with the Steampunk theme, I made Scylla a steam-powered clockwork creation, rather than a flesh-and-blood creature. Therefore, again I used only the standard drawing tools in SketchUp, rather than any of the organic modeling plug-ins (such as Subdivide and Smooth) that we now have access

to. This gives the creature a very mechanical, artificial look – bad for an organic, living creature, but perfectly matched for my design.

I started by creating the sweeping dome of the head using the Follow Me tool along a compound curve, as well as revolving a curve around a circle to construct the spheroid that forms the forehead. The final skull is constructed of several simple objects like these curves intersecting with one another, which is a very bad practice if I was exporting to an external renderer. But since SketchUp does not have a problem displaying them, neither do I.

FIG 14.13

The three rows of Scylla's teeth (as specified by the story) were created by extruding one row using the Follow Me tool, and then duplicating

FIG 14.14

FIG 14.15

and scaling the resulting geometry. Again, this would look very contrived on a real creature, but is perfectly in keeping with a mechanical construction.

The head and neck were created by duplicating and repeating groups of much simpler shapes, and the silhouette I had in mind was built up. From my original rough sketch, I know that the heads are largely going to be backlit, and the outline of the silhouette is going to be the most important feature of the design.

Step 7: Composing the Scene

Goal: To compose the scene and choose a camera angle.
Inputs: All the previously created geometry, my original rough sketch.
Tools: SketchUp, Film, and Stage plug-in.

I now take all the separate elements I have created in steps 1–6, and combine them to make my finished scene. The Scylla head is made into a component and duplicated six times, and I have added a standard 3D figure (from the Components browser window) to judge the correct scale of the elements.

This is where I experiment with different camera positions and fields of view (i.e., different lenses) to decide the final framing of my painting. I also experiment with different lighting directions, working out where I want the shadows to fall and how I am best going to match the atmosphere of my original sketch. I use the Film and Stage plug-in for this step so that I can view my camera positions as 3D movable objects.

FIG 14.16 Positions of cameras 1, 2 and 3 (from left to right).

FIG 14.17 View from camera 1.

FIG 14.18 View from camera 3.

Step 8: Exporting from SketchUp to Painter

Goal: Export a line drawing from SketchUp to Painter.
Input: My 3D model.
Tool :SketchUp.

I eventually choose camera 2 as my favored viewing angle, and export my scene as a 2D image. I export the image as a .tiff file, which seems to be the most reliable uncompressed image format to use from SketchUp, at a resolution of 4000 × 2700 pixels.

In Painter, I copy this image into a new layer, and set it to the "multiply" blend mode. I then clear the canvas layer beneath it.

Anything I paint on the canvas will now sit "below" the exported image, allowing me to be quite rough with my brush strokes.

FIG 14.19 View from camera 2, exported.

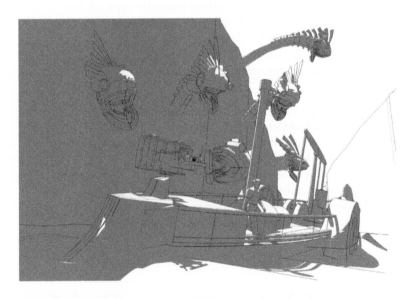

Step 9: Laying Down Rough Colors

Goal: To lay down the "underpainting" as a rough color wash.
Input: My original rough sketch.
Tool :Painter.

Using a large digital watercolor brush, I lay down rough areas of color. This is the digital equivalent of the "ink wash" technique I used when painting traditionally. Initially, I use the Eyedropper tool to pick color from my original sketch in order to capture some of the "feeling" and "atmosphere" that I like about it. I then block out the major forms of the boat using a square chalk brush.

FIG 14.20

Step 10: Composition Adjustments and Details

Goal: To improve the composition and legibility of the image.
Tool :Painter.

The composition is still lacking in some respects; I do not feel that it is as dramatic as it could be, since the boat is almost parallel with the bottom of the frame. The first thing I do is rotate the entire canvas and crop the image down slightly. I feel this adds to the unbalanced feel of the boat being tossed around by huge waves.

I then start to define the forms using a small "wet gouache" brush, picking out the highlights on the metal heads of the monster, as well as giving the vessel a crew.

FIG 14.21

Step 11: Photograph Elements

Goal: To add detail and texture to the image.
Input: Personal photographs taken in the Canary Islands.
Tool :Photoshop.

It is quite easy to make surfaces in digital paintings look flat and "plastic." There is no differentiation in surface texture between the rock of the cliffs and the water splashing against them.

I therefore take some photographs I took on holiday, and put them through a high-pass filter. I then overlay them over my image, giving more realistic textures to the surfaces I have painted.

FIG 14.22

Step 12: Final Detailing

Goal: To give a final "polish" to the image.
Tool :Photoshop.

FIG 14.23

This is the final stage of designing the painting and one in which all the finishing touches are added. I also do a final color correction; add some haze, smoke, and glare; and apply some film grain to "finish off" the image.

Conclusion

SketchUp was a valuable tool in creating an interesting, dynamic painting. It allowed me to be a lot freer and more adventurous than when using conventional tools, as I knew the underlying structure of the painting to be 100% sound. There is nothing more frustrating than realizing (after finishing a painting) that the underlying composition had ruined it from the very beginning. Here, I knew that I was painting from a good foundation, and could spend more time concentrating on color, texture, and atmosphere rather than worrying about perspective lines and vanishing points.

I do not know of any other 3D application that would have enabled me to create my scene as quickly or efficiently, although a lot of that is down to my own skills and personal preference. I am sure a user highly skilled in another package could have done something very similar, since I did not really use any features of SketchUp that cannot be replicated in other applications. However, using Maya for something like this would have been a frustrating case of overkill, and SketchUp is definitely the right choice for me.

I have been developing this workflow over a number of years, and it is always evolving and changing based on different project requirements, availability of new tools, and my own moods. But the fundamental technique of starting a 2D painting as a rough 3D sketch model is one technique I do not see myself abandoning any time soon.

Resources

Software

Corel Painter X: $399
Note : This is the price for Painter 11, which replaced painter XAdobe Photoshop CS4.

SketchUp Plug-Ins

SketchUp "film and stage" plug-in; available at http://sketchup.google.com/download/previousplugins.html
Ballista model from Google 3D warehouse by Erez

Geology and Georeferencing

SketchUp for Geoscientists

John Lang

John Lang is a Geoscience Information Specialist, with a BSc Geology (1980) and an MSc Geographic Information (2008), based in Perth, Australia. John specializes in innovative technologies for information management and is working as a spatial data management consultant to the petroleum industry. His recent projects include 2D/3D Google-based information systems for geoscientists, engineers, and managers focused on petroleum infrastructure.

Project: Is SketchUp with ArcGIS a practical tool for geoscientists?
Tools: Google SketchUp, ArcGIS, Google Earth; Plug-ins: ArcGIS, Cloud_V6, 3DVolume, Soap Skin and Bubble, and SketchyPhysics.

This project summarizes John's MSc thesis "Is Google™ SketchUp combined with ArcGIS a practical 3D tool for geoscientists using two case studies from Kyrgyzstan" The thesis was sponsored by Monitor Energy Ltd to enable 3D visualization of its petroleum and uranium assets in Kyrgyzstan, Central Asia. The thesis was completed in 6 months at Curtin University of Technology in Perth, West Australia, and won the 2008 Spatial Science Institute student award. The thesis has been updated to demonstrate the use of SketchUp

6/7, ESRI ArcGIS 9.2/9.3, and Google Earth 4/5 to build the 3D models for the following:

- Generic and conceptual petroleum diagrams.
- Regional petroleum basin imported from ArcGIS.
- Underground mine site from historic plans and GPS.

The results are applied to exploratory data analysis, conceptual modeling, illustrating, marketing, and exploration planning. The resulting 3D models confirm that SketchUp is powerful and simple to use, but has limitations with geographical information system (GIS) integration. SketchUp is unsuitable for volumetrics, large images, or large data sets and lacks a relational data structure. SketchUp neither is a true 3D modeling system nor has the functionality of geoscience modeling software. The SketchUp users are pushing these limitations through innovation. The results confirm that SketchUp with ArcGIS is a practical tool for geoscience education, marketing, conceptual modeling, and qualitative 3D visualization.

Project Context

The idea for the MSc thesis was a presentation of a 3D annotated sketch of potential petroleum traps. This visualization was highly effective for enhancing geological understanding of the petroleum potential. A brief Internet search suggested that millions of people were using the same software for sketching 3D models, sharing them through a 3D warehouse, and viewing them in a virtual globe. However, there was only one shared geoscience model (GeoSum3D, 2007). The lack of geoscience models contrasted with the popularity of the software and identified the topic for research. The number of users confirms the future of SketchUp, but is such a tool practical for geoscientists? The author, who is a geoscientist, identifies the following minimum requirements:

Part 1: Create generic 3D geological features.
Part 2: Create a sedimentary basin model from ArcGIS data.
Part 3: Create a 3D mine model from scanned maps and ArcGIS.

Techniques Utilized

ArcGIS/SketchUp Integration

The ArcGIS 9.2 plug-in was used for import of selected features and surfaces into SketchUp:

- Import of 2D and 3D shape files.
- Import of personal geodatabase point, line, polygon, and multipatch feature classes.
- SketchUp models were used as point marker symbols in ArcScene/ArcGIS 3D Analyst.

- Import of borehole (well) locations and borehole sections.
- Import of cross section locations and cross section images.
- Import of geological features such as formation tops, faults, folds, and unconformities.
- Import of digital elevation model (DEM) surfaces and surface images, including contours, digital elevation, and plans.

ArcGIS/SketchUp Integration Background

As the SketchUp product and users evolved to include terrain and world coordinates, importers were provided for Google Earth, GIS, and CAD. In 2005, a SketchUp 5 shape file importer was introduced, and in July 2007, an ArcGIS plug-in was released for SketchUp 6, enabling the import of selected point, line, and polygon features, and for Triangular Irregular Networks (TINs) and rasters. ArcGIS 3D Analyst/ArcScene can display SketchUp models as a 3D marker symbol for a point. The next version of the plug-in (not released yet) should contain a working SketchUp to ArcGIS multipatch exporter. An excellent set of tutorials is available on the Harvard Design School website (Cote, 2007) that demonstrates how to create a 3D model using data from ArcGIS.

New Approaches

A generic tool such as SketchUp combined with GIS has significant potential for conceptual modeling of the surface and subsurface of the earth and complements existing 3D geological modeling software. Prior to this thesis, the application of SketchUp with GIS to geological modeling had yet to be investigated.

Should creating 3D models be the role of the specialist? Since the 1990s, computerized 3D modeling of the earth has become a critical part of

FIG 15.1

geology. The industry has developed specialized software, including Surpac, GOCAD, Roxar, EarthVision, Petrel, Kingdom, and GeoModeller, to create, view, and analyze 3D geological models. These modeling tools have become increasingly powerful, complex, and expensive, leaving an opening for an easy-to-use, generic tool such as SketchUp.

Part 1: Create Generic Geological Models

I used SketchUp to create conceptual petroleum trap models that combine the standard geological features, including sedimentary layers, folds, faults, unconformities, and piercements, into 3D block models. The resulting models are exported to the 3D warehouse and viewed in Google Earth and ArcGIS ArcScene.

Step 1: Create SketchUp Petroleum Trap Models

Goal: To create generic 3D petroleum trap models.
Inputs: The CCOP guidelines for risk assessment of petroleum prospects, by Kalheim, Chaisilboon, and Caluyong (2000).
Tools: SketchUp, 3D Warehouse, and Google Earth.

To test whether SketchUp could create generic geological models, I created a set of petroleum trap block models based on the CCOP guidelines. The fold trap model consists of a 200-m-thick sandstone reservoir with a 100-m-thick claystones seal and was created using the following method

- Create a square base of 2000 m × 2000 m (VCB 2000,20000).
- Create a line curve representing the fold (or use shapes.rb to create a 3D dome).
- Copy the curve at 100-m intervals to create folds (VCB 100 × 4).

FIG 15.2

FIG 15.3

- Delete one curve to make a 200-m-thick sand.
- Draw two straight lines from the curve to the square base to create a face.
- Push–Pull (Copy) the face 2000 m to create the lower surface.
- Repeat for the next three surfaces, draw lines, and push–pull.
- Draw a line to create the oil and the face of the block model.
- Push–Pull (Copy) the oil and the face of the block model.
- Use materials to color the model.
- Add a 3D grid using the Ruby script Grid3d.rb or mesh_additions.rb.
- Add a dimension to the grid.
- Import a map compass from the 3D warehouse.

Step 2: Publish the Models for Visualization in Google Earth

Goals: To publish petroleum models.
Inputs: Generic petroleum models.
Tools: SketchUp, 3D Warehouse, and Google Earth.

The aim was to enable potential partners to visualize where the potential petroleum traps were in Monitor Energy's Kyrgyzstan exploration permits using Google Earth. This involved adding the World Geodetic System 1984 (WGS84) latitude and longitude coordinates of the location and the north direction of the model by typing the coordinates in the Model Info > Location (See Figure 15.4). The resulting models were exported from SketchUp using File > Export > 3D Model into kmz format and viewed in Google Earth.

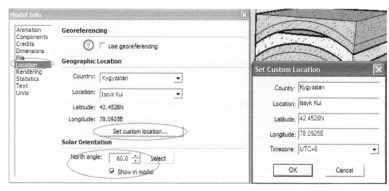

FIG 15.4

I published the resulting models in the 3D warehouse under the collection Geology 3D petroleum models under my user name "dinosur" (http://groups.google.com/group/geology-3d-petroleum-models).

FIG 15.5

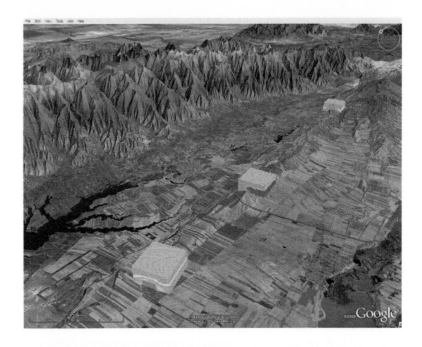

Step 3: SketchUp Models in ArcGIS

Goal: To publish petroleum models in ArcGIS 3D analyst/ArcScene.
Inputs: SketchUp petroleum models, and Shape file of X and Y coordinates.
Tools: ArcGIS 3D Analyst and SketchUp Pro.

ArcGIS is the most widely used GIS software for the petroleum industry. Unlike Google Earth, the ArcGIS extension 3D analyst can place 3D objects below the earth's surface. I installed the ArcGIS 9.2/SketchUp Pro importer/exporter (http://skethup.google.com/download/plugins.html#arcgis) plug-in,which adds a button to ArcGIS, which enables the use of SketchUp models as symbols for point feature classes in an ArcScene model, using the Import button.

I created an ArcGIS 3D point feature class and located the SketchUp models in the ArcScene document (See Figure 15.7). When time permits, I will investigate this method further as groups like The University of West Virginia have created an immersive 3D ArcGIS ArcScene/SketchUp virtual reality model of Morganstown village (http://humanitiesgis.org/projects/virtualmotown/index.html).

Step 4: Visualize Drilling and Production

Goal: To create a realistic directional drilling program visualization.
Inputs: Example directional drilling program and generic trap model.
Tool :SketchUp Pro.

FIG 15.6

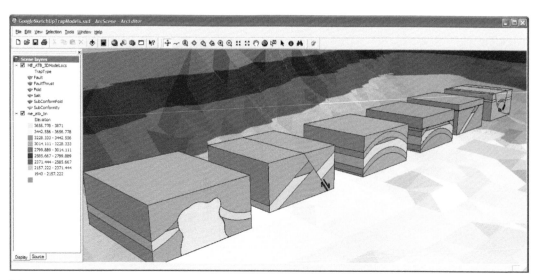

FIG 15.7

This step required the design of a drilling rig, platform, and drilling program that intersected the reservoir created from the previous steps. At work, I successfully created a platform from an imported AutoCAD model supplied by Worley; however, due to copyright reasons for this example, I created a simple jackup rig and production platform based on my previous work experience. It is available in the 3D warehouse as "Oil and Gas Production platform" by the user "dinosur". Using the Scale tool, I resized the drilling program to intersect the oil-bearing sand (green) to demonstrate how a geoscientist would effectively produce a sand of this geometry.

FIG 15.8

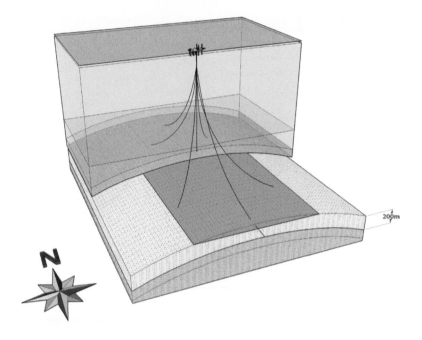

200m

FIG 15.9

Part 2: Create a Sedimentary Basin Model

Monitor Energy Ltd owns the At Bashi petroleum exploration license in Kyrgyzstan. The license covers a large underexplored basin surrounded by mountains. After the success of the generic geology models, a good case study was the import of ArcGIS data into SketchUp to create a 3D geological model of the At Bashi basin.

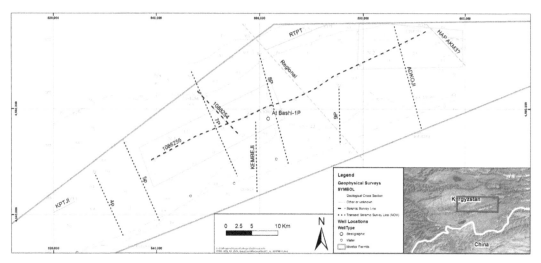

FIG 15.10

FIG 15.11

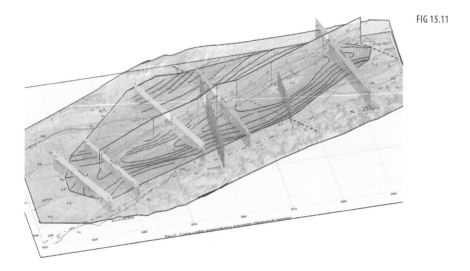

Step 5: SketchUp Import of ArcGIS Points and Lines

Goal: To import ArcGIS shape files and feature classes.
Inputs: ArcGIS point and lines.
Tools: ArcGIS, ArcGIS 9.2 SketchUp Plug-in, and SketchUp Pro.

ArcGIS features can be imported into SketchUp in two ways. Prior to June 2007, the shape file importer for SketchUp 5 was used to import all the features in a point, line, or polygon feature class. This method is effective and is documented in detail on the Harvard Graduate School of design website

265

(http://www.gsd.harvard.edu/gis/manual/arcgis2sku_fp/index.htm)and is not repeated here. In June 2007, Google released a Beta ArcGIS 9.2/SketchUp 6 Pro importer/exporter (http://sketchup.google.com/download/plugins. html#arcgis) that supported the import of multiple selected 2D and 3D features from an ArcGIS map document and the import of TINs from ArcGIS ArcScene. This beta script appears to work with SketchUp 7, with the following major limitation: SketchUp fails to place the imported features at the correct real-world location in an existing model. The imported features would instead be centered from the maximum extent of the imported feature classes. The fundamental problem is the site-centered nature of SketchUp, which requires a model to have a center location with a WGS84 latitude and longitude and zero elevation. My solution was to select the site center at a known latitude and longitude and to create a feature class that extends equidistant in the X and Y axes beyond the extents of other feature classes.

Importing the site center feature class (shown in blue), with any import, ensures the model data remain correctly georeferenced.

Using the ArcGIS plug-in, a point, line, or polygon feature class can be exported from ArcGIS to SketchUp with an elevation z. The selected features at WGS84 X, Y, and Z locations are exported from ArcGIS with options for elevate by field and naming of groups. This method is satisfactory, but has limitations including the inability to import 2D point feature classes. It is recommended for detailed information that point and polygon features are converted into 3D features prior to export. An excellent set of 2D to 3D tools is contained within the ET Geowizards plug-in for ArcGIS, which can save the cost of ArcGIS 3D Analyst.

FIG 15.12

Step 6: SketchUp Import of ArcGIS Contours

Goal: To import ArcGIS contours to create a surface.
Inputs: ArcGIS lines and TINs.
Tools: ArcGIS, ArcGIS 9.2 SketchUp Plug-in, and SketchUp Pro.

Contours digitized in ArcGIS and imported into SketchUp can be used to create a TIN from lines of equal elevation using the Sandbox from contours tool. Invalid edge TIN lines and surfaces were deleted in SketchUp. This identified a further limitation as Sandbox was not able to create surfaces from large contour feature classes. The author suspects the same limitation as cloud6.rb, of approximately 10,000 vertices for building a TIN from contours.

Step 7: SketchUp Import of Digital Elevation Model

Goals: To import points to create a surface.
Inputs: ArcGIS points.
Tools :ArcGIS, Cloud6 plug-in, and SketchUp Pro.

ArcGIS import TIN is the simplest method to import a DEM into SketchUp; however, this requires the 3D analyst extension. An excellent alternative is to use the cloud6.rb script to import the X and Y locations and elevation into the model from an ASCII file exported from ArcGIS and then automatically create a TIN. To place the TIN at the correct location, an ArcGIS model was built, which calculated SketchUp site coordinates from Universal Transverse Mercator (UTM) Z43N coordinates by subtracting the site center locations from the UTM Z43N coordinates. This method was used to import the SRTM digital elevation model. The satellite image was used as a material to color the DEM surface.

FIG 15.13

FIG 15.14

The Cloud6.rb Ruby script was unable to import the full basin digital elevation model of 20,000 points and failed to build the TIN from the cloud after approximately 2 hours. The SRTM data were resampled to approximately 5000 points, and the import worked successfully. It appears that the upper limit for building TINs is approximately 10,000 points on the hardware used by the author. In addition, attempting to import and drape images over 4 MB could cause SketchUp to fail with a "bug splat." The author recommends keeping images below 2 MB and TINs to below 10,000 points for speed and efficiency of the model.

Step 8: SketchUp Import of Sections, Wells, and Fields

Goal: To import points and lines to create scanned sections and well images.
Inputs: ArcGIS points.
Tools: ArcGIS, Cloud6 plug-in, and SketchUp Pro.

The ArcGIS plug-in cannot directly import a scanned cross section or image. However, by drawing the cross section as a line in ArcGIS and measuring the horizontal and vertical size of the image, a correctly scaled cross section can be imported into SketchUp. First, calculate the actual dimensions of the cross section in length (l) and height (h), and calculate the actual elevation of the top of the section. Next, draw the 2D cross section feature to the total length (l) of the cross section image and import to SketchUp using the actual elevation of the cross section. Extrude the cross section line by either using the Move/Copy tool to duplicate the feature and move it by (h) to the base elevation of the cross section, or use the Ruby script projections.rb, extrude lines along z (by Didier Bur) to create the cross section surface. The scanned image is imported as a texture and placed as a material onto the surface using l for width and h for height.

This method can be used for viewing a well log (image of the geological properties of the well) that can be viewed from any direction in the model. Using the same methodology described for importing the cross section, create a polygon or line width of the log, and extrude to the depth of the log. When finished, group the object as a component and set the properties of the component to always face the camera SketchUpWellField.

FIG 15.15

Step 9: Interpolate a Surface Between Sections

Goal: To create a realistic surface between two or more sections.
Inputs: Scanned cross sections and digitized tops.
Tools: SketchUp Pro, and Soap Skin and Bubble Plug-in.

A common requirement for geoscientists is to interpolate surfaces between digitized cross sections. The manual option is to draw lines between the cross sections until a surface is created. To simulate a more natural-looking surface, I used a soap bubble interpolation between the lines using the Soap Skin and Bubble Plug-in for SketchUp (Leibinger, 2007). This enabled pushing and pulling the structure to confirm the structural interpretation. The following workflow interpolates the top of the Paeleaozoic (Pz) between two cross sections.

FIG 15.16

Digitize the Pz horizon line on the georeferenced cross sections using the $$$Line$$$ and Arc tools. Join the ends of the lines to create a closed loop and triple-click the line to select the entire loop. Use the Skin tool to create a skin between the loops. Choose the number of vertices, and adjust the X/Y ratio to make the skin bulge or droop. The results were used to create realistic petroleum reservoirs from sections and existing interpreted contours. A good alternative is the SubdivideAndSmooth.rb, which creates organic 3D shapes from block models.

Part 3: Mine Model Using SketchUp and ArcGIS

I used SketchUp to create a 3D visualization of an abandoned mine in Kyrgyzstan from Russian plans. The aim was to validate the location of the mine within Monitor Energy Ltd's exploration permit. The SketchUp model enabled me to communicate of ideas and concepts with the teams, provide illustrations for brochures, and ultimately to sell the prospect to investors.

FIG 15.17

Step 10: ArcGIS Export to SketchUp

Goals: To export the ArcGIS features, georeferenced maps, and sections into SketchUp.
Inputs: ArcGIS points, lines, and scanned sections.
Tools: ArcGIS, Cloud6 plug-in, and ArcGIS SketchUp plug-in.

First I use ArcGIS to create a vector map of the scanned Russian maps, including the point locations of mine shafts, mine adits and lines for contours, and mine tunnels to produce a map of the area. The SRTM data were imported into SketchUp using the cloud6.rb script, and the Google Earth image was used as a material to color the surface. The mine plans and section locations were adjusted to provide a good fit with the SRTM model.

FIG 15.18

Step 11: GPS Validation

Goal: To validate abandoned mine site with GPS.
Inputs: GPS Locations of the mine site.
Tools: GPS, ArcGIS, and Google Earth.

FIG 15.19

Afield trip to Kyrgyzstan with global position sensors (GPSs) identified key features of the abandoned mine, including cemented-up shafts and open adits (mine drains). I exported the GPS locations to Google Earth to validate the adits with the topography. I then shifted the ArcGIS map and SketchUp model to match the GPS locations using the Movelt.rb plug-in, which confirmed beyond doubt that the mine plans and sections belonged to the abandoned mine

FIG 15.20

Step 12: Create a Drilling Program

Goal: To estimate the number and direction of drill holes.
Input: SketchUp model.
Tool :SketchUp Pro.

To evaluate a potential resource, the best method is to design a drilling program to sample the minerals. From the narrative of mineral thickness, I created a set of parallel polygons using the Move/Copy tool and VCB, and the layers were rotated with the Rotate tool to the correct angle and then rotated again to the correct direction to represent the mineral layers. The drilling engineer recommended an 80-m drilling grid, parallel to the mineral layers, and at approximately 60-degree inclination to intersect the minerals. One of the biggest risks is to intersect an existing mine shaft or tunnel as the drill can get stuck, causing significant loss of time and equipment. To minimize the risk of intersecting the mine tunnels, the grid of wells was shifted until no intersections were visualized using section cuts .

FIG 15.21

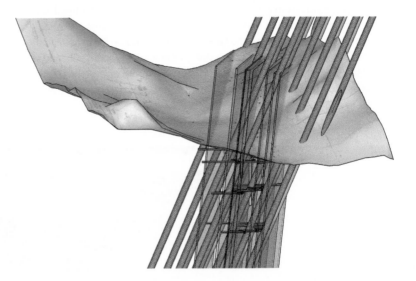

Note that Intersect with mode was not successful at identifying which drill holes intersected a tunnel.

Step 13: Pit Volume Estimation

Goal: To estimate the open cut volume for the site.
Inputs: SketchUp model and slope stability angle.
Tools: ArcGIS, SketchUp Pro, and VolumeCalculator21 plug-in.

The lowest cost method of mining is to create a pit; so, using an engineer-supplied stable slope angle, I used ArcGIS to create a set of pit contours, imported these to SketchUp, and used Sandbox to create a generic pit. Using

the Intersect with Model, I intersected the pit with the surface and deleted the remainder. The VolumeCalculator21.rb was used to estimate the volume of rock required to be extracted for the minerals to be mined.

FIG 15.22

200m
500m

Conclusion

The author, who is a geoscientist, found SketchUp, combined with ArcGIS, a practical tool for visualization and qualitative 3D modeling of small to medium data sets. To summarize, SketchUp is recommended for geo-science 3D modeling and visualization under three or more of the following conditions:

- The data and images are of small to medium size or can be abstracted.
- The modeling is used for qualitative purposes, such as illustrative and conceptual purposes, or for the sharing of ideas.
- For shared visualization between teams or the public.
- The data are uncertain or imprecise.
- When specialist software is not available or inappropriate.
- The 2D data exist in GIS or CAD, and 3D visualization is required.
- For integration with ArcGIS or Google Earth.
- When time is short and the budget is low.
- For data entry to specialist modeling systems such as Surpac.
- When the model objects are not attributed with information.

The choice of SketchUp with ArcGIS and Google Earth was invaluable in locating the mine site through the shifting of the cross sections to fit the terrain. The SketchUp model location was relocated easily when accurate GPS information became available. SketchUp was particularly easy to use for creating drilling options, with section cuts used to visualize the effects of a particular grid and direction. SketchUp enabled visualization of specific site issues, including drilling collision avoidance and open cut options, but does not have the power for quantitative modeling of volumes or collision analysis. SketchUp exported the mine model to Surpac using AutoCAD file format where quantitative analysis was to be performed, and the results were imported back to SketchUp.

Since the completion of this project, I use SketchUp regularly for teaching the ideas and concepts of 3D modeling to students. At work, we successfully combine petroleum infrastructure models with geological models to visualize production options and risks. The recent addition of subsea Google Earth has added a whole new dimension of underwater construction visualization. I am researching the SketchyPhysics plug-in for geoscience problems, including subsea facilities construction; plume modeling; slope stability, for example, the slope stability of blocks after 30 seconds at 20-, 30-, and 40-degree slope angles; sedimentary fill; seismic movement; or deformation under gravity .

FIG 15.23

Resources

Software

ESRI ArcGIS 9.3 ArcView is a desktop GIS software that provides geographic data visualization, mapping, management, and analysis capabilities along with the ability to create and edit data. Price is about US$1500. Purchase from http://store.esri.com.

ESRI ArcGIS 3D Analyst, ArcGIS Extension: Three-dimensional visualization and analysis. Price is about US$2500. Purchase from http://store.esri.com .

ET GeoWizards extension for ArcGIS by Ian Tchoukanski, ET Spatial Techniques. Price is US$195. Purchase from http://www.ian-ko.com/ET_GeoWizards/gw_main.htm .

ESRI ArcScripts, over 5000 free scripts for ArcGIS. Download from http://arcscripts.esri.com/ .

SketchUp's Plug-ins

ArcGIS (Beta) Import/Export of ArcGIS data to/from SketchUp and use SketchUp models as 3D Marker Symbols. Download free from http://sketchup.google.com/download/plugins.html#arcgis .

3D_Grid.rb Creates a 3D grid along X,Y,Z axis, by J. Patrick and D. Bur. Download from http://www.crai.archi.fr/RubyLibraryDepot/Ruby/3d_grid.rb .

Attributes.rb Attach arbitrary attribute data to entities and then do queries based on those attributes, by @Last. Download from http://www.crai.archi.fr/RubyLibraryDepot/Ruby/EM/attributes.rb .

BezierSpline.zip Polyline can be converted into any BezierSpline curvex. Download from http://www.crai.archi.fr/RubyLibraryDepot/Ruby/Bezierspline.zip .

Cloud_V6.zip imports x, y, z points from an ASCII file and creates 3D surfaces. Download from http://www.crai.archi.fr/RubyLibraryDepot/Ruby/EM/Cloud_V6.zip .

GetDimensions.rb displays dimensions of component, by CptanPanic. Download from http://www.crai.archi.fr/rubylibrarydepot/ruby/GetDimensions.rb .

Grid.rb to create a rectangular grid of lines, by Jim Patrick. Download from http://www.crai.archi.fr/rubylibrarydepot/ruby/grid.rb .

K_tools_21.rb draws 2D and 3D maths functions to do basic geometrical construction, by Klaudius. Download from http://www.crai.archi.fr/rubylibrarydepot/ruby/k_tools_21.rb .

MoveIt.rb moves groups/components in 3D space using [x,y,z] coordinates, by Octavian "TBD" Chis. Price is US$5. Download from http://www.smustard.com/script/MoveIt .

Links.rb adds a URL to an object, by Didier Bur. Download from http://www.crai.archi.fr/rubylibrarydepot/ruby/links.rb .

mesh_additions.rb creates a 3D mesh, by @Last. Download from http://www.crai.archi.fr/rubylibrarydepot/ruby/mesh_additions.rb .

Shapes.rb to create 3D shapes including spheres, domes, and cones, by @Last. Download from http://www.crai.archi.fr/rubylibrarydepot/ruby/shapes.rb .

SketchyPhysics.rb Newtonian Physics Software Development Kit (SDK) by Newton Game Dynamics (2006) "for real time simulation of physics environments," by DarthGak. Download from http://code.google.com/p/sketchyphysics/ .

SoapSkinAndBubbleTools.rb for creating mechanically and pneumatically strained surfaces, by Leibinger. Download from http://www.tensile-structures.de/sb_software.html .

SubdivideAndSmooth.rb organic modeling toolset, by Dale Martins. Price is $22. Download from http://www.smustard.com/script/SubdivideAndSmooth .

VolumeCalculator21.rb (or ZVolume.rb by Gareth Swarbrick) to calculate the volume of a selected groups or components, by TIG. Download from http://www.crai.archi.fr/rubylibrarydepot/ruby/VolumeCalculator21.rb .

Other Plug-ins

EasyCalculate is a set of expressions (currently 110) for the ArcGIS field calculator, by Ianko Tchoukanski. Download from http://arcscripts.esri.com/details.asp?dbid=12224 .

Export to KML 2.5.4 converts shape files to and from kml, by Kevin Martin. Download from http://arcscripts.esri.com/details.asp?dbid=12224 .

Visualization of Historic Landscapes

Patrick J. Reynolds

A graduate of the Copperstown Graduate Program in museum studies, Patrick Reynolds has over 15 years of experience in working with museums and historic sites. He came to SketchUp in 2007 as a tool for use in exhibit design, education, and preservation of historic sites.

> **Project**: Modeling of the vanished town of Byng Inlet
> **Tools**: SketchUp 7, Google Earth, historic maps, photographs

This project was started by a simple connection made through the Internet. A resident of a remote town in Ontario posted the following note on the Google SketchUp Help Discussion Group: "Hey Folks, I am interested in recreating a northern Ontario lumbering town inside a computer using various source materials. Can SketchUp do this?" I responded volunteering my time for the project so that the "kids living there can see what the town looked like." After a series of e-mails and trawling the Internet for historic photographs and maps, we indeed proved that SketchUp "can do this." In fact, it is the built-in tools of SketchUp that make it ideally suited to this task.

The project was a volunteer project as a prototype for future projects. The total time taken by the project was approximately 120 hours including research and modeling. The final output is a georeferenced model for private viewing in Google Earth and SketchUp.

Project Context

Historians and educators frequently encounter puzzles from the past. Vanished historic landscapes are often full of mystery and intrigue. Although two-dimensional photographs and maps can provide insight and understanding, they lack a layer of realism that a three-dimensional model can provide. This project uses SketchUp to push and pull the flat remnants of the past into a three-dimensional, "living" model that can be used to analyze photographs and provide insight into what life in this remote village of Byng Inlet must have once been like.

Historic Byng Inlet, located in Perry Sound, Ontario, was once a thriving industrial town. The complex at Byng was at one time the second largest sawmill in Canada, which employed several hundred workers while the town's overall population was only 4200. At its peak, the village included a school, church, general store, railroad depot, hotel, and even a modest movie theatre. Today, the site is mostly abandoned, home to just a few families, and is primarily an area widely known for sport fishing.

The Graves & Bigwood sawmill was built and completed by 1902. The mill and its facilities covered over 1 square mile with a large lumber yard, green lumber yard, planing mill, 11 wood-fired boilers for generating steam power, and dock slips and a box factory close by. A massive mill fire that occurred on May 20, 1912, saw losses in excess of over 55 million feet of lumber. The Graves & Bigwood Company mill was rebuilt. In 1927, after the nearby sources of lumber were depleted, the mill was closed down. Without any other form of industry to keep the population employed, most of the people left the area.[1]

This project took place entirely "in the cloud" of the Internet. There was a small but substantial collection of photographs of Byng Inlet. You may notice that the quality of some of the images used throughout the project is poor. This is due to two factors: They are old photographs and do not have the resolution we expect today from digital cameras. Second, the images were optimized for Web delivery and viewing; although such low-resolution images are a detriment to viewing in printed form, they are ideal for use inside SketchUp models.

Technical Aspects

SketchUp was used for the project because numerous built-in features of this tool made the assembling of various parts of the re-creation quite easy. Terrain data (TIN) was imported into SketchUp from Google Earth. The built-in ability of

[1] http://www.ontarioabandonedplaces.com/bynginlet/byng2.asp.

SketchUp to import and scale images as textures allowed maps to be imported at scale; finally, photographs were used to enhance the buildings in the model using historic photographs that were brought to life via the integrated Match Photo tools. Most of the modeling was done with the native SketchUp tools.

New Approaches

SketchUp has quite a large user base in the field of architecture; but its use in modeling historic sites has only begun to be exploited. The ability to match photographs and use the program for what I call "poor man's" photogrammetry makes SketchUp a very useful tool for pulling historic photographs into a three-dimensional model. This is a very powerful tool native to SketchUp and is frequently underutilized as it is used for little else other than for creating very simple Match Photo buildings for Google Earth. As detailed in this chapter, this feature can be used for many other advanced applications.

Step 1: First Attempts via Match Photo

Goal: To provide preliminary explorations of modeling.
Input: One historic photo of the mill.
Tools :SketchUp Match Photo.

Photogrammetry is a term used by cartographers, archaeologists, and architects. It refers to a process in which geometric properties of objects are determined from photographic images. There are currently many high-end software packages that make photogrammetric calculations using very complex formulas based on optics and projective geometry. Although these programs have a very high degree of accuracy, they are often expensive and difficult for a layman to use.

The Match Photo feature of SketchUp allows even a novice user to create reasonably accurate three-dimensional models from photographs. In the case of historic photographs, one has to make a few inferences about scale and proportions to get the model as accurate as possible. Before beginning the modeling process, it is advised that you become acquainted with the architecture of the concerned area and era.

The photo matching process is rather straightforward. First, the image is brought into a blank workspace using the Camera > Match New Photo menu items (See Figure 16.1). As shown in this example, the reference photo should provide a three-quarters view of the building. The Match Photo interface can be a bit overwhelming at first, but there are three steps that can simplify the visual confusion:

1. Set the origin to the corner of the building by dragging the yellow square to the corner of the building.
2. Using the green and red alignment guides, align the guides to two perpendicular faces on the building. In this example, I used window

frames. Care should be taken to accurately position the guides. Zooming in with the scroll wheel can help to increase accuracy. Avoid using the ground plane, which is frequently off-axis.

3. Finally, scale the drawing. In the case of historical photographs, you may need to use some common sense and logic to make an educated guess on the scale. Scaling is done by dragging the blue axis up and down or by typing a value in the Match Photo Spacing dialog box.

Once the axis and scale are set for use in Match Photo, the basic cubic form of the building can be modeled with the L using the red, green, and blue axes for proper alignment. Right-clicking on the faces of the building will allow you to Project Photo to each applicable surface. Once the photo is applied as a texture, the size of the building can be adjusted and the gable of the roof can be drawn.

FIG 16.1

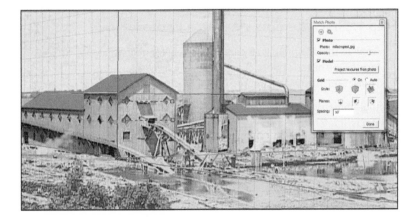

Step 2: Combining the Model with Historical Maps

Goal: To integrate scaled map and model into Google Earth terrain.
Inputs: Photograph-textured building and 1899 insurance map.
Tool :SketchUp.

The seamless integration of SketchUp and Google Earth allows you to quickly and easily geolocate and import terrain data for models. With contemporary buildings, it is quite easy to locate the building site in Google Earth, zoom-in to a convenient scale, import the data, and fine-tune the location of the building to match the Google Earth imagery.

In the case of Byng Inlet, the Google Earth imagery did not show where the historic buildings were located. Further research and intermediary steps were required to locate the photo-matched buildings. A lengthy search of the Internet succeeded in locating an 1899 insurance map of the area, compiled

by Charles Goad; this map showed the mill and the immediate vicinity and was used for insurance evaluation at the turn of the century. This type of insurance map is fairly common for towns and cities of even small sizes. They were created to assist fire insurance companies in assessing the risk associated with insuring a particular property.

The insurance map was brought into SketchUp and carefully "stitched together" to overcome the overlap caused by scanning the originals in book form. Once combined, they were grouped, and then scaled to the correct size using the Tape measure tool. In this example, the scale was set as 50 feet to the inch.

Scaling the map accurately is a very important step in assembling a map to Google Earth terrain.

Most maps have an illustrated scale. Place the Tape measure tool on the scale, drag it to the appropriate increment on the map, and then immediately type in the increment of the scale (in this case, 50 feet). You will then be asked if you want to resize the model. If "Yes" is your answer, you can scale the entire model proportionately.

Once the map was scaled, the model buildings were placed onto the map. They, in turn, were scaled to the map using the Tape measure. The groups bounding box was grabbed by the corner while simultaneously holding down the Shift key to ensure that it is uniformly scaled. The resultant model is a scaled photo-textured model on a scaled map. This does indicate progress, but a village is yet to be re-created. Further research and modeling is required to bring it to life.

Tip

Scaling with the Tape measure tool is the fastest way to rescale an entire model, and it scales all dimensions equally. This can be accomplished with the Scale tool; but difficulty arises when trying to scale all X, Y, and Z dimensions equally.

Step 3: Combining the Model with Georeferenced Terrain Data

Goal: Integration of model into Google Earth.
Inputs: Photo-textured building and Google Earth terrain.
Tools :SketchUp, Google Earth.

In this example of re-creating the historic Byng Inlet village, the terrain data obtained from Google Earth did not contain any matching visual clues – the historic buildings are mostly gone. The steps below (Figures 16.2a and 16.2b)

FIG 16.2a

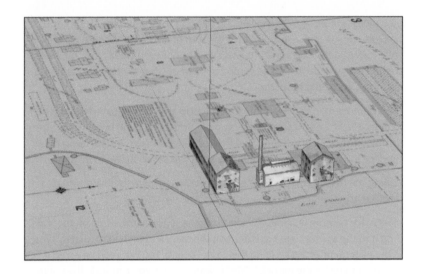

illustrate how the use of historic maps as an intermediary step will allow you to accurately scale and locate your model.

With the model opened in SketchUp, it is now necessary to locate the terrain in Google Earth. Zoom close to the landscape and center it in the Google Earth window. To ensure that the Google Earth terrain is properly oriented, make sure to hit N. This will orient the tool toward north and set your view perpendicular to the surface.

In SketchUp, toggle the Google toolbar from the View menu, and select the Google Toolbar to make it visible. Next, select Get Current View. The program will automatically import the terrain and landscape portraits into your model as groups. A careful study of the map and landscape will give clues regarding proper orientation and alignment. You may encounter variations in alignment. Early cartographers often used magnetic north for surveys. For contemporary modelers, it is important to remember that magnetic north moves. Adjustments vary from location to location; in the end, I made the adjustment visually, using the stream and shoreline in both sets of data to orient the respective overlays.

FIG 16.2b

The image in Figure 16.3 shows the historic insurance map overlaid with Google Earth terrain. To allow the best placement, it was set to be partially transparent so that it was possible to see both the map and the terrain. Transparency was adjusted by activating the Materials dialog box via B or Paint Bucket.

The map was then sampled using the Eyedropper tool, which makes the map active in the Materials dialog box. Transparency was adjusted using the opacity slider at the bottom of the dialog box. Note the 12° discrepancy in "true north." Final elevation of the building was set in the subsequentsteps.

Tip

The Earth's magnetic North Pole is constantly moving. When working with old maps, you may find that the North indicated on these maps does not allow the features to line up with any existing features. It is possible to mathematically correct for this; but it can be quite a technical process. In the case of Byng Inlet, adjustments were made using visual clues from both the Google Earth snapshot and the historic insurance map. A best-guess estimate proved quite serviceable and accurate for this model.

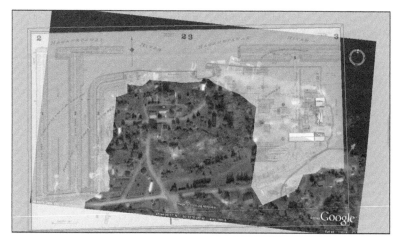

FIG 16.3

Before discussing the modeling in depth, it is helpful to learn a bit about how SketchUp implements terrain data in a model. When SketchUp imports terrain data, there are actually two sets of data that are imported. First is a flat snap-shot of how the terrain looks like from satellite observations, and the second is the actual terrain/elevation data – a skin on which the satellite image is projected. The view of these layers can be toggled on or off by utilizing the Toggle Terrain tool on the Google toolbar.

Tip

The above information about how SketchUp implements terrain data is pointed out here because one needs to remember what surface you are modeling on. Modeling on the Google Earth layer can cause you to end up with buildings that are aligned with the ground but not necessarily vertical as they are in real life. If you are beginning to model using terrain data imported by Google Earth, unless the land is perfectly flat, it is best to model on the Google Earth snapshot first and then move to your model and adjust it to the proper position on the terrain.

Step 4: Additional Modeling and Refinement

Goal: To detail buildings based on location abstracted from map and the addition of details provided by historic photographs.
Inputs: Outlines from the map combined with historic and contemporary photographs.
Tools: SketchUp native tools, Rotated Rectangle Ruby script.

A problem that is frequently encountered by novice users is how to properly seat buildings on a hilly terrain. Online tutorials detail how to form the buildings and extract surface materials but overlook the fact that at times the buildings end up appearing to float on air. Common sense should be the guidepost. Just as in real life, buildings need a proper foundation to rest on. These foundations account for the varying terrain.

FIG 16.4a

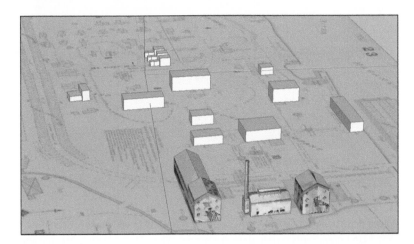

Unlike the modeling of contemporary buildings that are shown on the Google Earth terrain, this example uses the historic insurance map as the primary source for location information. The map was imported and grouped to keep it from "sticking" to the modeled buildings. It was also assigned to a layer so that it can be quickly hidden or displayed as the modeling progresses.

SketchUp's inference engine uses the main axis of the model as a reference. When modeling real-world situations, often features are not perfectly aligned to the axis. Using the Rotated Rectangle Ruby script will allow you to easily draw buildings that are not aligned with the model's main axis. In this manner, you can quickly trace the building outlines indicated on the map.

After the preliminary outlines of the building are traced, it is time to begin detailing. As stated previously, historians need to play detective when recreating historic buildings. A quick search of the Internet revealed a few historic photographs that provided details about appearance and construction. A search of popular photo-sharing sites like Flickr or Picasa also turned up some contemporary photographs of a few extant buildings in Byng Inlet.

FIG 16.4b

For this exercise, the buildings were not modeled in extreme detail; simple building profiles and the most basic features of windows and doors were added to give the town a sense of realism. While modeling one house at a time normally, I found an interesting tip for drawing the roof. I was getting bogged down in trying to scale the roof to make a proper overhang. After repeatedly modeling many houses, I found a streamlined and efficient method to do this, which is outlined here:

Starting with the basic block of the house, group just the top face; then using the Scale tool, scale the eaves as needed to produce the eave of the house. Next, pull up the offset portion to get it to the proper height. The inference engine of SketchUp then allows you to find the center of the roof. The Line tool is used to draw the pitch of the roofline. Now, using the Offset Line option on the front (triangular) face, you can draw a perfectly symmetrical eave. Line will be needed to complete the fascia. Finally, use the Push/ Pull tool to carve out the roof and pediment. These simple steps are roughly illustrated in Figure 16.5a.

FIG 16.5a

Windows were added based on the historic photographs. Google's Window Maker Ruby script is ideally suited for adding simple windows. A dialog box allows you to specify the height, width, and type (double hung or slider) of windows. This plug-in has the added convenience of cutting an opening in the wall as the window is placed, which makes it easy to quickly populate your models with low-poly windows.

FIG 16.5b

Next, a simple door and a porch were added, and the model was textured to make it look real. This house was made into a component as it was used repeatedly in the model. Finally, the Google Earth terrain layer was turned on by using the Toggle Terrain icon. Using the Move tool, the height or altitude of the building was adjusted so that its foundation was inset into the Google Earth terrain layer of the model.

FIG 16.6

Modeling from historic photographs can be challenging. Take time to familiarize yourself with the layout of the town. Pay attention to key landmarks and buildings, and use them to determine where the photograph was taken. Was the photograph taken from a hill or a prominent vantage point? Byng Inlet's photographs are dominated by the large cylindrical sawdust burner that tower over many of the buildings in the town. The use of key features as anchors will help you to reconstruct the locations where the photographs were taken and the angles they illustrate.

As seen in the illustration below (Figure 16.7), it is possible to infer where the photographs were taken. In this example, the historic photograph has been added to a plinth modeled on the ground. For educational purposes, these plinths were added to several locations in the model that match the historic buildings with those modeled in SketchUp.

FIG 16.7

FIG 16.8

Tip

When there is a need to model multiple instances of buildings that are identical, make them a Component. Components allow you to reduce the size of the model file and let SketchUp perform better. Setting the axis of the component at the base of the foundation allows them to "stick" to the surface where they are placed. Another advantage of using Components is that when you change or edit one instance of a Component, the change is reflected in all instances of that Component. In this model, many of the workers' houses were instances of the same Component; they can quickly populate the model with adjustments made only to their location and elevation.

As an experiment, I began to abstract imagery for the faces of buildings and applied them to the buildings in the model. This was not done via photo matching but by selecting the face of the building and then importing the images via the File/Import option on the toolbar. This led to some visually intriguing results. These images can be left as they are, or traced and modeled for further refinement of the model.

FIG 16.9

Step 5: Exporting the Model to Google Earth

Goal: To export a.kmz file for use in Google Earth.
Input: Model feature in the Tools/Google Earth toolbar.
Tools :SketchUp, Google Earth.

When modeling is complete, it is very easy to view it in Google Earth. Under the Tools/Google Earth toolbar, you will find a command called Place Model. Activating this option will open a progress bar indicating the status of your

export. When complete, Google Earth will immediately open and your model will be displayed in the sidebar under "Temporary Places."

Tip

The procedure used in this tutorial is intended for private viewing and not for inclusion in Google's public 3D building layer. This model is too large for inclusion, and since it is based on buildings that no longer exist, it will not be accepted by Google.

For a model to be accepted by Google Earth, the following criteria must be met (adapted from Google, see http://sketchup.google.com/3dwarehouse/):

1. Models should represent structures that actually exist.
2. Ensure your model sits properly on the terrain in Google Earth.
3. Models should not include an excess of entourage (trees, cars, and people).
4. Models should be completely photo-textured. Improper or partial texturing is one of the more frequent reasons for rejecting a model.
5. Models should be of the correct size and height, and be properly aligned to match what appears in Google Earth's aerial photography.
6. Models should not be too complex. When modeling for Google Earth, you need to strike a balance between realism and simplicity.
7. Models should not exhibit "Z-fighting." Z-fighting is the flashing you see when two or more coplanar faces are overlapping.
8. Models should not include more than one discrete structure each.

For a more complete and detailed list of criteria, refer to this Web site: http://www.google.com/intl/en/sketchup/3dwh/acceptance_criteria.html.

FIG 16.10

Conclusion

The final model contained over 100 buildings, scaled and geolocated. The resultant model is viewable in SketchUp or Google Earth and is currently being used by schools in the vicinity of Byng Inlet to teach the children more about the once-thriving community of this town. As my contact in Ontario viewed the model, he exclaimed: "This is amazing! I never knew there were so many houses and buildings. . . . They are all gone."

The recently released Google Earth API has many additional features to add more layers of content to the SketchUp model once it is imported into Google Earth. Placemarks, Web links, and even recorded narrations can now be added to location tours, allowing limitless possibilities for educators and historians.

SketchUp is ideally suited for modeling historic sites from photographs. The ability to import terrain and utilize historic photographs for textures allows for a synthesis of information that would be difficult to achieve with other software solutions. The amount of detail and accuracy included in the model is limited only by the amount of source material available. Google SketchUp is an immensely powerful tool, limited only by your imagination.

Resources

An early version of the model in this tutorial can be found in the 3D warehouse by using the search term, "Byng Inlet." The final model was too large for inclusion into the 3D warehouse, but most of the significant items covered in this tutorial can be seen.

The authors thank Gary McLaughlin of Byng Inlet, Ontario, for the use of photographs in this project.

Software
> SketchUp, Google Earth

SketchUp Plug-Ins
> Rotated Rectangle and Window Maker are available from
> http://sketchup.google.com/download/rubyscripts.html.

Dynamic Components

Matt Chambers

Matt Chambers, Independent Consultant, has been using, teaching, and consulting on 3D applications at numerous university and commercial capacities over the past 8 years. He discovered SketchUp in 2003, when he was working as an adjunct architecture professor at North Dakota State University. Over the past several years, Matt has trained hundreds on how to include SketchUp into very specific design workflows. As a lead beta-tester, Matt helped refine and define how Dynamic Components are built as well as how they can be used.

Dynamic Components are "smart" components that are created to do any number of things. Pieces can animate when the component is interacted with, parts can copy and position themselves when the component is scaled, and any number of configurations can be stored in and accessed from a single component. This is done by applying functions and formulas directly to the component's attributes, which are things like position, rotation, material, size, etc. The attributes have always been there; the Component Attributes dialog allows for their manipulation beyond the visual clicking and dragging ways most SketchUp users are accustomed to. There are many workflow possibilities with Dynamic Components, and it would take a book to adequately

address them all. By examining specific examples I have used in my SketchUp workflow, I will offer a glimpse into their potential as well as provide some helpful tips for both creating and using Dynamic Components.

With regard to creating Dynamic Components, you will rarely see Google use the verb "program" because (I am guessing) it conflicts with SketchUp's mantra of "3D for Everyone." From experience, I can tell you that having a working knowledge of programming surely does not hurt anyone. A fondness to algebra and trigonometry is also a big plus. I do not intend to scare anyone away from Dynamic Components; building a component with simple dynamic functionality, such as replication, is relatively easy.

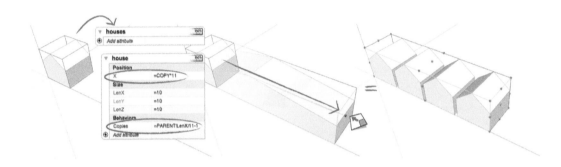

anMDynamic Component function examples similar to the one above can be found at http://tinyurl.com/dc-functions. The Dynamic Components detailed here were more of a technical challenge to create. From a user perspective, there are certain qualities that will make a Dynamic Component more practical. It should be clear in what exactly is dynamic about it, it should function as expected, and its digital "weight" should be manageable (Dynamic Components, especially ones that replicate parts and have a lot of functions, can become very large very fast). Those qualities may appear obvious, but for an example of why they need to be stated, search the Google SketchUp 3D Warehouse (http://sketchup.google.com/3dwarehouse)for "Dynamic Window." You will find some windows that glue to a surface, some that copy and position when scaled, some that hold multiple window configurations, and some that have no dynamic feature whatsoever. Trying to find a specific Dynamic Component currently will either frustrate you to the point where you do not want to use them or motivate you to create better one.

There are three components I will look at, all of which are related to an "entourage" workflow of adding a supporting context to an otherwise complete SketchUp model. One is a moderately detailed, "multiple-option"-style Dynamic Component with parts that animate, second is a "replicate and position"-style Dynamic Component complete with intentional imperfection, and the last is a "shotgun"-style Dynamic Component that positions parts randomly. My examination of these components will not be linear. … I will not detail their step-by-step creation or specify exact modeling situations where they could or should be implemented. What I will do is illustrate their dynamic features while showing the appropriate attributes to reveal how they function the way they do. I will share some experiences of hitting practical limits in creating Dynamic Components as well as offer what I have found to be useful integration tricks within the larger SketchUp toolset. The Dynamic Component tool palette consists of three icons. The first activates the "Interact with Model" tool, and the other two open the "Component Options" and "Component Attributes" dialogs, respectively.

Interact with Model

Component Options

Component Attributes

t is important to note that anyone can use SketchUp Dynamic Components, but the professional version of SketchUp is needed to create them. The three Dynamic Components referenced in this chapter are available from the Google SketchUp 3D Warehouse. You can find them by searching their names. While I do highlight the important attribute formulas and functions of each model, I do not include its complete Component Attributes. I encourage you to download each model and explore the Component Attributes dialog to fully understand how each component works. The Component Attributes dialog only displays one parent–child relationship. The Outliner can be used to quickly access nested parent–child attributes.

The first Dynamic Component is called "Multiple DynaComp Vehicles." It holds four vehicles, three of which are hidden at any given time. The vehicle displayed can be selected from the Component Options dialog.

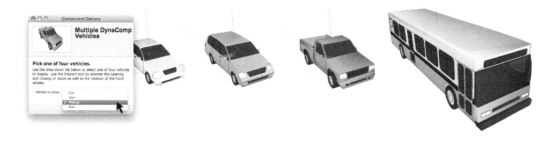

Clicking on the doors and tires of the vehicles with the "Interact with Model" tool will result in simple visual animation. There are four animation techniques being

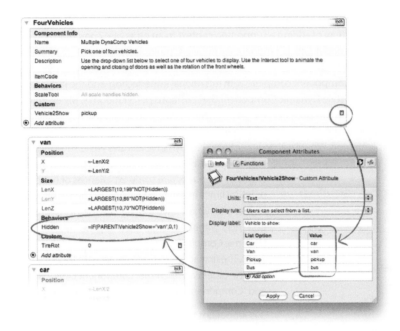

implemented in this model. The car and pickup doors are the most basic. A click with the Interact tool makes the parts rotate along one axes between two values.

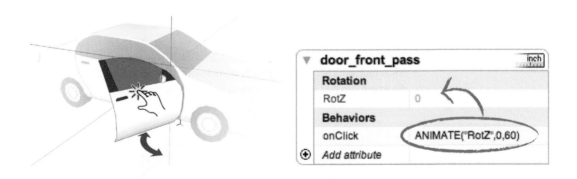

he van's sliding doors do not rotate, but each door will change both X and Y positions simultaneously. Two attributes can be animated with a single Interact click by separating animate behaviors with a semicolon. The OnClick attribute value field is different from the other value fields in that it takes a behavior, not a function. That is why it does not start with an equals sign as the functions in the other value fields do.

294

he bus's sliding doors do something that is subtly different. As with the van door, both X and Y positions are animated; however, the bus doors animate the directions in succession. This is done by animating an intermediate value between 0 and 200. Between 0 and 99, one thing happens; between 100 and 200, something else happens.

The final animation technique allows for some parts to animate other parts. Clicking on the bus doors or any of the vehicle's front tires animates what you are clicking on as well as the "sibling" parts. When doing this, the intermediate attribute that is being animated needs to be the parent component that holds the siblings that are being animated.

This component functions on its own as a moderately detailed, "multiple-option"-style Dynamic Component. However, if it were to become a part of a "copy & position" Dynamic Component, the copied geometries and formulas

295

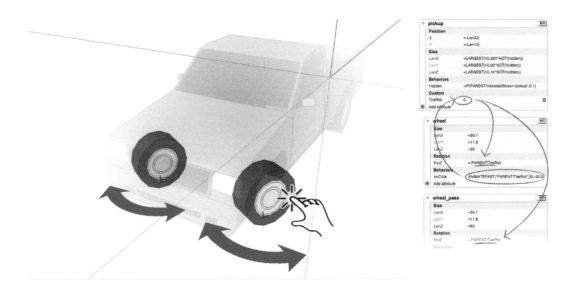

would quickly become a file-size and computer-processing burden. To reuse parts of this component inside a replicating Dynamic Component, I lightened the overall weight by removing the bus altogether and greatly reducing the remaining geometries, materials, and attribute functions.

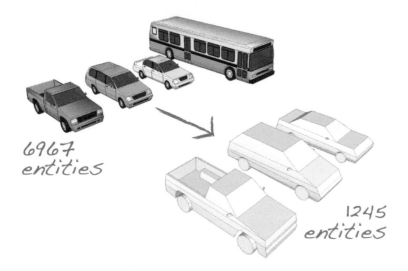

6967 entities

1245 entities

ith the lighter geometries nested inside the replicating Dynamic Component, it will process much faster. The style also lends itself more to "essence of parking" and less on detail.

The "Sloppy DynaComp Parking" component initially consists of a single, 90-degree, vacant parking spot. There is also some visual instructions to aid in

its use. Those become hidden when the component consists of more than one parking space.

he Component Options dialog offers the user some creative configuration options. Clicking on the individual cars with the Interact will hide them. This Dynamic Component was built with imperial units, but as with most numerical operations with SketchUp, metric units can be entered to adjust the parking spot width and depth.

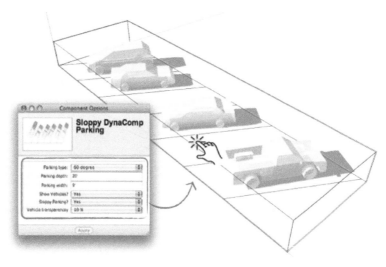

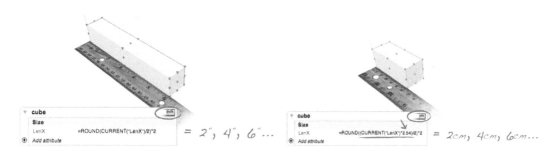

he "SloppyTDynaComp Parking" component has replicating parts, but because there are several other things happening at the same time, the Component Attributes is more complex than the simple house replication example shown at the beginning of this appendix. This is in part because it is not one static parking space that is repeating, but a collection of lines that define the parking space. The lengths of those lines and the distance between them are defined by the user. Additionally, the angle of these lines can be user configured. These configurations affect formulas that determine overall lengths and positions. Because angles are involved, several trigonometric functions are called. I hope you remember SOH CAH TOA.

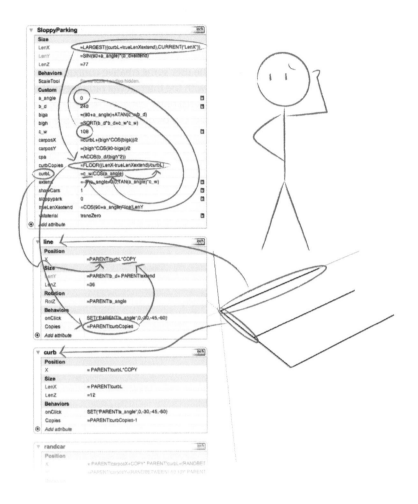

I do not have enough red ink in my computer to highlight all of the attribute functions for this Dynamic Component, but there are a couple of useful ones that are worth noting. As previously mentioned, clicking with the Interact tool on vehicles will hide them. If hidden geometries are visible, they can be unhidden the same way. This is a surprisingly simple and very useful authoring "switch" trick. It does not matter if the Hidden attribute is entered manually or is the result of a formula, it will always equal either true (1 or greater) or false (zero or less). A simple OnClick behavior will set that value to the opposite of whatever it currently is. When using OnClick behaviors, you are telling an attribute, and not the attribute value, to do something. This is why "Hidden" is inside double quotes.

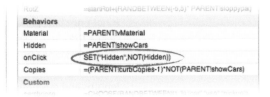

he "NOT(Hidden)" trick is also very useful for reducing the size of "hidden" things. This trick was used in the "Multiple DynaComp Vehicles" component

298

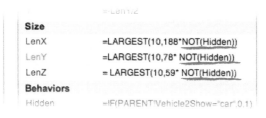

Size

LenX	=LARGEST(10,188*NOT(Hidden))
LenY	=LARGEST(10,78* NOT(Hidden))
LenZ	= LARGEST(10,59* NOT(Hidden))

Behaviors

Hidden	=IF(PARENT!Vehicle2Show="car",0,1)

to reduce hidden vehicles to 10" cubes. It does not affect the function of the Dynamic Component, but it keeps things tidy.

A function of Dynamic Components that is one of my favorites is the ability to assign random values to attributes with the RANDBETWEEN() function. This was used to add some intentionally imperfect parking. Adjusting the values in the parking component's RotZ value field will yield interesting results.

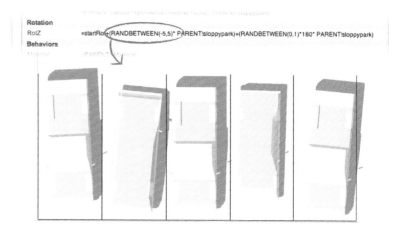

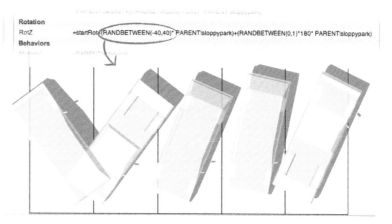

The "Sloppy DynaComp Parking" component is functional for creating a quick row of imperfectly parked vehicles, but it has its usage and programming limitations. This component only results in a single row of parking. The ability to create an entire parking lot could have been built in (in fact it initially did), but adding another dimension of scaling and copying essentially squared

the necessary attribute formula calculations. It proved to be more practical to resort to traditional SketchUp copying and arraying to produce multiple rows. This method of mixing Dynamic Component functionality with standard SketchUp tools has additional advantages in that each manually copied row can have a different length and rotation. When multiple similar Dynamic Components are selected, the Component Options dialog can be used to configure them all simultaneously.

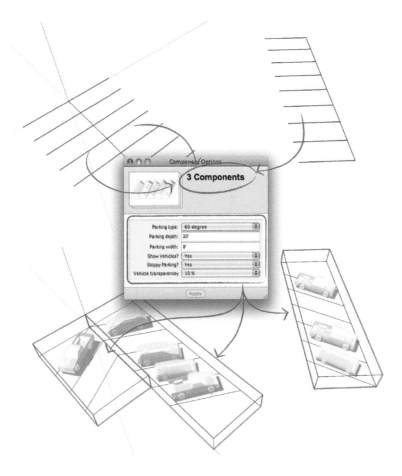

The final component to be examined is called "DynaComp Crowd Control." Its use and function is straight-forward. Scaling the component results in a randomly positioned crowd.

The Interact tool will rerandomize the crowd if the results do not look quite right. Different levels of crowdedness as well as a "Crowding along one edge" option are available on the Configuration Options dialog.

In the "Sloppy DynaComp Parking" component, for each visible vehicle, there are two hidden ones. The RANDBETWEEN() function is once again used, this

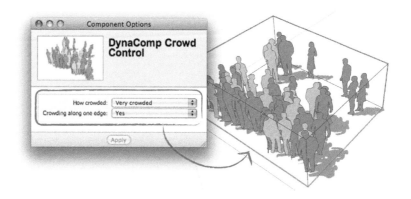

time to determine which vehicle will be visible. It is a common and easy-to-implement technique for holding multiple configurations in a Dynamic Component. In the parking component, it is a manageable technique because of the relatively low polygon count for each vehicle.

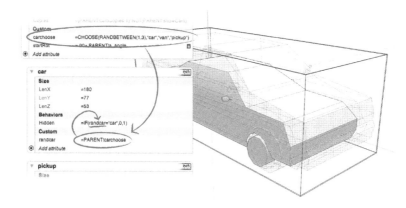

Because the "DynaComp Crowd Control" component is composed of nine different "characters," this "hide all but one" technique would be inefficient. The file size would be eight times bigger than it needs to be. The crowd is actually not as random as it appears; the Component Attribute formulas first determine how many people will fill the size of the scaled space. Each of the nine characters is selected in succession and randomly placed. If there are 10 or more characters needed to fill the space, they start to repeat. For most of the nine "character" children components in this Dynamic Component

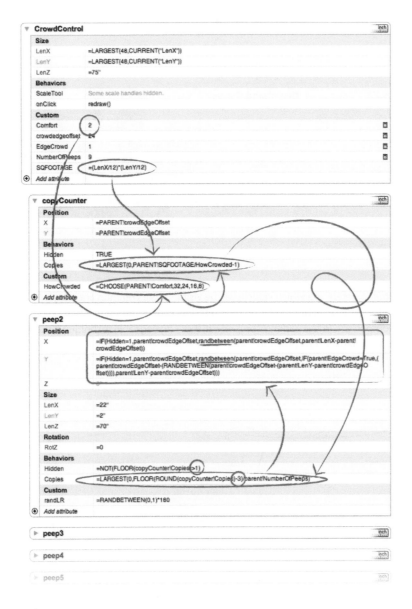

(the first one is an exception), their attribute functions and formulas are identical except for two numbers in the "Hidden" and "Copies" attribute value fields.

shdwed a practical combination of Dynamic Component and traditional SketchUp workflow with the "Sloppy DynaComp Parking." Properly built Dynamic Components can also be integrated with many of the available SketchUp Ruby scripts for even more functionality. "Drop.rb," available from http://www.smustard.com, is one of them. Because the "Z" attribute for each "character" child component is not set, it is a flexible value that will be inherent in any manual or Ruby-script-related move. Double-clicking on the "DynaComp Crowd Control" component to edit it and applying the "Drop.rb" script will result in the individual people components dropping to whatever surface below them.

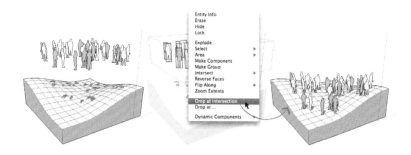

There is usually a question that both the Dynamic Component user and the Dynamic Component author ask: "Is there a Dynamic Component that does [fill in the blank]?" A user will try to find it; an author will try to create it. If you are like me, you will do both. I believe having a solid understanding of the potential of Dynamic Components – along with the right inquisitive questions – will result in Dynamic Components that are both creative and useful. It is easy to create your first one, and once that is complete, you will quickly find there is no shortage of ideas waiting to be made dynamic.

Index

Page numbers followed by *f* indicates a figure and *t* indicates a table.

Printed and bound by CPI Group (UK) Ltd, Croydon, CR0 4YY

22/10/2024

01777530-0012